MONTE CARLO

MONTE CARLO
A LIVING LEGEND

Text by Frédéric Mitterrand

The Vendome Press

The publishers wish to thank Monsieur Daniel Aubry,
director of the Patrimoine Historique at the Société des Bains de Mer,
without whom this book could never have been realized. For the
photographs reproduced in *Monte Carlo*, we also wish to acknowledge
the work of Walter Carone, Wolfgang Vennemann, and X, as well as
all the photographers employed by the Société des Bains de Mer.

First published in the USA by
The Vendome Press
1370 Avenue of the Americas
New York, NY 10019

Distributed in the USA and Canada by
Rizzoli International Publications
through St. Martin's Press
175 Fifth Avenue
New York, NY 10010

Library of Congress Cataloging-in-Publication Data
Monte Carlo: a living legend : photographs from the Société des bains de mer:
text by Frédéric Mitterrand.
p. cm.
Originally published: Assouline, 1993.
ISBN 0-86565-953-2
1. Monte-Carlo (Monaco)—Pictorial works.
2. Celebrities—Monaco-Monte-Carlo—History—20th century
3. Société des bains de mer—Photograph collections.
4. Casinos—Monaco—Monte-Carlo—History.
I. Mitterrand, Frédéric.
DC946.M63 1994
944'.949—dc20 94-16537
 CIP

Printed and bound in France

à la Société des Bains de Mer

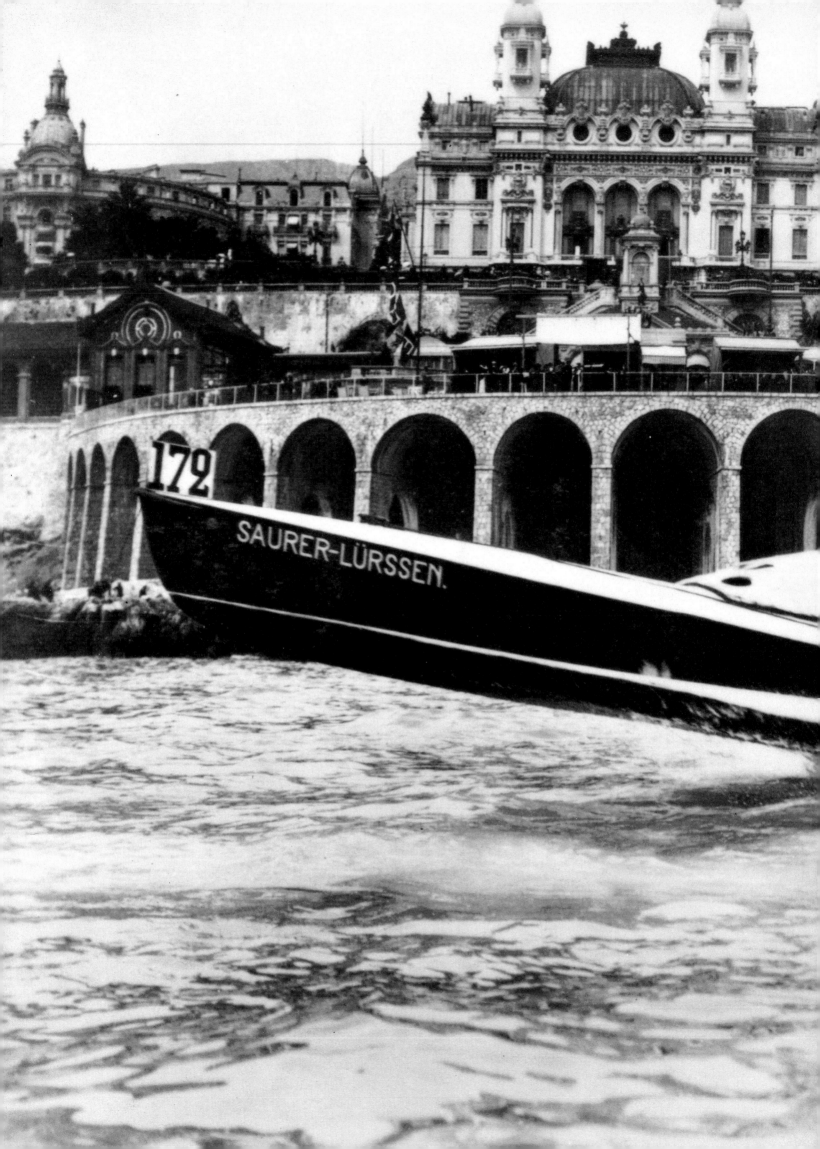

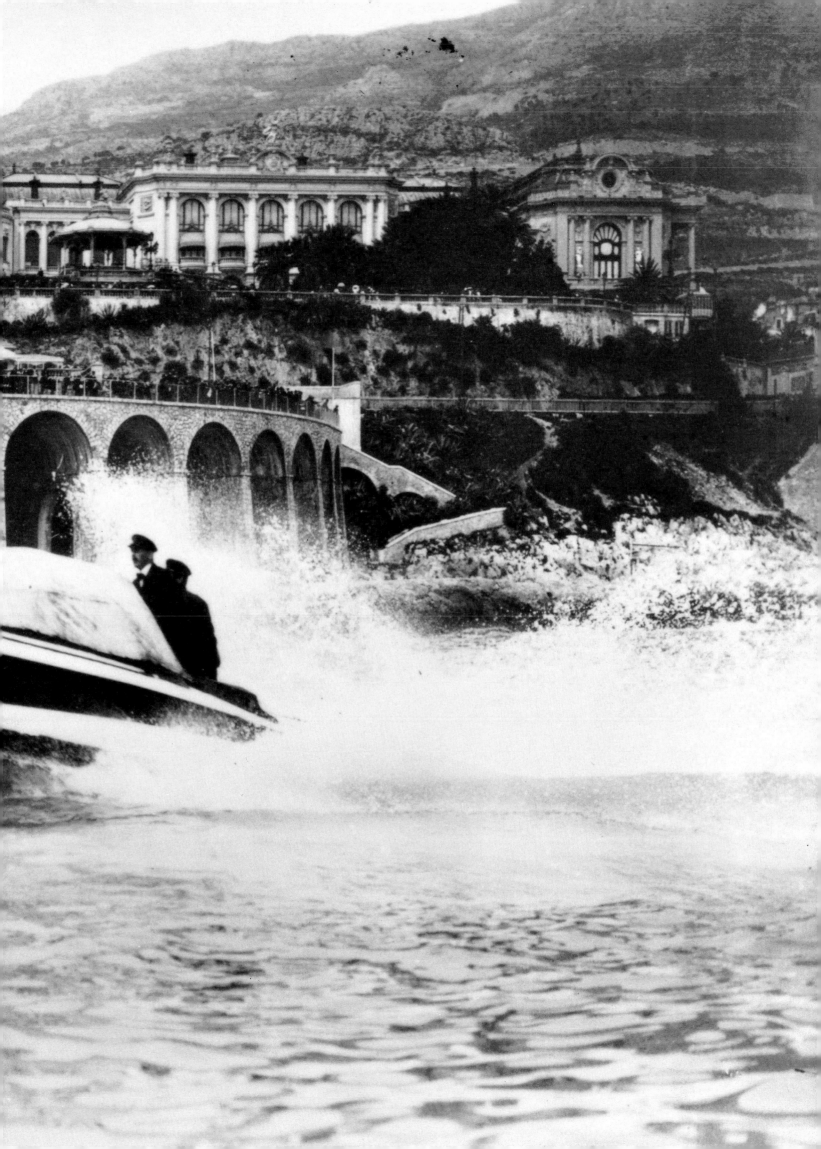

F O R E W O R D

I can think of nothing more intimidating than a legend. Dining with the Queen of England could, in the end, be a relatively easy, pleasant experience, but to give an honest, sincere opinion of Cinderella or Snow White, one would need to be a Bruno Bettelheim or a very young child in order to avoid the risk of destroying the magic.

The legend of Monte Carlo counts among the most powerful to emerge in our century. It survives the whole army of people who talk, dream, and write stories about the Principality; indeed, it simply feeds on such fare, just as great monuments draw nourishment from the dust of time that covers and then endows them with mystery. Thus, I am hopelessly intimidated, and all the more so because I know that Cinderella and Snow White are alive and well in Monte Carlo, albeit under other names, right along with princes charming, film stars, and old ladies à la Babar.

And so, rather than evoke an enchanted world head on, a world whose lights I do not dare attempt to reflect—for fear that they fade away at the first touch of my ardent yet awkward blandishments—let me offer a few Tom Thumb tips selected to help the reader withdraw into the magic labyrinth. What follows, therefore, is an ABC—a lexicon, as the intellectuals might say—presented as merely a few traces to keep friendly readers from losing their way once the calls begin to sound (*Messieurs. Dames. Faîtes vos jeux!*) and the festival lights start to blaze.

ARGENT (MONEY!) An important chapter in the legend, one that arises directly from the casino and those mad chemin-de-fer games into which generations of millionaires have thrown themselves, desperate to preserve their reputations as gamblers. It is linked to the idea of the transient, the source of its value. Also those early, cloudy mornings when the concierge at the Hôtel de Paris obligingly provided the train tickets needed by a Grand Duke finally cleaned out and making a hasty retreat to Saint Petersburg in order to recover. Money also had everything to do with the little friends he left behind, especially the pretty Parisian returning to a cheerless flat in the Rue de Prony, there to await another hero with a compromised destiny. Money spent as if there were no tomorrow, on nights of lucky martingales, in the jewelry shops with convenient hours. Caviar consumed by the ladle-full, and champagne drunk by the magnum. Decanted in the shoes of beautiful women. Banks of flowers, expensive clothes, and promises of eternal love, at least until the following night. Money earned more often elsewhere, but sometimes on the spot, most particularly in bed, as long as the subtle cocktail of rules and conventions flowing from differences of age and status were respected. Today this cocktail remains one of the craftiest subterfuges of Monegasque magic. Indeed, money circulates in Monte Carlo very much like fresh produce, and if it continues to be an obsession of millions of simple souls everywhere the world, generating bursts of green envy in certain minds upset that a poor country had thus grown rich, the possession and use of money have proved optional to an abundantly happy life in Monte Carlo. A youthful heart, a graceful insolence, charm, and wit provide a perfect substitute. One has only to make a start, and, if done nicely, there will always be someone else to sign the check.

N O T A B L E P E R S O N A L I T I E S

The Aga Khan for having found in Monte Carlo the mother of Ali, the delightful Theresa Magliano, at the time of her appearance at the Opéra in a ballet, the memory of whose choreography has unfortunately passed into the silent realm of reference books. Prince Albert (of Grimaldi). Princess Antoinette, elder sister of Prince Rainier, an attractive personality and tireless protector of our four-legged friends. Innumerable Austrians, including the Emperor Franz Joseph,

who came in pursuit of the evanescent Sissi, and the director Erich von Stroheim, who copied every last detail of the architecture in order to reconstruct it in Hollywood. Finally, all those anonymous tourists in shorts, fleeing their air-conditioned buses and waiting, sweatily under a relentless sun, for one of the Princesses to make a mythic passage through the revolving door of the Hôtel de Paris.

B

BAINS (BATHING) Ludic activity, vigorously discouraged in other parts of the Riviera because of galloping pollution, yet miraculously still safe and tonic at Monte Carlo, whose athletic reputation swimming in the Mediterranean helped to establish at the beginning of the 1920s. The sport assumes its most elegant form at the Beach, with its combined pleasures of a vast swimming pool and a plage of fine sand, complete with nautical provisions of the most refined sort: cabanas, tents, marine vehicles, swimming instructors, swift restaurant service, and healthy food. It should be noticed that, during the summer season, the rental of bathrobes, towels, and other bathing essentials is handled by women choristers from the Monte Carlo Opéra, but they are not required to perform the "Ride of the Valkyries" while giving out the key to your dressing room. Contrary to the wide-spread habit of confusing life on the beach or at pool side with anything goes, of freedom of the body with immodesty, persons of distinction benefited by conforming to the canons of hydrotherapeutic elegance defined at Monte Carlo in the years between the two World Wars. This was when Serge Lifar, Coco Chanel, and Jean Cocteau invented the cult of sunbathing and bronzed skin, in reaction against the arrière-garde composed of those devoted to umbrellas and nacreous flesh. The triumph of the modern, vigorously reinforced by the construction of magnificent infrastructures along the coast, all in the Art Deco style, allowed the good life at Monte Carlo to continue throughout the year. It also permitted the rejuvenation of a clientele already thoroughly shaken by the various European revolutions. This movement, issuing from a universal commotion that all but buried the joy of life in the trenches of Verdun, included

psychoanalysis, the telephone, jazz, gold-tipped cigarettes, a cinema that would soon be talking, detective novels, cocaine, women in slacks, leftist ideas, convertible automobiles, avant-garde painting, recorded music, the Ballets Russes, Americans, whisky, gigolos, and face-lifting. It would be well to remember all these things while making our way to the beach, given that almost nothing of greater interest has been invented since. True Monte Carlo taste favors bathing suits over "slips" for men, one-piece wear over bikinis for women, and it would surely avoid multicolored bermudas as well as "strings," not to mention those hideous, more or less phosphorescent lycras. Berets, straw hats, foulards, espadrilles, polos, T-shirts, canvas trousers—white or variously colored—should be welcomed for après-bain or cocktails between cabanas. One must take equal care in choosing sunglasses, fantasy jewelry, children, and nurses meant to complete the essentials of a bathing party. If a certain inventiveness seems desirable in regard to these accessories, their use should not go beyond the condition of a charming and inevitably silent fantasy. Inflatable buoys shaped like ducks or sharks, tearful brats demanding ice-cream in lieu of their "shrimp cocktail," and young Dutch au pairs sunburnt "lobster red" are all to be proscribed or redirected to Nice in the event they linger too long. For those over twenty-five, swimming should be done after six in the evening when the light is at it softest. And beyond the age of fifty, one should swim at dawn, during winter, and at the popular Larvotto beach, the better to enter, like Greta Garbo, that curious and admired category of athletes intimidating by reason of their longevity. Beyond a million dollars in annual revenue, one can do as one wishes.

NOTABLE PERSONALITIES

Josephine Baker, because she was saved from the process-servers by Princess Grace and made the last come-back of her career in Monte Carlo. Baron de Balkany for his marriage to Princess Marie-Gabrielle of Savoy, at nearby Eze, the only event of this type that could be compared to the wedding of Rainier and Grace. The Maharanee of Baroda whose proud beauty, splendid jewels, reverses of fortune, and private griefs epitomize both the bright and the dark sides of the legend. Bjorn Borg and Anthony Burgess because they lived in Monte Carlo protected from the vampire

tax collectors of social-democratic Sweden and Her Gracious Britannic Majesty, the Principality appearing to them, even in November, as beautiful as a numbered bank account.

C

CONSULS A sovereign state, the Principality of Monaco stimulates a great flowering of diplomatic vocations. Here the consulates of foreign powers abound, investing the various charitable and worldly events honored by the kind presence of the princely family with the indispensable cachet of elderly, heavily decorated gentlemen and their diamond-encrusted wives. Their combined breeding exiles, at least for the duration of a violin solo or a waltz, the Ferrari playboys and the top models in plunging décolleté to the tables at the back of the Sporting d'Été. Persons desiring to make themselves useful would have taken profitable note that it is not entirely necessary to be the citizen of another country in order to become a consular representative in Monaco. It suffices simply to be presentable as well as agreeable to all parties concerned. Thus, prudence should be exercised in the choice of country to represent. Senegal and the Order of Malta having already been assigned, and the Middle East disqualified for overzealous tendencies at banco, the states of the Caribbean, the Pacific, and Africa deserve consideration.

NOTABLE PERSONALITIES

Maria Callas, who often went aboard the *Christina*, a sort of floating palace, albeit delightfully nouveau riche, and who could have become the prima donna assoluta of Garnier's magnificent Opéra had the ship's owner, Aristotle Onassis, not preferred fishing for American film stars rather than attending to bel canto. Princess Caroline (of Grimaldi) and Princess Charlotte (the same chapter). Coco Chanel and Jean Cocteau for having "fixed" the criteria allowing registration in the legend. King Christian X of Denmark for having taken part in the most beautiful of the regattas held between the World Wars, and Winston Churchill for having snuffed out innumerable cigars in the Hôtel de Paris's ashtrays, now treated like holy relics. Colette for having cavorted

with Polaire in many "artistic" cabaret pieces, before a devoted public composed of pomaded young men and their natural enemies, the powerful "amazon" women sporting mustaches and tailored, belted suits.

D

DIAMONDS One of the essential attributes of the legend. Diamonds may be worn at all times and in all security on Monesgasque territory, thanks to the ubiquitous though discreet presence of the police. Presently, the tradition of hotel "cats," even though brilliantly played by Princess Grace herself in the Alfred Hitchcock film *To Catch a Thief*, is restricted to such triste enclaves of cupidity and greed as Cannes and Saint-Tropez. The pleasure of extending a soignée hand adorned with a glittering bracelet through the door of a luxury automobile may be practiced in Monte Carlo without fear of a swift one-armed heist suddenly carried out by hooligans astride speeding motorcycles, as has occurred at San Remo and Palm Beach. Despite the efforts of Far Eastern manufacturers of phony gems, the deplorable excuse of adventuresses who claim to wear fake jewelry so as not to be robbed of the real thing is simply unacceptable. A girl's best friend, according to Marilyn Monroe, diamonds are also the sweet consolation of their grandmothers. It should therefore come as no surprise to see diamonds virtually corseting triple chins and ample poitrines over which men no longer bow, other than a few young lovers of gold Rolex watches, which are also readily available every morning in the armada of jewelry shops on the main square. Donned without excess for a "late breakfast," diamonds can be worn more aggressively at lunch on the terrace, when they must compete with silverware flashing in the sun, before releasing all their fires, in a show of luxury without stint, at the various receptions of the evening. Like all the benefits of a secretly threatened society, diamonds require a certain setting or ambiance in order to come fully into their own. For them, the Rolls-Royce, the toy poodle, and the mink stole should be protected from sneak attacks by the Santana jeep, Husky, and the acrylic track suit.

Uncle David (Niven), as the infant Princes fancied him, for having more or less made Monte Carlo his second home. Bella Darvi for having sunk in a few nights of chemin de fer everything she had obtained from her derailment with Daryl F. Zanuck. Jaqueline Delubac, for the simple fact that seeing her enter the Hôtel de Paris leaves a memory far more unforgettable than high noon on the Bay of Naples. Serge Diaghilev for having tried every hotel in Monte Carlo as his fortunes turned, for the better or for the worse, while simultaneously he provided the history of choreography with some of its most beautiful pages. Lady Docker, because she was firmly requested to leave the Principality, a delay in her departure permitted only for a reasonable period of recuperation. Dukes and Grand Dukes are not cited under this rubric—too numerous in general, too pinched in France, too shot at in Russia, too Marbella in Spain, too Mercedes in Germany, too papal in Italy. There remain the Windsors, of course, but the letter A for Attraction has not been designated by the editor of the present book. . . . (A note from the publicity department confused but happy at not having to mention yet again Wallis and her Doudou.)

E

ETHNOLOGIST Even if one may be occasionally caught dreaming of Prince Charming, endowed with power by reason of magic—the power to seduce, the only real power—one cannot deny that it is shrewdness and an open mind that make a good sovereign. In this regard, we cannot overlook the remarkable personality of Albert I, the emblematic representative of a cultivated dynasty generous in its support of the arts. Son of Charles III, brilliant architect of Monaco's rebirth, Albert I, ethnologist and oceanographer, proved to be a Prince who went beyond mere enlightenment. He brought to the Rock numerous scientific events, built the Anthropological Museum, installed the modern port, and the magnificent, even extravagantly exotic garden. He encouraged technological experimentation of the most challenging sort and launched (in 1911!) the automobile rally in Monte Carlo. Above all else, however, what the world

has to thank this Prince for is the grandiose and visionary act of having the oceanographic museums built in both Paris and Monaco. Who else at the outset of this century foresaw the vital importance that the seas and oceans would assume for future generations? One takes up residence on a rock thanks to his courage and genius, and one stays there, thanks to something else altogether. What can one say? The Grimaldis take charge. They know their duty.

NOTABLE PERSONALITIES

Anita Ekberg, because she had a great fondness for certain first-class racing drivers and, to the delight of many, confused the swimming pool at the Beach with the Trevi Fountain in Rome. Elmir (De Hory), because it was in Monte Carlo that he painted some of his most notorious fake masterpieces, works that deserved to be put up at auction under their borrowed authorships at the time of the great public sales. Elsa (Maxwell), out of respect, naturally, for all the frantic activity designed to get herself invited at least once to the princely palace, and in indulgence of her penchant for alcoholic beverages, bad checks, and the powerful girl friends of Suzie Solidor, fierce vestals of the rock near Cagnes. Maurice Escande for his annual feats of soporiphic hypnosis, worked upon Monte Carlo's matinee lovers of classical theater. Finally, Yevgeny Yevtushenko, the great Soviet poet of the Brezhnev years, because he did not come to stir up the laboring masses, despite pressure—a bit tepid, to tell the truth—from the Principality's Communist cell.

F

FRANCE Never out of mind, yet never mentioned, as the old saying goes. In any event, a vague, distant republic, whose immigrants are admitted even in government circles, which goes well beyond the conventions of the Maastricht Treaty. Numerous friendly gestures on the part of France cannot, however, make up for that country's 19th-century kidnapping of Roquebrune and Menton, whose subjects had rebelled against the Prince under the pretext of paying too much tax! A fatal error for which the rebels' descendants can never hurl enough Mediterranean maledictions

against their forebears, with each fiscal declaration painfully drawn up under the taunting gaze of their onetime fellow citizens of Monaco. The existence of France is nonetheless borne out by a few boundary marks lost along a surrealistic line that cuts apartments in half, leaving pedestrians convinced that, with one foot in each country, they are reliving an old Charlie Chaplin film.

NOTABLE PERSONALITIES

Fanny (Ardant), illustrious Monegasque to the core, whose mother was the cherished lady-in-waiting to Princess Grace. King Farouk, nicknamed the "locomotive" of chemin de fer, who came to Monte Carlo to forget for a while the lost splendors of Cairo, and his son King Fuad, whose marriage to the delightful Princess Fadila took place in the princely palace. Errol Flynn, who floated his yacht in a nebulous sea of whiskey, and Frank Sinatra who enlivened certain balls to make up for his libations, which too were deemed excessive, and rightly so. Pierre Fresnay because the echo of his famous quarrels with Yvonne Printemps, Mme Fresnay, still sends a chill up the spine of the more venerable members of the Hôtel de Paris staff. And Prince Florestan, of the graciously rustic first name, because he was the unfortunate monarch against whom the 19th-century revolution occurred, with wretched consequences, as we have seen, for the people of Rockbrune and Menton.

G

GRIMALDI One of Europe's oldest reigning dynasties, the Grimaldis can legitimately look down on the houses of Windsor, Orange-Nassau, and Saxe-Coburg as if they were so many squatters installed upon rented thrones. The issue of a powerful family in the Republic of Genoa, which had given way to total disorder after the Guelfs and Ghibellines began massacring one another, François Grimaldi, called the "Trickster," quite simply seized the Palace of Monaco on January 8, 1297. The clever swashbuckler and his armed men passed themselves off as pious Franciscans, so successful in their devout guise that the supposedly honorable brotherhood caught

the palace guard completely off guard. Very quickly the latter found themselves dispatched to heaven, once the blades came forth as if by magic from beneath the monastic robes. They had only to look at the toes of the kindly visitors to see that they were shod in heavy boots and court shoes, despite the vow of poverty essential to their supposed condition. Still, *autres temps, autres moeurs,* and such robust beginnings of a great career have now gone well beyond the statute of limitations, obliging one to admire the skill of the Grimaldis, who have stubbornly clung to their rock, against all the high winds and rough seas of history. Bombardments from the hillside terraces of Turbie by generations of local seigneurs and their competitors intent upon gaining access to the sea, attacks by every kind of pirate pursuing the very opposite objective in their attempts to scale the cliffs, black plagues, choleras, and various bouts of warmongering, corrupting forays into Italian intrigue and the voluptuous life at the Versailles court. Then came the revolutions that shattered the most arrogant crowns, followed by the railways, not to mention the troublesome lemons, the Principality's prime export, but a commodity no longer salable that a few overwrought subversives took pleasure in hurling at the Prince's agents. Next came the contract with France, a document bitterly renegotiated on several occasions, successful reconstruction of local fortunes through games of chance, and, contrary to the official line, plenty of democratic turbulence on a tormented bit of earth where blood runs relatively hot. Always in the foreground, the vital challenge for each new generation of Princes: quickly an heir! In fact, the rather too affectionate Republic to the north stands to gain the 150-hectare Principality in the event the dynasty should die out. With the distant German cousins deemed all but intolerable, the Grimaldi mimosa must bloom constantly. Just imagine a Prince Gottfried, or Princesses Brünehilde and Walburga, with everyone in loden coats and Mercedes, the national anthem accompanied by pure Tyrolean yodeling.

Notable personalities

Prince Albert for having been one of the most powerful monarchs in Europe, the friend of Kaiser Wilhelm II and President Poincaré, the builder of the oceanographic museum, and the

husband of a beautiful American woman (already in the early 20th century!), who was quickly adopted by the Faubourg Saint-Germain. Prince Louis for having courageously resisted occupiers in black-and-brown uniforms and for having married a charming actress, Princess Guislaine (already, again!). Princess Charlotte for her chic and her anticonformism, a good bit of which has of course resurfaced in her grandchildren. Prince Rainier because of his success in many enterprises, and Princess Grace because she was the very incarnation of everything that a dream Princess should be, leaving the blue-blooded offspring of other royal families to play the involuntary roles of Cinderella's ugly sisters. Prince Albert because he is as good as he is good-looking. Princess Caroline because she is the sum of her parents' qualities. Meanwhile, Princess Stéphanie, in reality a sweet and serene person, finds herself coopted as the best-selling subject of the popular press, at least until this institution finally discovers other victims.

HOTELS It would be a mistake to become fixated on the Hôtel de Paris. Monte Carlo boasts many other smart addresses where one is more likely to meet battalions of millionaire Texans offering the possibility of seeing Houston. Tied up in the port there are yachts on which one can appear elegant and "trendy" even in bare feet. Also available is the Hermitage with its tunnel, through which fearless young people on the fast track can speed their way towards the tabernacle of worldly desires in bathrobes. It should be noted, however, that while the Louvre, the Balmoral, and the Versailles accept guests in an honorable manner worthy of their three stars, the Prince's Palace, albeit clearly a five-star/grand-luxe venue, stubbornly refuses to become a hotel and accept reservations. It is also not a good idea to boast of having spent a dream weekend at the Réserve de Beaulieu or the Eden Roc, for nothing could be more certain to bring skeptical looks from the most modest habitué of a family pension near the station or a camp site. Residing in Monte Carlo is a privilege, and on the other side of the frontier lies the third world.

Rita Hayworth because she made neighborly visits from the Château de l'Horizon, situated between Cannes and Golfe-Juan, and because she was the first Hollywood star to become an authentic Princess. (Gloria Swanson and several of her girl friends had, of course, already broken into the Almanach de Gotha, but this hardly counts by comparison with the marriage of Rita Hayworth to Prince Ali Khan.) Helmut (Newton) because he lived in the Principality with his wife, Alice Springs, and because they both made admirable photographs illustrating to perfection not only the highlights of the legend but also its sidelights. Alfred Hitchcock for having been the instrument of destiny when he made a film in Monaco starring Grace Kelly at the zenith of her splendor. Barbara Hutton because she came with almost all her husbands, one by one, whether he was a racing driver, a polo player, a former swimming champion, a mad gambler, or a world-class adventurer, Monte Carlo being a sort of supreme ANPE (state employment office) for each of these occupations.

I

ITALIANS Delightful Mediterranean neighbors, justifiably famous for their charm and elegance, and a summer presence in Monte Carlo since the victory of Marius over the Cimbrians and Teutons in the 2nd century BC. Meanwhile, they like nothing better than to annoy the Renault/Adidas-Reebok French with their Lamborghinis, gorgeous women, and salmon risottos. This book having been financed by a Parisian publisher of good reputation, the reader can readily understand that the authors have not thought it necessary to hold forth in a chapter devoted to making useless as well as invidious comparisons.

Julio Iglesias, a great favorite in Monte Carlo, as well as elsewhere, of women who love languorous fox-trots before an azure sea on nights when the moon is full. Igor (Stravinsky) who, while in

Monaco, composed several of his most beautiful ballet scores for Diaghilev, before, less enthusiastically, he settled several of his friend's unpaid bills. Ira von Fürstenberg, because of, well, a certain "confidential report." Ivana (Trump), for having come here to console herself for her divorce from "the Donald," a real-estate baron only too well known to his bankers, and for having made her brilliant, if somewhat overdressed, debut in the European jet set.

J

JACKPOT If your ambition is to make it in the world by hitting a big, fat jackpot, forget the idea right away. Nothing on earth is more capricious than luck and the windfalls (sometimes acid rainfalls) of money. If, on the other hand, winning is merely one of the risks you are willing to take, in a game where all that counts for you is the ineffable giddiness that comes with each turn of the card, then the Casino is your Palace. Indeed, the Monte Carlo Casino—designed by Garnier, embellished, decorated, painted, repainted, overloaded, marquetried, chased, carved, gilded, patinated, restored—is a temple dedicated to two accessory divinities—the Belle Époque and Betting—and thus home base for the true bettor. Here, illuminated by monumental chandeliers of Bohemian crystal, guarded by white caryatids, watched over by eternally smoking, almost nude beauties, you can give yourself up, the whole night long, to the delights of your passion. Meanwhile, out front, on the building's elaborate pediment, flanked by two lustily bounding angels, the clock relentlessly ticks off the temporal space that separates several of the themes evoked by the wall paintings in the gaming rooms: evening, morning, love, luck, madness. DEO JUVANTE—God willing!—says the device adopted long ago by the Grimaldis.

NOTABLE PERSONALITIES

Pascal Jardin, because he always arrived at the crack of dawn, after madly driving through the night in an open car, and then stood there, a cigarette in hand, to enjoy the astonishment of his

little Parisian girl friend as she beheld the sparkling panorama: the Monte Carlo harbor. Glenda Jackson, because it was in Monaco that she played several very pretty scenes in *The Romantic Englishwoman*, a fine but forgotten movie produced by Joseph Losey. Philippe Jullian, because his watercolors and drawings still turn up in the big summer auctions. Curt Jurgens, because the principality counts among the rare places in the world capable of taking him away from Gstaad and Saint Moritz.

K

KANGAROOS At last hearing, there aren't any, at least not any more, in the Monte Carlo zoo, though a good many are still to be found in the local hotel rooms, where it seems that one must jump onto whatever moves—just to feel alive! Australians, if no one else, would surely understand.

NOTABLE PERSONALITIES

Kashoggi, a modest little yacht a bit over 100 meters long, which must remain offshore to avoid being pirated away by a band of envious New Yorkers. Karim Aga Khan, for the beautiful photographs of him with his little brother Amyn at the Beach pool during the early 1950s. Kay Kendall, in delightful memory of her appearance at the Red Cross Ball on the arm of Rex Harrison, before death came knocking a few kilometers down the Riviera near Portofino. Deborah Kerr, ideal for the local cast of characters, among whom she made a great hit, before being lured away to Marbella by an error of casting for which the persons responsible are still being sought. Boris Kochno, sacrosanct embodiment of many a full-color page in the annals of the 20th century: the Roaring Twenties, the White Russians, dance, and Diaghilev; the 1950s and the great revival of ballet in Monte Carlo; the posthumous dispersal of his fabulous collections at a Sporting d'Hiver auction, where the whole mob of nostalgia fanatics sent prices through the roof.

L

LAGERFELD As one of his Parisian friends commented, in regard to Monegasque railway traffic: Since we have kept the Gare Saint-Lazare, it is only fair that they should be allowed to keep Lagerfeld. Meanwhile, watch the doings of the local smart set around La Vigie, a splendid replica of the princely palace—half candy box, half Louis XIV—situated at the eastern extremity of the Principality, where, for the benefit of posterity, Lagerfeld will perhaps write letters in the manner of Madame de Sévigné, no doubt bitter chocolate in flavor more than melting Rabutin.

NOTABLE PERSONALITIES

Serge Lifar, for the sublime photographs of his bare torso at the Beach, his marvelous Oriental profile in a perfectly tailored dinner jacket at the Sporting Ball, and the inexhaustible grace he spread before the public during his decades on the stage of the Monte Carlo Opéra. Jerry Lewis, because he made whole assemblies of chic ladies laugh while fleecing them of fortunes on behalf of sick children, a performance that no one since has been able to match. Gina Lollobrigida, because Monte Carlo is the only place in the world where her plunging necklines remain furiously in style, and because she never fails to come every summer to inspect and make sure that hers remains the most sensational plunge of its kind. Sophia Loren, occasionally without Carlo Ponti, but always with her jewels, which neither cat nor fiscal thieves can steel from her strong-box hold on the good life. Raymond Loewy, modern designer of great cleverness and refinement, for having spent a melancholy retirement contemplating Monte Carlo as if it were an undeserved punishment. Anja Lopez, because she was the handsomest, the most sympathetic, and the most flamboyant of the great female battleships, and because, alas, she went down with all the other big vessels.

M

MONTENEGRO Monte Carlo's only rival in the realm of famously tasteful puns. (No, I have not seen anyone mount anything.) With a bit of similarly delicate wit, the leading bullies of that

former Yugoslav Republic might have obtained the blessing of a currently resistant United Nations to rebaptize their country "would it please His Excellency the African Ambassador to use the elevator," a name certainly longer but also purged of all racist connotations. In any event, the destinies of the Principality and Montenegro have never ceased to cross since the 19th century. After all, the pleasures of fashionable life in Cetinje, the little Paris of the western Balkans, inspired Franz Lehar to imagine the adventures of the Merry Window and Prince Danilo, whom provincial music-lovers regularly mistake for Monegasques. As for King Nikita himself, father of the Montenegran nation and father-in-law of Queen Helen of Italy, he managed to visit Monaco during a few, rare reprieves from the unfair exile forced upon him in 1918, when King Peter of Serbia seized the Montenegran throne.

NOTABLE PERSONALITIES

Joseph Mankiewicz for having made the flamboyant scenario of *The Barefoot Contessa*, starring Ava Gardner, unfold along a Riviera in which the most beautiful colors and the most extraordinary characters came from the Monegasque legend. Marie Béatrice de Savoie, known as "Titi," because it was here that she found herself fervently pursued by Maurizio Arena, to the immense joy of the paparazzi, who followed the couple like panting dogs before the curtain came down on this brilliant coup within *la dolce vita*. Mary of Douglas Hamilton, because she was the first wife of Prince Albert I and gave birth to Prince Louis II before the annulment of her marriage by the Holy Sea. Martine (Carol) because she went to sleep here for the last time in a suite at the Hôtel de Paris, which cannot but move the loyal fans of *Caroline Chérie*. Matisse because he loved everything about Monte Carlo, which in gratitude provided him with a few more colors for his palette. La Môme Moineau, the flower-seller of the 1930s who became a millionaire after having convinced a very rich gentleman that she was the most beautiful flower he could possibly give himself. For some forty years, she reigned supreme, from her yacht with the silver-gilt plumbing, among those popular aristocrats who make the poor dream and the rich feel secure.

N

NIGHTS The loveliest are those that end after the summer balls, when, ignoring the playboys, the vamps, and the beautiful youth, one can walk back to one's hotel along the sea, guided by the lights of the casino and comforted in gentle melancholy by the wind, the surf, and the rustling of the palms. Lulled into dreams of an enchanted kingdom and sweetened by a vaporous disquiet, the fortunate visitor can then witness Monte Carlo borne away on the first glimmer of dawn towards the last reflections of the expiring night.

NOTABLE PERSONALITIES

Princess Naoumet El Bey because no one ever knew from what country she had obtained her title, perhaps the nation called Adventure, and also because it was evident that, whatever her native habitat, she held an estimable position in it, witnessed by the regularity with which mysterious bankers processed her bills. Natasha (Paley) for her photographs by Man Ray, which she proudly exhibited in her suite. Kate de Nägy for having failed to break the bank and for having managed, instead, to make several of her admirers blow their minds. The volcanic Queen Nazli of Egypt for having attempted to trick her son, King Farouk, into a vain scheme of reconciliation, surrounded by well-fed, heavily mustachioed men and punctuated with imprecations that no translator could be persuaded to elucidate. Stavros Niarchos because he was the only person who ever claimed to be bored in Monte Carlo. (Meanwhile, Aristotle had enough amusement here for two, as well as for all the Greek shipping tycoons combined.) And Jack Nicholson, because no one recognizes him when he wanders out to take his morning coffee near the port.

O

ONASSIS The *contre-prince* of the 1950s, as one would say a contretemps, whose memory leaves the Principality's establishment with mixed feelings. In that milieu he served at once as a great piece of luck, a threat, and a demon, as well as a powerful stimulant. He did much to

bring Monaco into the modern age and the world of big business, all the while perched on the battle charger of his SBM (Société des Bains de Mer), before retiring with admirable grace when the total failure of the unwelcome LBO was finally resolved. He also left a fertile legacy of anecdotes, royal tips, and, in the tradition of great monarchs, a variety of architectural details, among which the most beautiful is undoubtedly the ceiling opening to the sky over the restaurant on the top floor of the Hôtel de Paris, a veritable replica of the concealable swimming pool on the *Christina*.

Notable personalities

Oscar de la Renta because he is much worn here by chic Americans. Oscar of Sweden because he came to Monaco to forget the headaches the Norwegians caused him (today no one remembers, but around the turn of the century this was a most engrossing drama). The Orchestre de Grégor and its Armenian jazz, a surrealist troupe of White Russians and Caucasians who around 1920 adapted their style to the needs of modernist *thés dansants*, complete with violins playing the blues and buxom choristers in translucent muslin.

P

PRINCES Objects of everyone's curiosity, the point of departure for every strategy, and the goal of every ambition, Princes are an abstract entity, more or less cherished by the popular press, that grips Monaco's collective unconscience and leaves it palpitating with an infinity of rumors and dreams. The fact that the Princes happen also to be charming, each in his own way—and Heaven knows they have their several ways—is not in the end so very important. The general giddiness they inspire flows from their glamour, and even if they were tyrannical or bloodthirsty, it would have little affect on the fascination caused by their presence/absence. Thus their carefully staged appearances ritualize the life of the Principality, while any surprise encounter with them triggers a Pavlovian excitement, forever reconfirming the sense that even

when they are not there, one is always and everywhere in their environment. Given these conditions, seeing Princes becomes a signal event well worth all the sacrifices that a long stay in Monaco can sometimes exact: retiring late yet always appearing in fine form despite sunburn and the hotel's little note left under the door for the third time. Order another bottle of champagne for the elegant parasites who have an invitation to a party at the Sporting, where, of course, Prince Albert has promised to make an appearance. Read the automobile magazines dedicated to the Harley Davidson that Princess Stéphanie adores. Seduce the lady in charge of pressing clothes to release one's dinner jacket without gobbling up one's last 500-franc note, all for the sake of pretending that one has been invited to the Rose Ball, where a furtive entrance through the emergency exit may allow one a glimpse of Princess Caroline as she makes her way into the great hall through a storm of flashbulbs. Pretend to be an expert in the complicated history of the Principality, just in case one may be presented to the sovereign, and just in case some anecdote concerning Prince Florestan may have escaped him. Should one have the ultimate good luck to be at a swimming party somewhere near the Princely family, such capital fortune would clearly have to be managed with infinite subtlety. Since being chosen in this manner allows those so blessed to be invited to dinner by new and brilliant associates, at least for the next several weeks, and there to monopolize the conservation, holding in rapt silence persons who theretofore had never had the courtesy to hold so much as the elevator door, they need to gain firm control of their emotions, to maintain a steady gaze without appearing to notice, to feign discreet acknowledgment in the event an august smile should by some chance be directed towards them, and to adopt henceforth that deferential though natural air proper to those whom glory has touched. A few words of conversation, a friendly remark, a "pass me the pink napkin" or "the water seems warmer than yesterday" should be carefully stored away in the personal memory bank, or risk being taken for the latest of the social climbers by a swarm of people devoured by envy. The experience does not have to be spoken about, since, between the reserved comportment on the one side and the royal affability on their other, everyone will have their eyes riveted on the essential fact they spoke to one another!

Pavlova, because she made the White Russians loved in Monte Carlo, whereas before they had been somewhat feared: "They did not pay their bills even when they were Princes, so now that they are broke, we shall see" Lili Palmer, because for her Monte Carlo was a true city, an expression of the elegance of life. Gregory Peck for having been one of the old friends from Hollywood whom Princess Grace was delighted to see again. Mary Pickford, because she built her Pickfair mansion in Beverly Hills somewhat after the manner of the Casino, to which Erich von Stroheim had introduced her. Pinin Farina because his coachwork can be found rolling along virtually every street in the Principality. The Polignac Princes, because they are to Monaco what King Solomon was to the Ethiopian Empire. In marrying Princess Charlotte, Prince Pierre assured the rebirth of the dynasty, just as the King of Judea did when he married the beautiful Yeminite/Abyssinian sovereign, thereby creating a lineage that would last 2,500 years. Finally, Porfirio Rubirosa for the magnificent pepper mills that bear his name, in honor of a mysterious gift he received from nature and made famous in suite after suite and pretty woman after pretty woman, some of whom are still recovering almost forty years later!

Q

QUIETNESS One cannot always own a limousine as long as a yacht or a brightly colored racing car in order to attract attention. Moreover, it is not particularly fun to be looked at all the time as if one were an exotic animal merely because of some means of locomtion. Neither is it entirely pleasant to be forever accompanied by a more or less neatly turned-out colossus so as not to have one's diamonds snatched or simply not be kidnapped. This sort of unpleasantness goes unacknowledged in Monaco. And the reason is clear: Everyday security is the overriding preoccupation of an efficient and discreet police force that, quite beyond its impressive effectiveness, has the advantage of being equipped in the latest, state-of-the-art manner. Thus, one may without the slightest anxiety enjoy a six-door limo because it seems the most practical

way of transporting an entire family all at the same time, including an old English governess, without resenting the 1930s, when cat-thievery had yet to be invented. And that, despite what some aggrieved souls may say, is well and truly freedom.

NOTABLE PERSONALITIES

Richard Quine for having fallen deeply in love with Kim Novak while here, and Anthony Quinn for having come back to the Hôtel de Paris in bare feet, thanks to the loss of his shoes in the course of a whirlwind evening, which must have been joyous indeed, since the aforementioned shoes were discovered one at a time in modest hotels located at opposite ends of the Principality.

R

REGRETS Like Marie Bell—who, half-wasted by time and utterly ruined, melted away, a pale flame with an immaculate silk scarf fluttering in her wake, in a dawn of ambiguous promise—no one here knows what that strange vocable means. Actually, regrets are for the timorous, the hesitant, the penny-ante players. Such people do not exist in Monte Carlo, or if so, they remain out of sight. Moreover, when one has lost everything, there still remains everything else—the quality of the air, the sun on the rocks, the walks along the sea, and the slow twilight, the theater and the dance, sport and affection. These are all activities in which it is only too easy to lose oneself, so rich, diverse, open, and surprising is the cultural life of the Principality, a place where otherwise things can be rather too exclusive.

NOTABLE PERSONALITIES

The beautiful Hélène Rochas, Queen of Paris, for the many reasons that make her loved and, within the context of this book, for her dazzling curtsy to Princess Grace. In addition, there are all the *rois*, as the French call *rex* or king, beginning with Edward VII of England, who so often

arrived with his "friends." Also King Zog and Queen Geraldine of Albania, who came to console themselves during their sad exile on the heights above Cannes while dreaming of the casino in Durazzo. Alphonse XIII of Spain who played polo, while Gustav of Sweden rested up from his tennis parties by sitting on the sidelines vigorously tapping his foot until the pretty little footman brought his chamomile tea. Carol of Roumania, because the Chinese tourniquet, the famous speciality of the comely Magda Lupescu, helped him forget his losses at roulette. Rudolph (Nureyev), whose fine musculature and smart swimsuit can be admired full page in this book. Régine (Crespin), a beguiling native of southern France whose powerful and universally admired voice shook the walls of Charles Garnier's venerable Opéra. Robert Redford, because he earned the right to succeed Cary Grant in the role of impeccable seducer à la Hollywood.

S

SPORTS Every sport is played in Monte Carlo, and world champions have often dazzled the Principality with virtuosic demonstrations of their gifts: Johnny Weissmuller at swimming, Suzanne Lenglen at tennis, Olivier Gendebien at car racing, Prince Albert I at the regattas, Rudolph Valentino at tango, Cousteau at underwater exploration, and Omar Sharif at bridge. All Monaco lacks is a bob-sleigh track, but that little problem could be solved if only the Heir Apparent, Prince Albert, would marry the daughter of the Mayor of Beausoleil. Given that in Monaco wild game consists of millionaires, hunting is practiced without permit and throughout the year, but no insurance policy covers the risk of accident or missteps (sudden bankruptcy, surprise disappearance, unforeseen rivals, "borrowed" credit cards and limousines, a much tougher prey than the tenderness of one intoxicated evening would have suggested).

NOTABLE PERSONALITIES

The divine Sacha Guitry who rewarded all his wives with a winter in the Principality. Vittorio de Sica who joined with Marlene Dietrich to film *The Monte Carlo Story*, one of their cult films,

31

in fact so much a cult picture that those who saw it can be counted on the figures of one hand. Françoise Sagan, because that temptress roulette awaits her in Monte Carlo like the wolf in *Little Red Riding Hood*, unless the interdiction our beloved writer imposed on herself in France should also become operative in Monaco. Empress Soraya for her beautiful green eyes, deep as the sea beyond the rock, where they have contemplated so many bitter-sweet memories. Romy Schneider for having believed that, with a beautiful aparment overlooking the port, Alain Delon would love her forever. The Savoys because the Italians still treat them as Kings, which is only fair considering the exile from Rome they imposed on the royal family.

T

TATOOING Beautifully effective decoration on the suntanned shoulders of handsome young men on water skis, seducers with gray temples and a romantic past, and pretty top models eager to confirm their identity with an indelible admission of discreet eroticism.

NOTABLE PERSONALITIES

Tamara (de Lempicka) for having (alas) put away her brushes and for having (happily) long lived in a grand, inimitable style consisting of chamomile-champagne, violets, furs in July, and a furiously *Mittle Europa* accent. Nadine Tallier, because she no longer stays at the same hotel or any longer under the same name. Charles Trenet, because he gave several farewell performances in Monaco, all but the last of which turned out to be *au revoir*.

U

URBANISM During the 1970s, it was fashionable to criticize the flamboyant urbanism of Monte Carlo. And anyone who acquired a tower apartment, with a view overlooking the new Hong Kong, very quickly became resistant to all forms of new construction, fearing that

neighbors might arrive just outside the windows in an equally spectacular tower next door. Strangely enough, even though the high-rises continue to proliferate, the panoramic views have remained uncompromised. With its tunnels, its viaducts, and its elevators that transform the rocks into veritable Gruyères, with its quarters projected over the sea by Herculean technology of mind-blowing sophistication, the Principality can finally be proud of its stubborn urbanism, an urbanism bold enough to challenge or even surpass Manhattan. As for the insomniacs of Nice—holding on with white knuckles to their Epeda-Multispire mattresses suspended some 50 meters above the ground, nervously awaiting the earthquake that the tabloid media promise with hellish regularity and full sadistic detail—they quite naturally remain unrepentant in their hostility towards further development. In Monte Carlo, however, the planet would have to reverse its course in order to put an end to the antiseismic attitudes of the local population. Meanwhile, there remain those who fondly indulge their nostalgia with old photographs taken at the turn of the century, when villas were few and all but lost in the ambient verdure of the Mediterranean world. There is little one can do for them, right as they may be, but recommend Menton, an unspoiled coastal town that can still boast flowering hillsides and a giddy joie de vivre.

N O T A B L E P E R S O N A L I T I E S

Ulysses who certainly came ashore on Monte Carlo's rock in the course of his voyage around the Mediterranean, though one cannot be sure on which page he recorded the event in his excellent guidebook: *The Odyssey*. Umberto de Savoie, a gentleman King beginning in May 1946, who often arrived under the name Comte de Sarre, here finding himself so very close to his lost Italy. The Urach cousins, whom the mean-spirited Coq Gaulois excludes from the princely succession under the shocking pretext of their being overly Germanic. Peter Ustinov, England's verstaile actor/writer/producer and professional bad boy, because he comes smelling of Max Ophuls, which makes one all the more sad that the subtle and charming Viennese never had the time to make the film Monte Carlo deserved.

V

VIOLINISTS Civil servants usually on strike at the Bastille Opéra, a species all but extinct in the casinos and at ordinary soirées, but at Monte Carlo nothing is ordinary, including our romantic musicians in evening dress reeking of moth balls, lavender water, and a flowering boutonnière at the Rose Ball, where they swarm over the floor thrilling the audience with their richly vibratoed bowing. In the old days Monaco's musicians were usually Russian, whose emotive style of playing survives well enough to melt the heart even of Iraki terrorists (who, frankly, make only rare appearances in the Principality). The performance involves a perpetual smile as the violinist bends into the décolleté of ladies so carried away with feeling that they forget the lobster thermidor on their plates. As soon as the lights go on at the Hôtel de Paris, the Beach, and the Sporting Club, the fiddlers strike the opening chord and take a quarter turn about the room, always refining a repertoire in which eternal Romany never ceases to promenade on unsinkable barcarols.

NOTABLE PERSONALITIES

Vaslav (Nijinsky) for the wonderful photograph that Diaghilev made of him in their room at the Hôtel de Paris. Rudolph Valentino because it was in Monaco that, while seeking his way in the world, he found his boat ticket for America and success as Hollywood's first superstar. Queen Victoria who came to Monte Carlo and, between bumpers of grappa, shed many a tear over the devastating loss of dear Prince Albert, not to mention the doings of the Prince of Wales, future King Edward VII and the toast of Monte Carlo at the height of its Belle Époque glory.

WAGONS-LITS, XYLOPHONES, YACHTS, AND ZONE The first remain the most elegant way to arrive in Monte Carlo, and the third the most elegant way to leave, while the second prolong the sweetness of evening tea. The last refers to, once and for all, the vast wasteland that lies beyond the frontier.

NOTABLE PERSONALITIES

Richard Wagner whose music could often be heard at the Monte Carlo Opéra when it was still disdained in Paris. Grand Duchess Xenia of Russia, because there were once many Grand Duchesses Xenia of Russia, which meant that one of them was always sojourning in Monte Carlo. Yvette Guilbert for Prince Louis II who adored her songs. Zaza Gabor because for her a city in which a jeweler can be found every 10 meters must be the perfect materialization of Paradise.

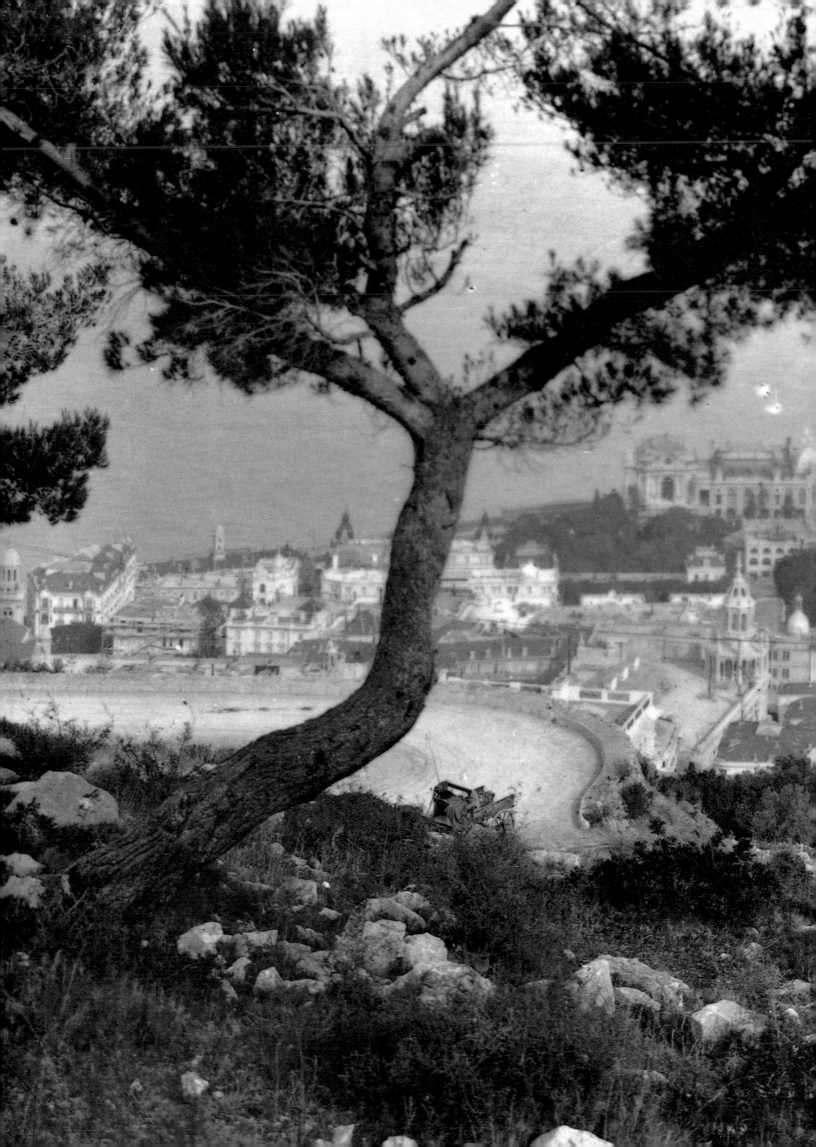

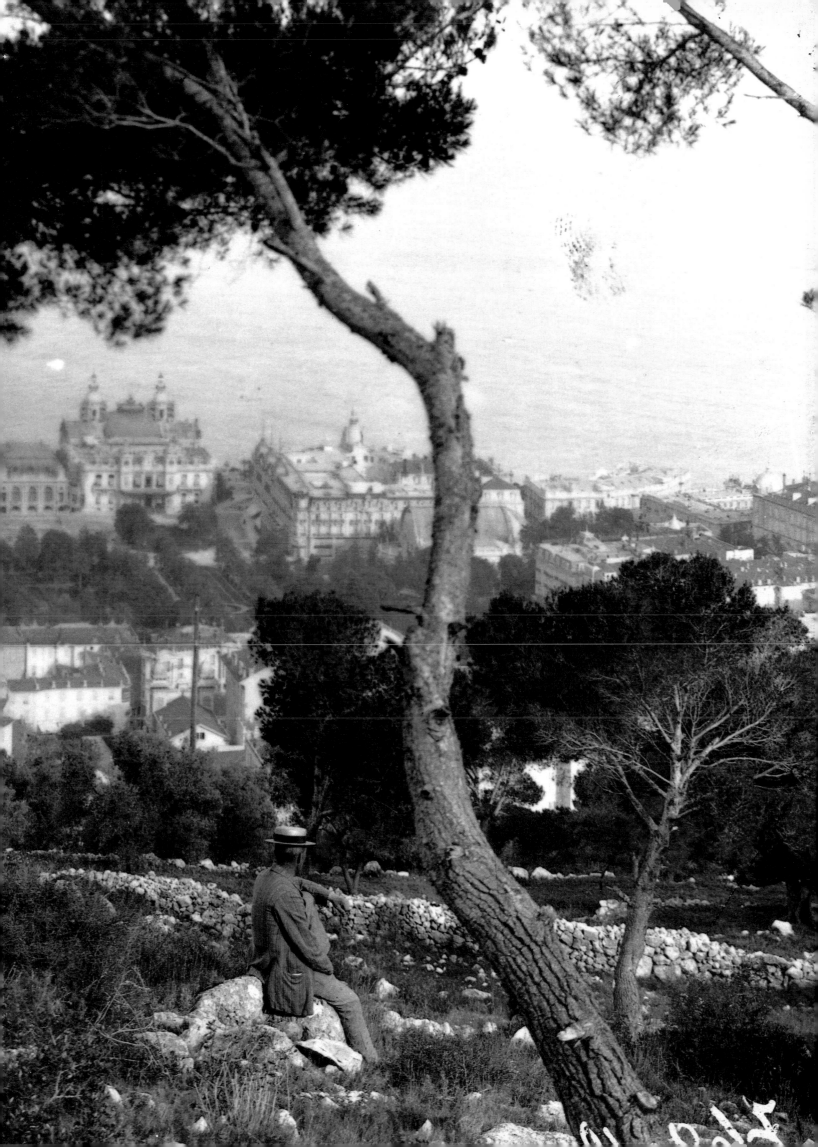

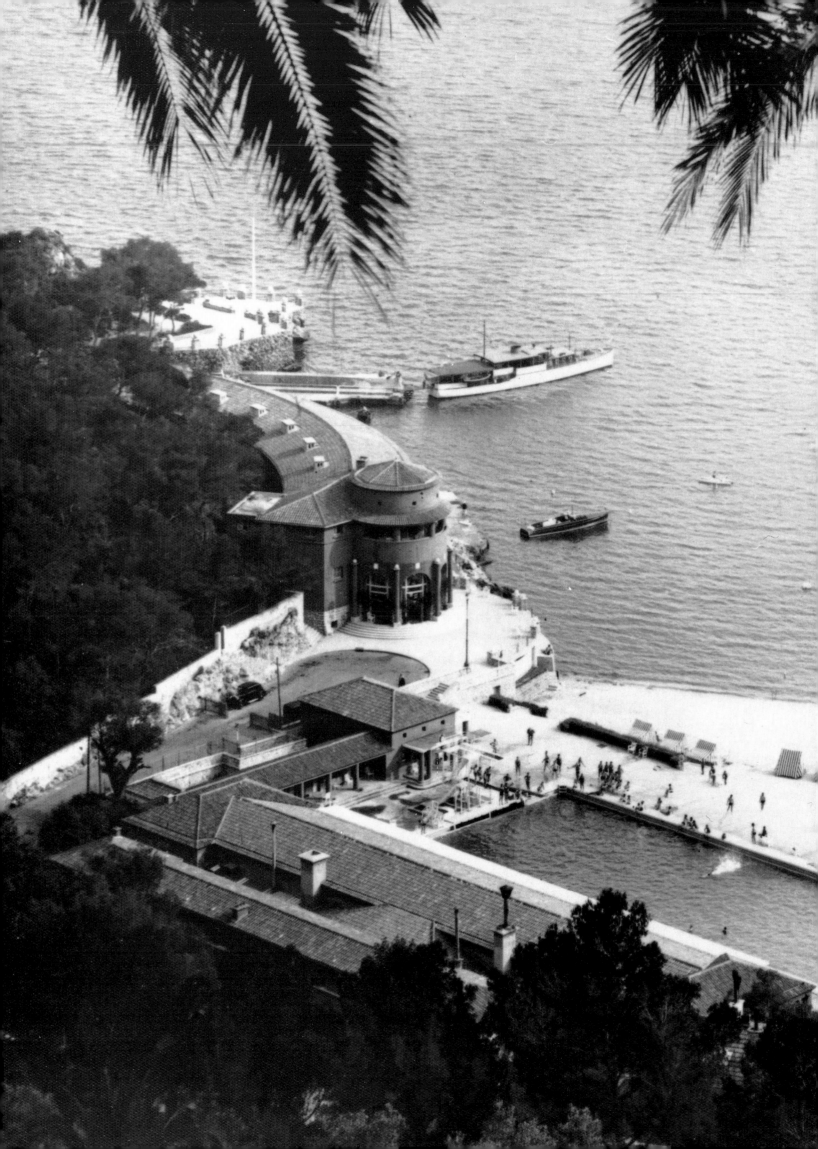

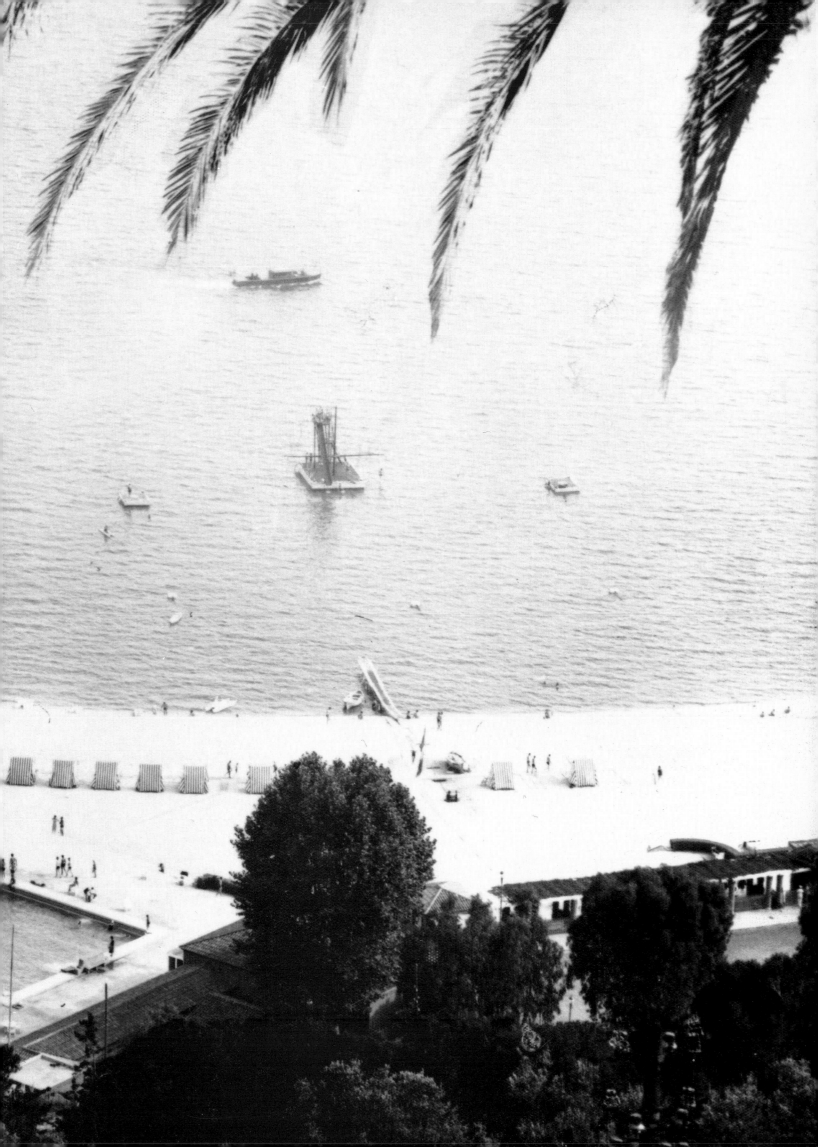

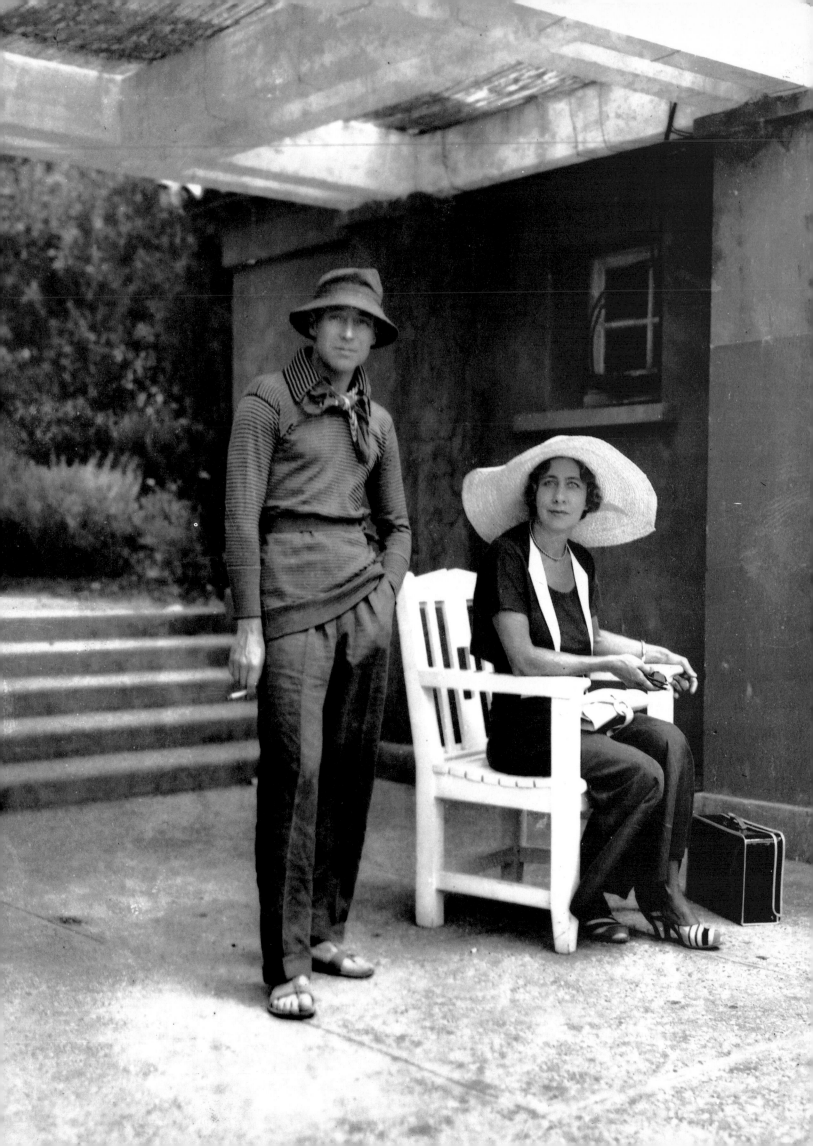

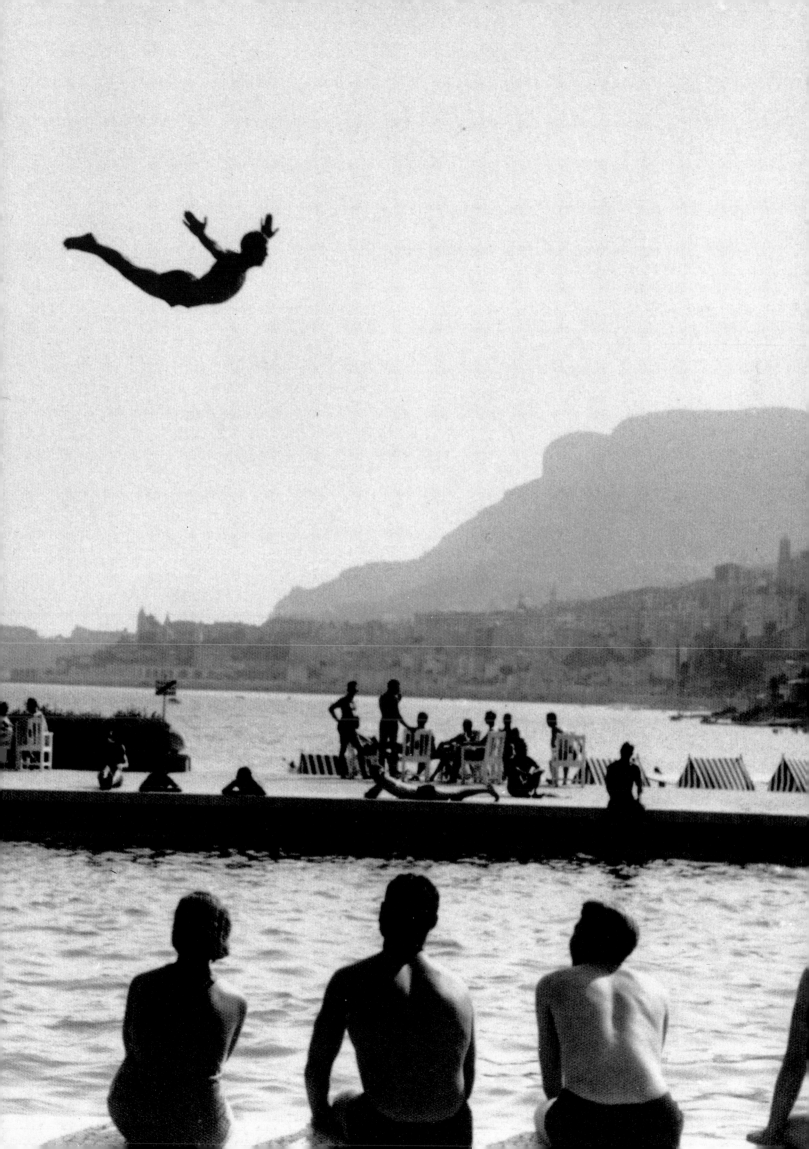

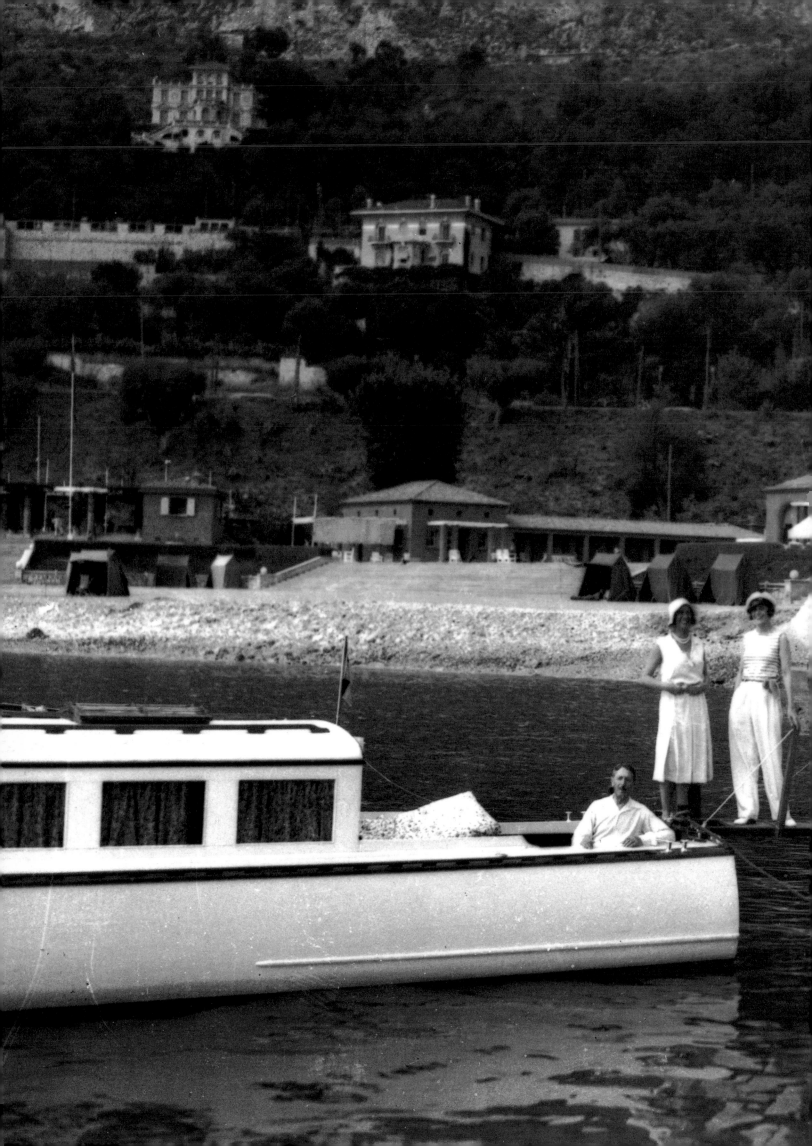

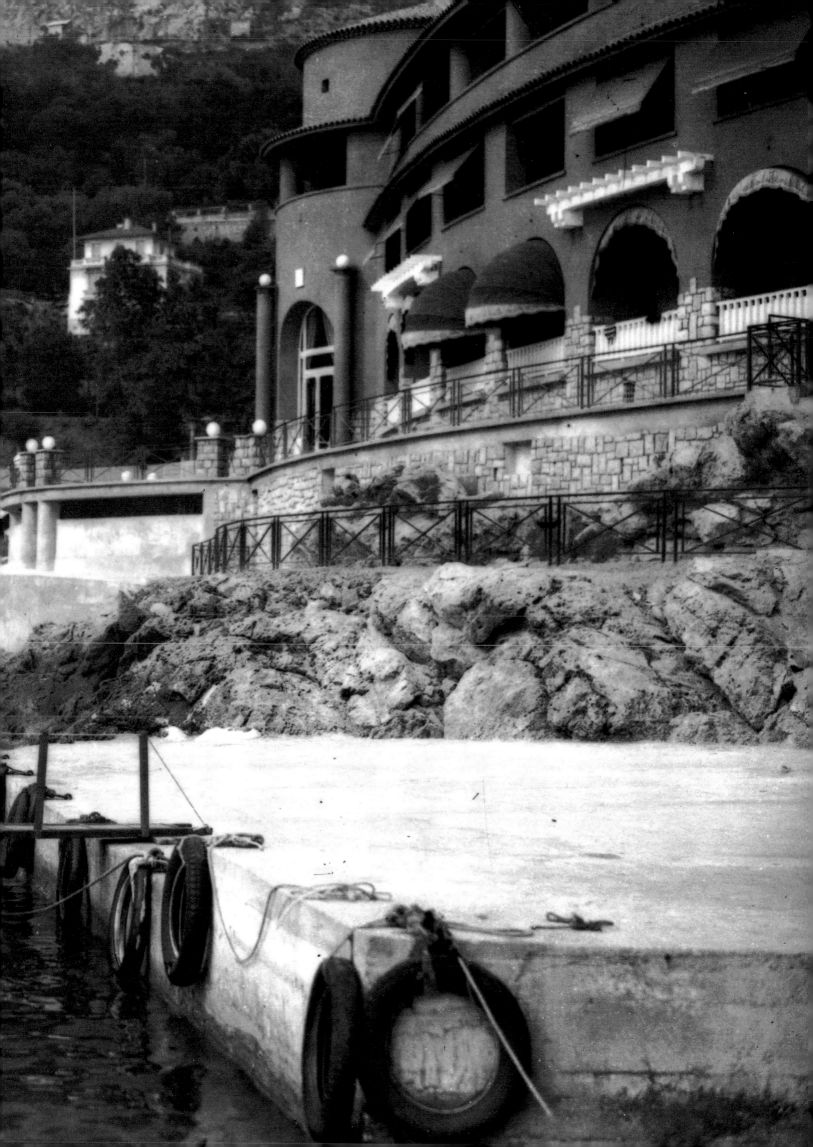

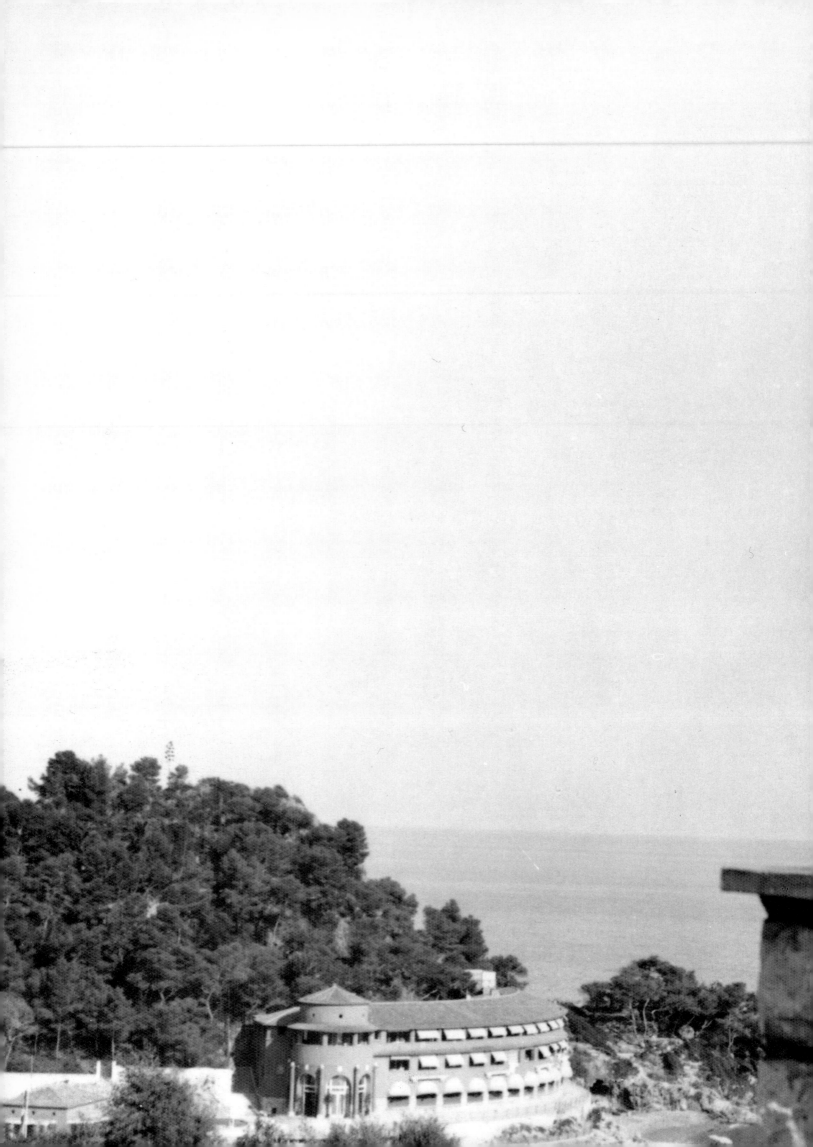

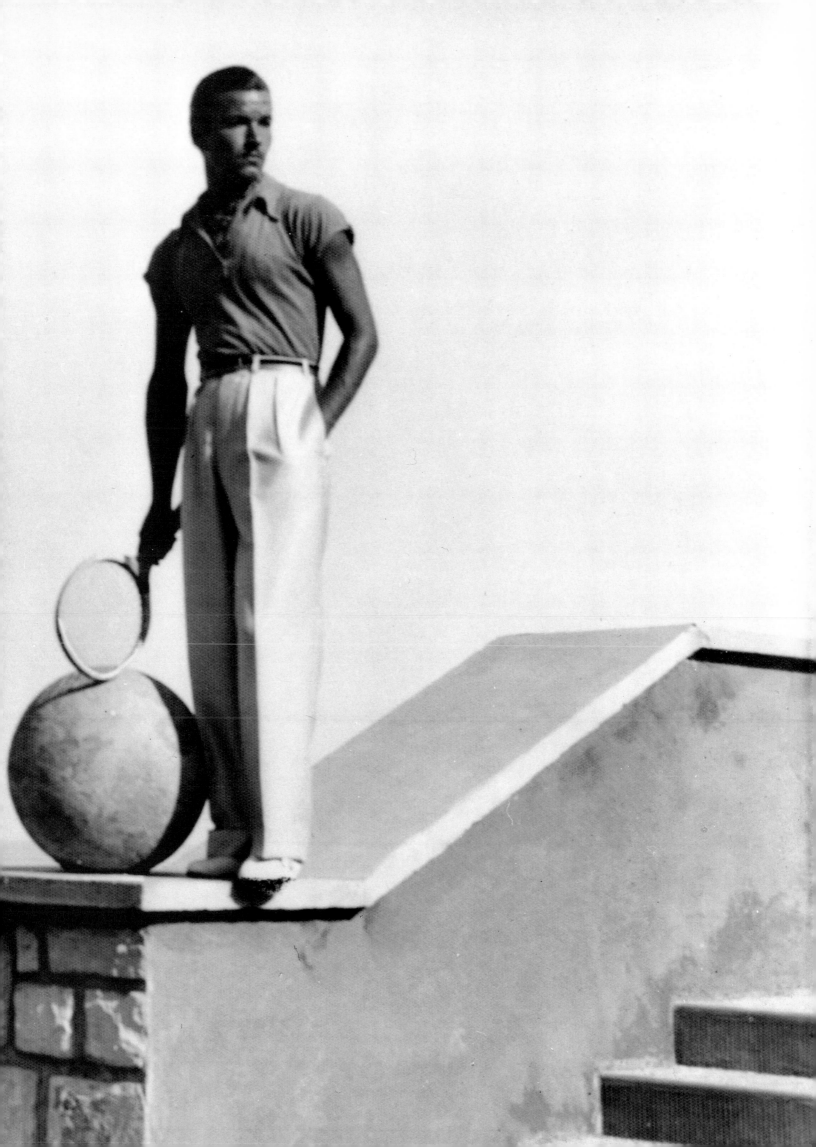

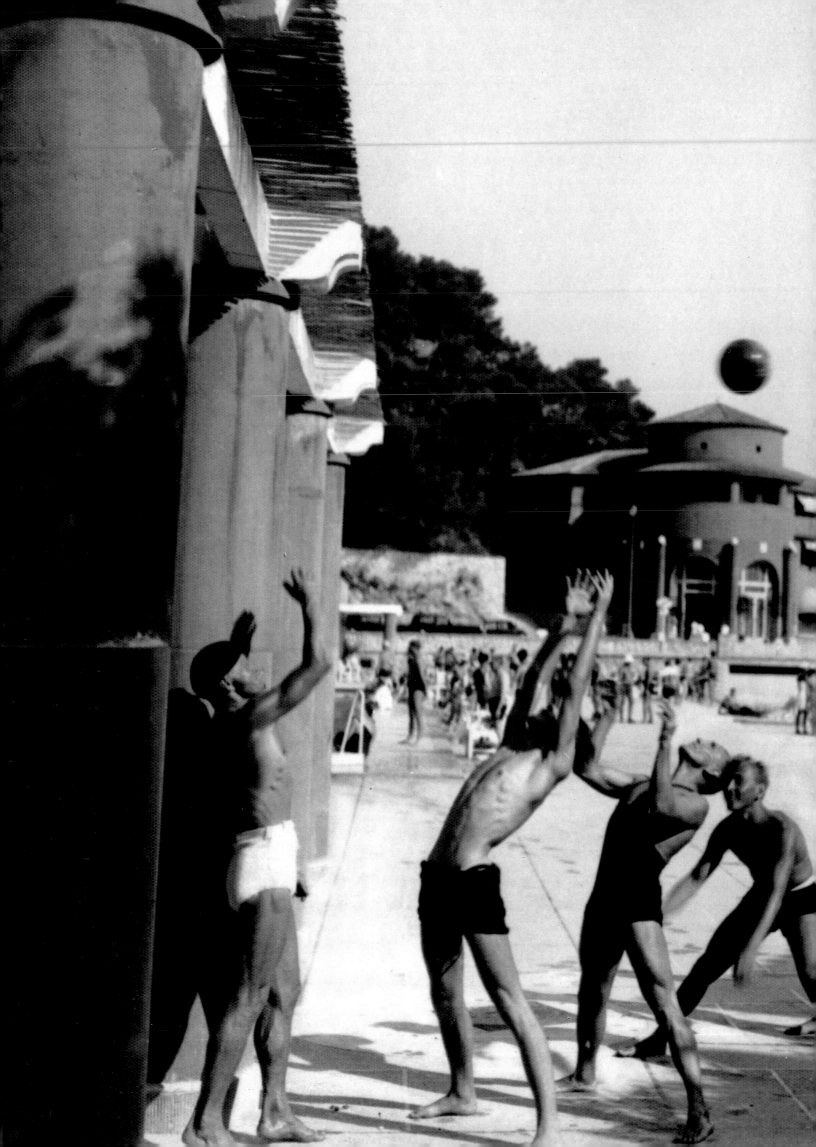

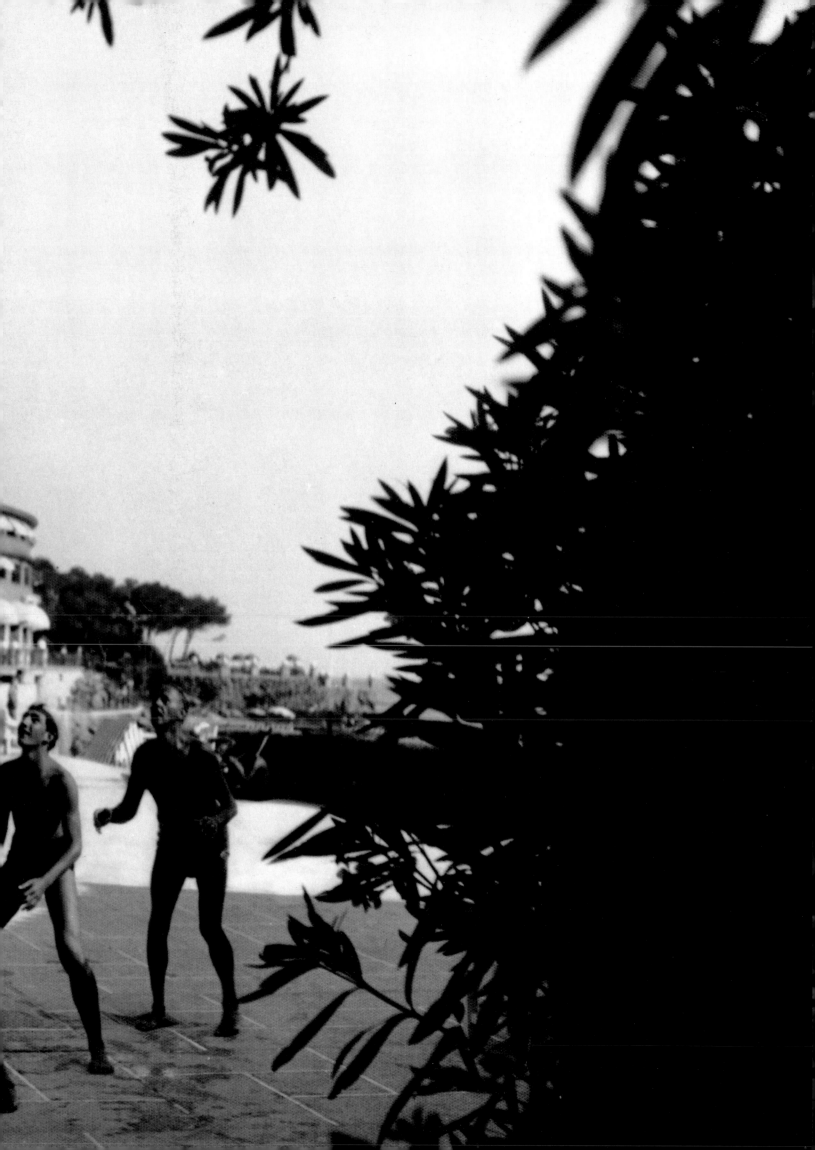

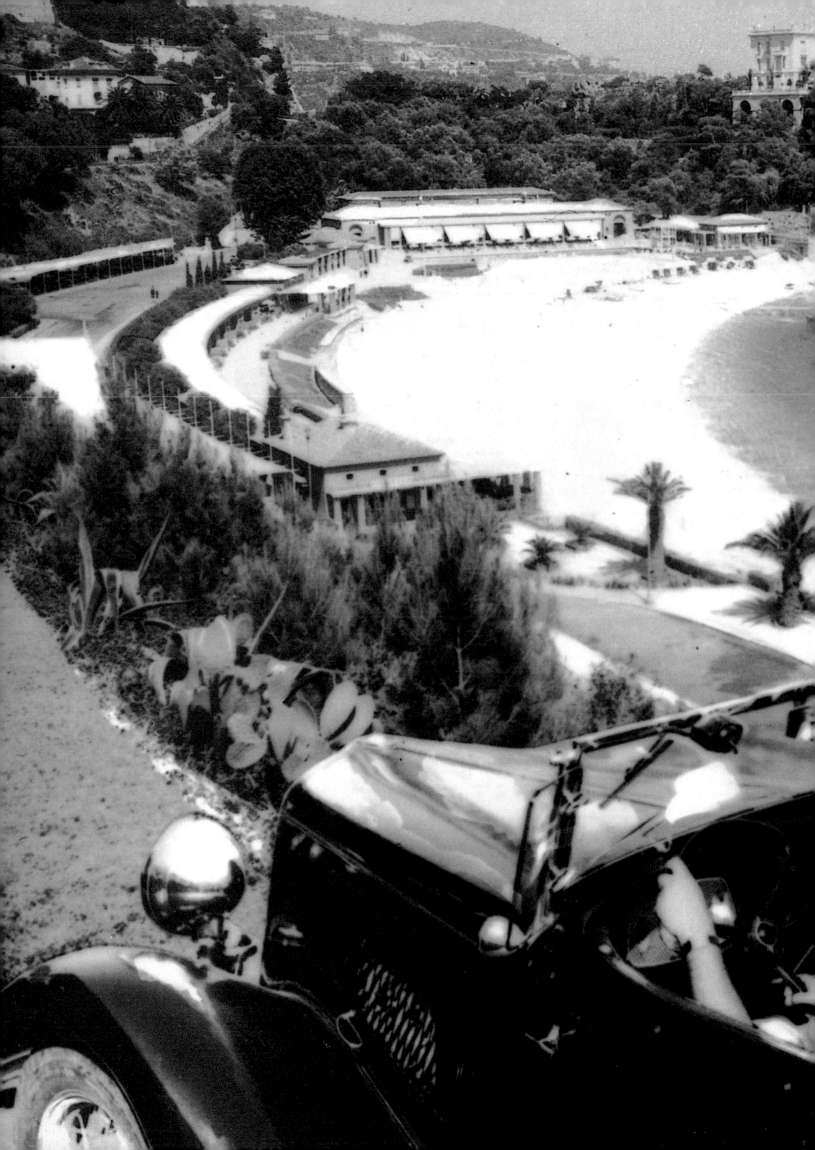

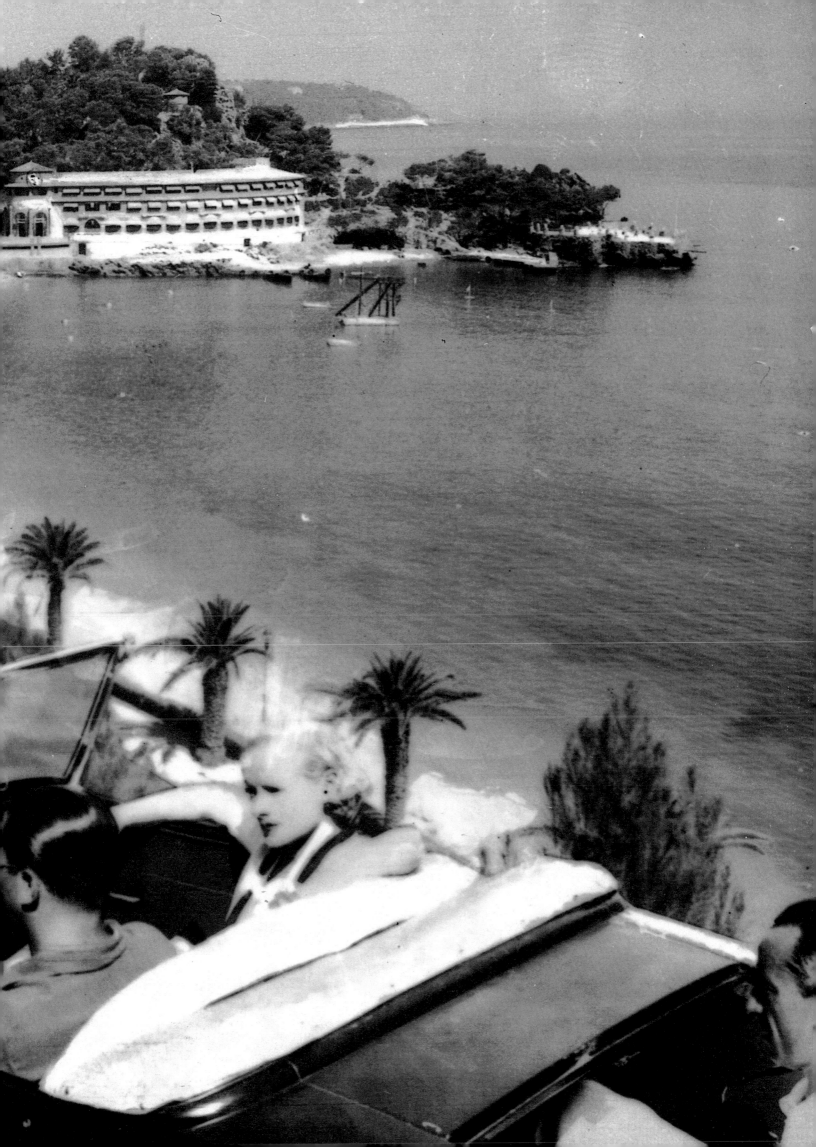

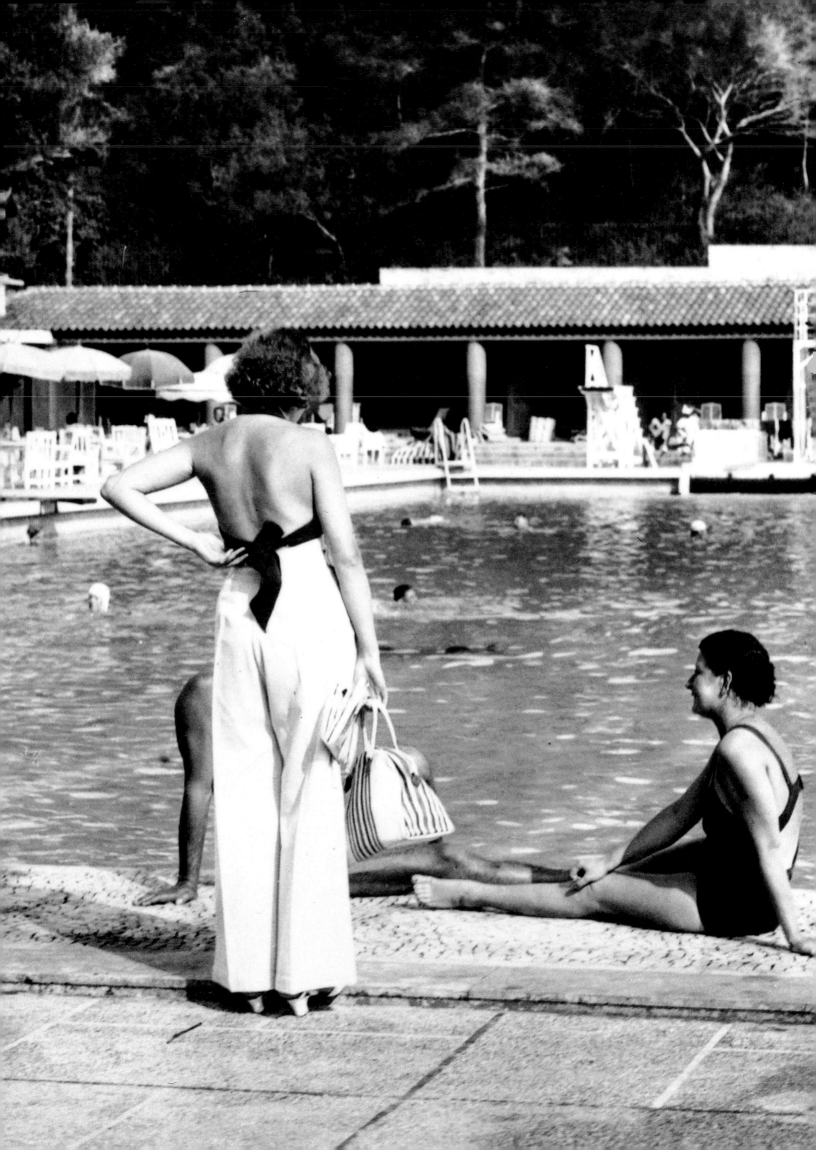

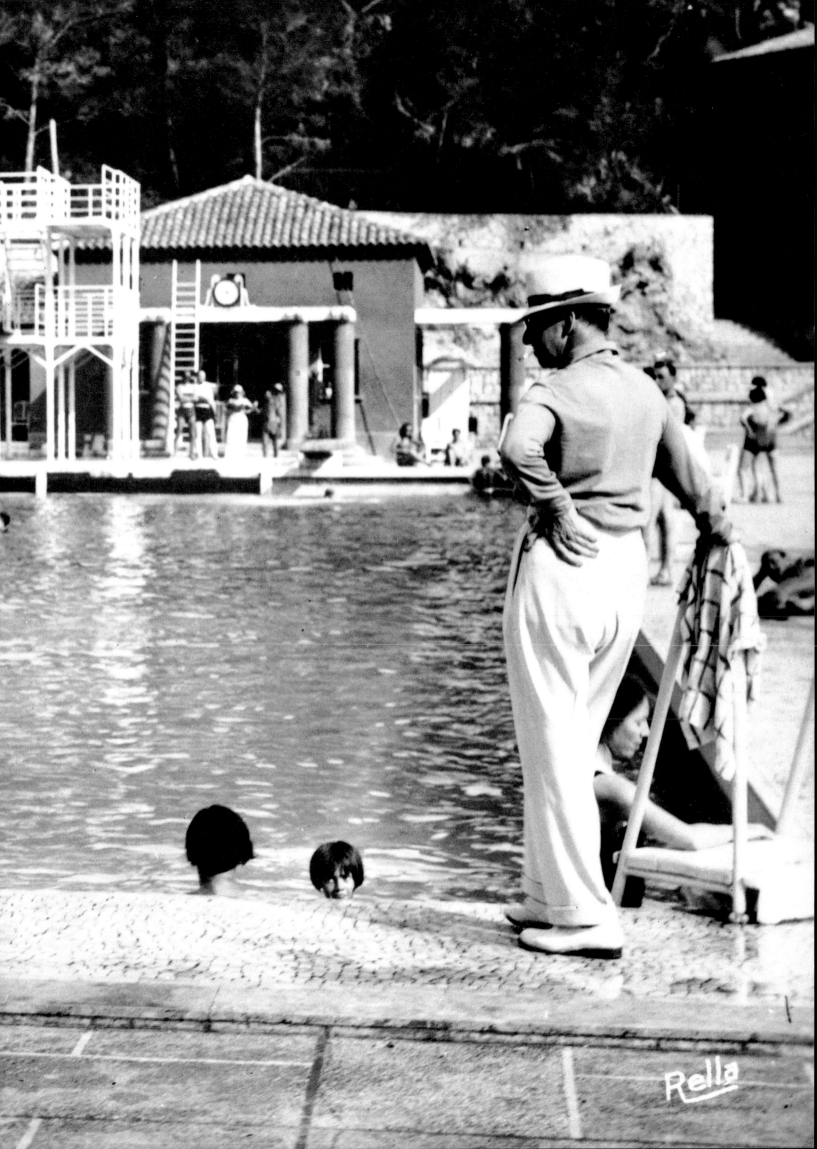

Rella

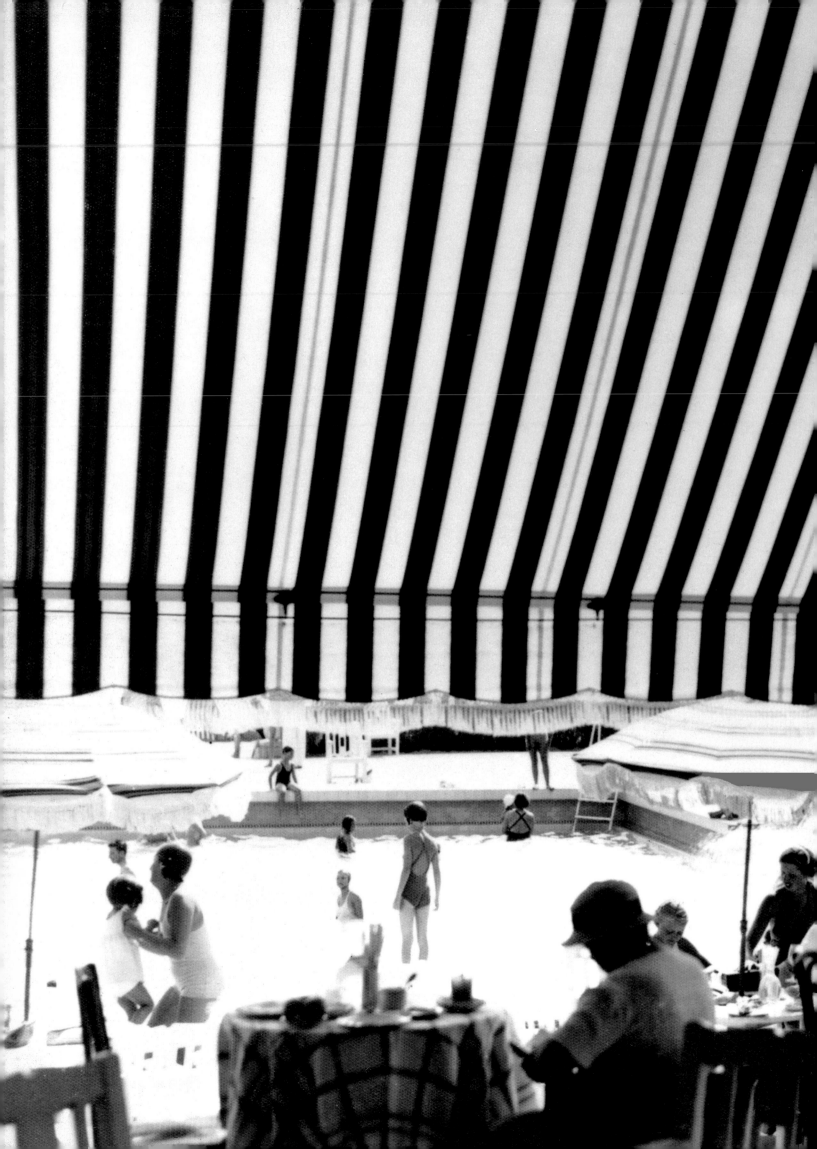

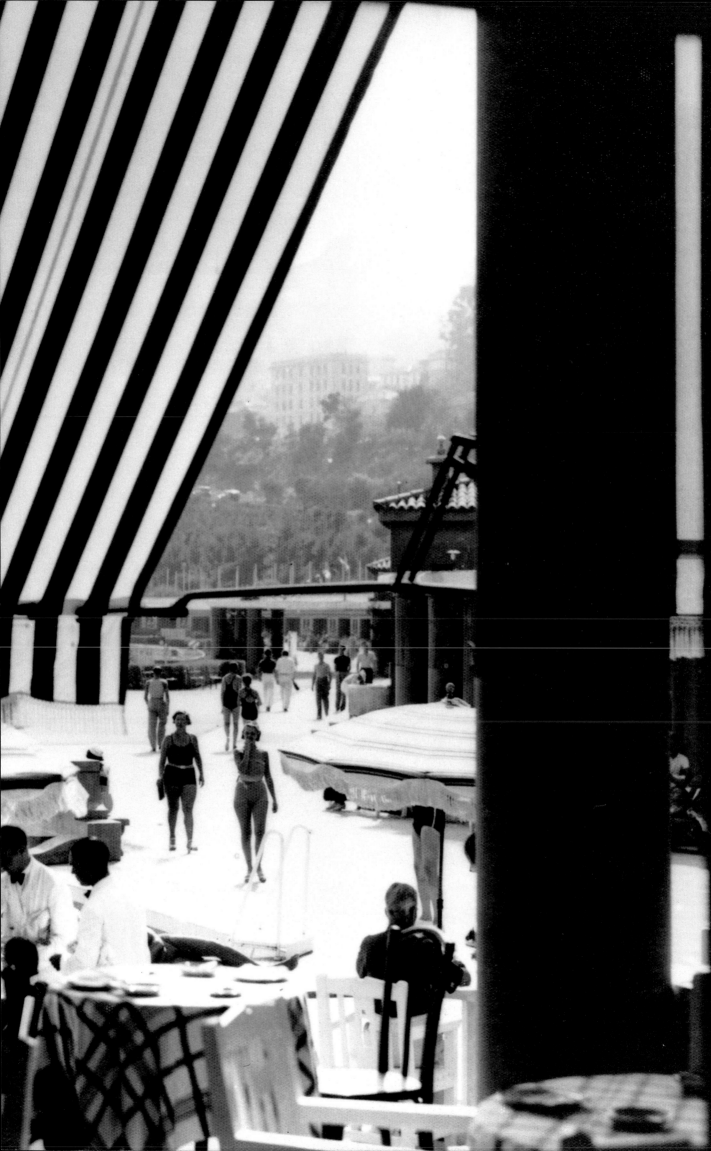

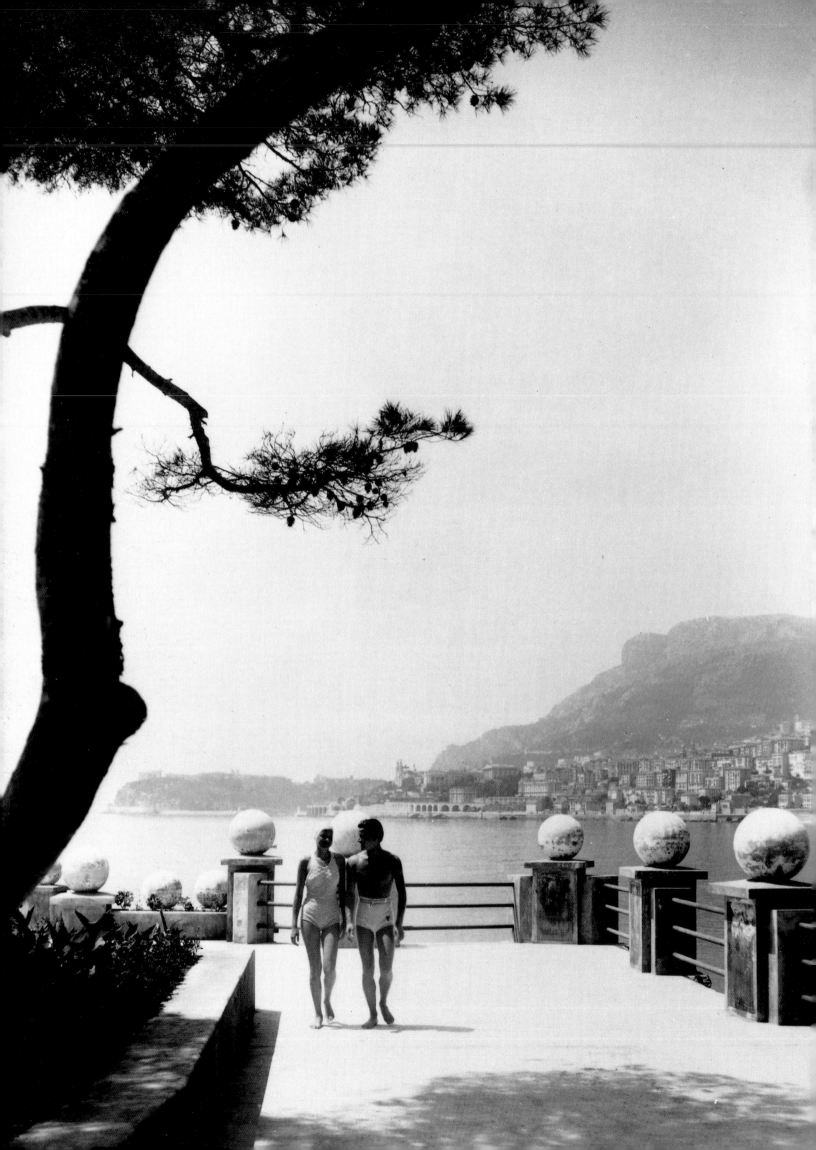

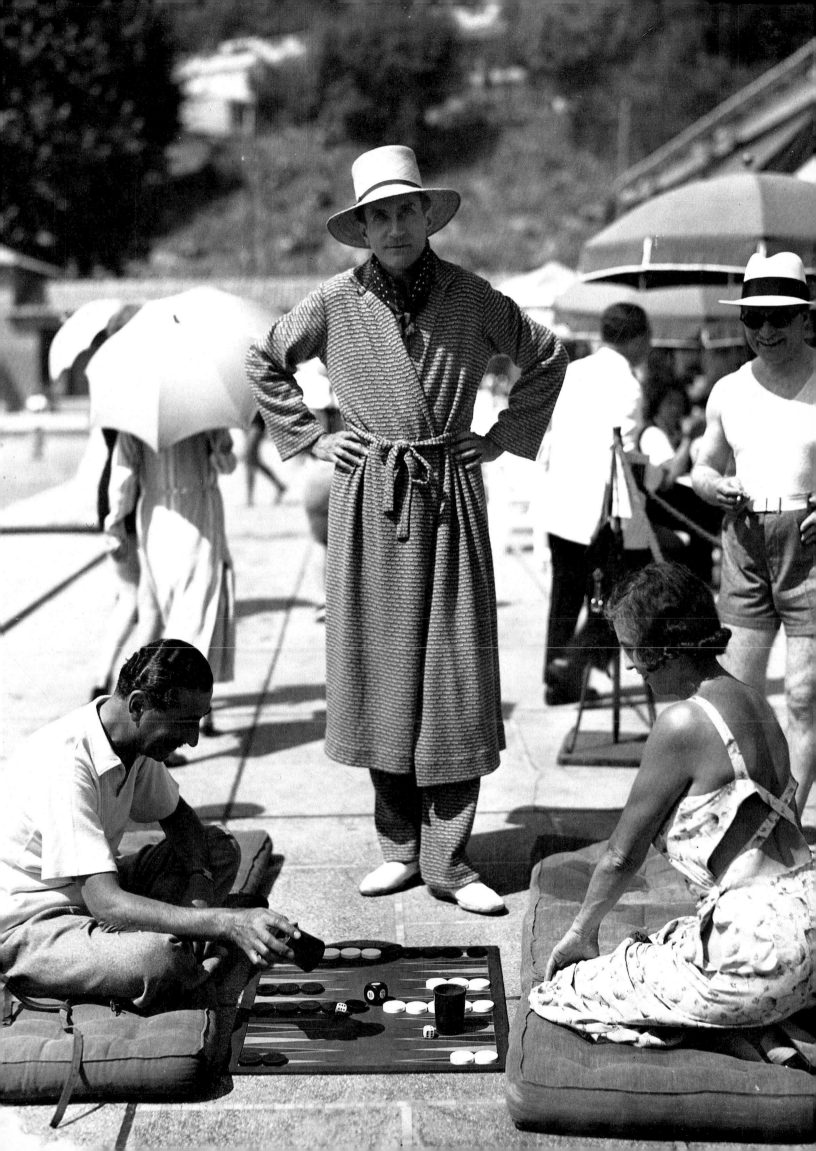

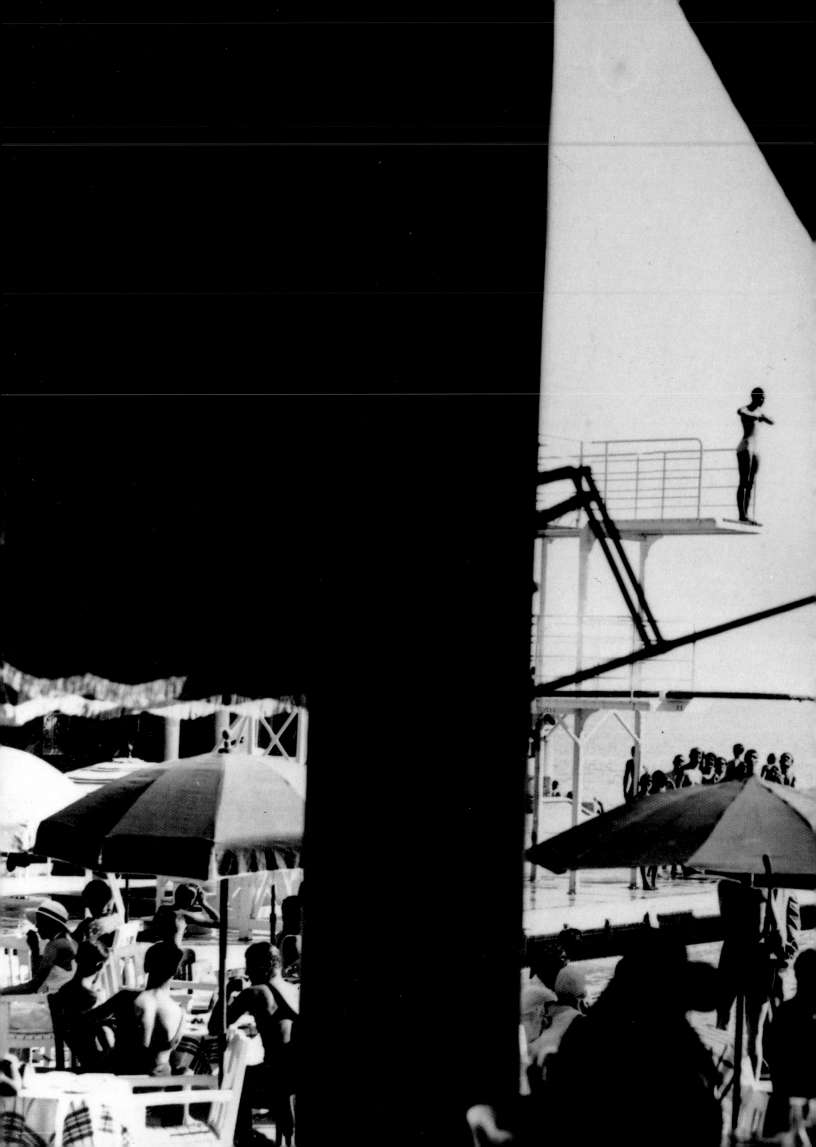

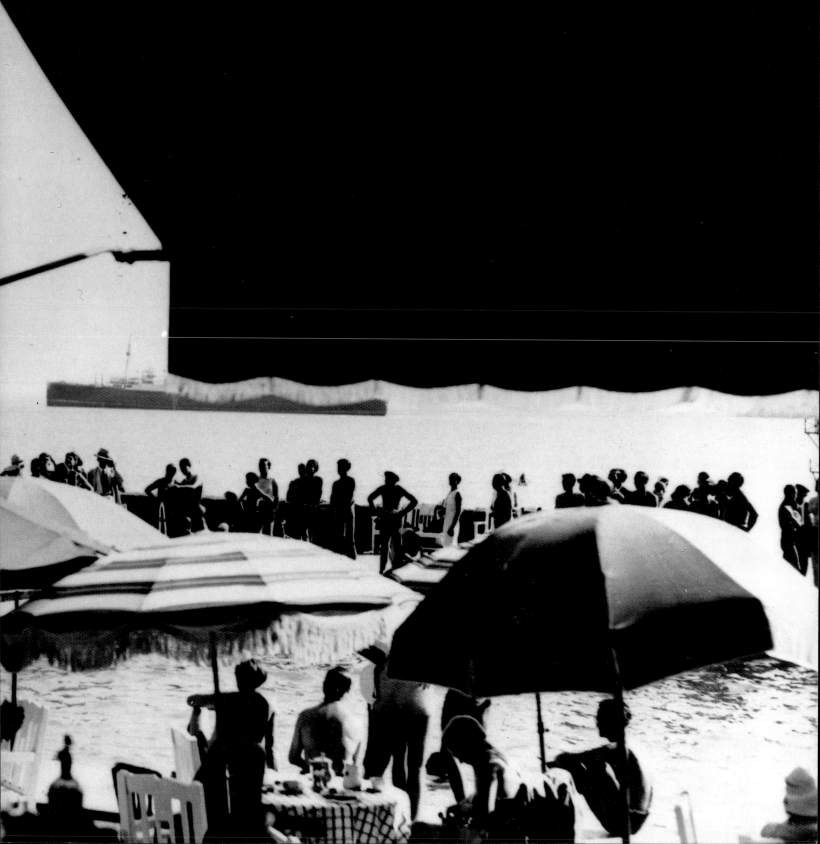

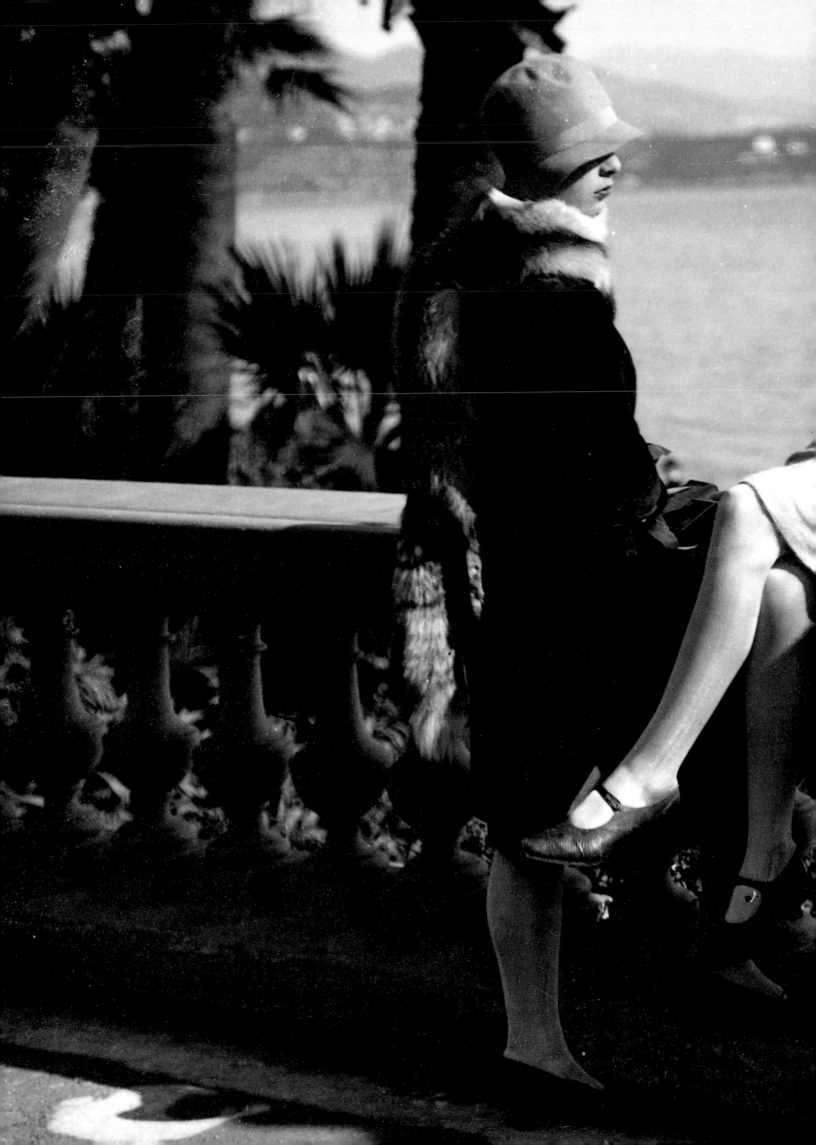

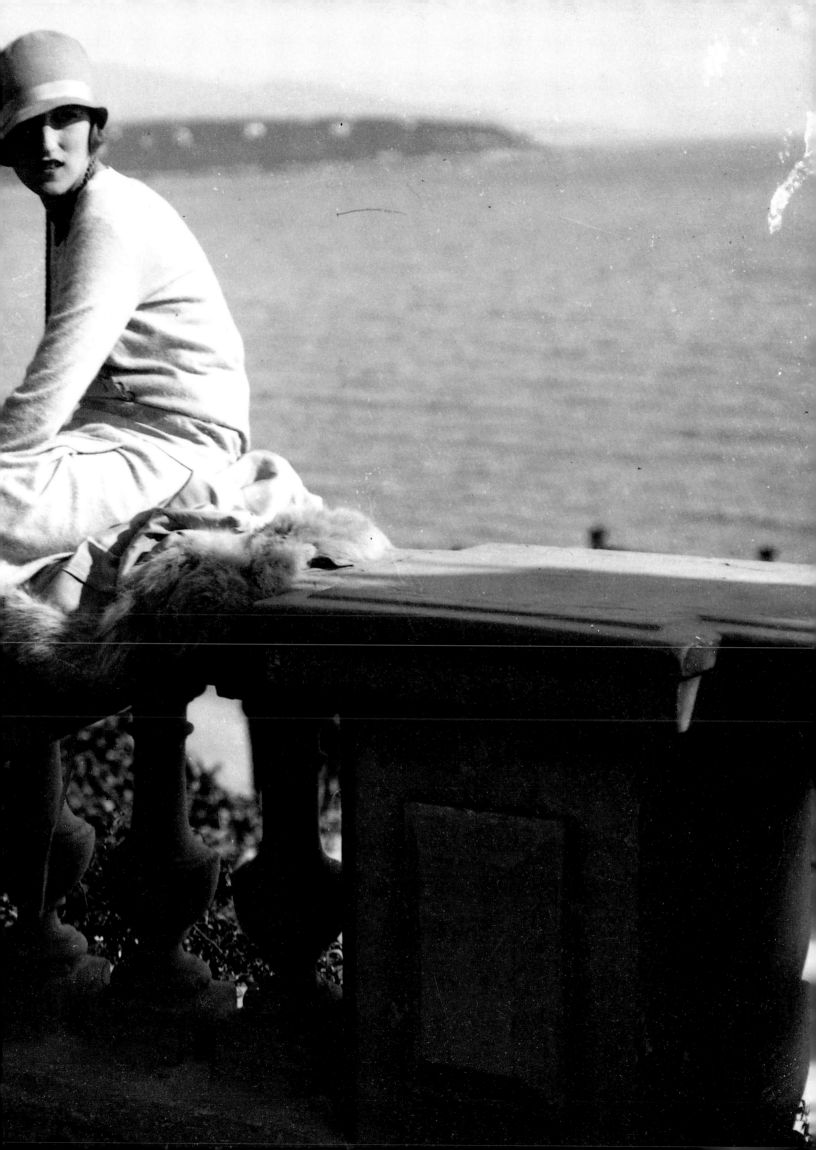

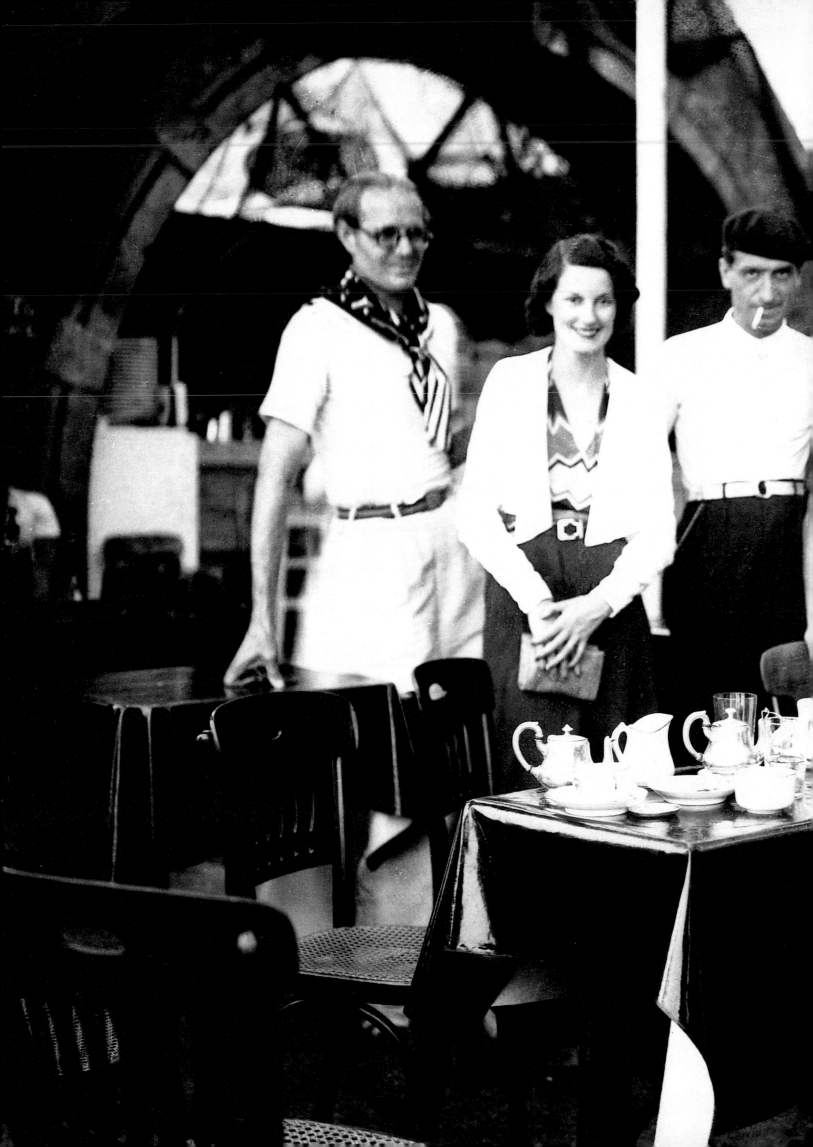

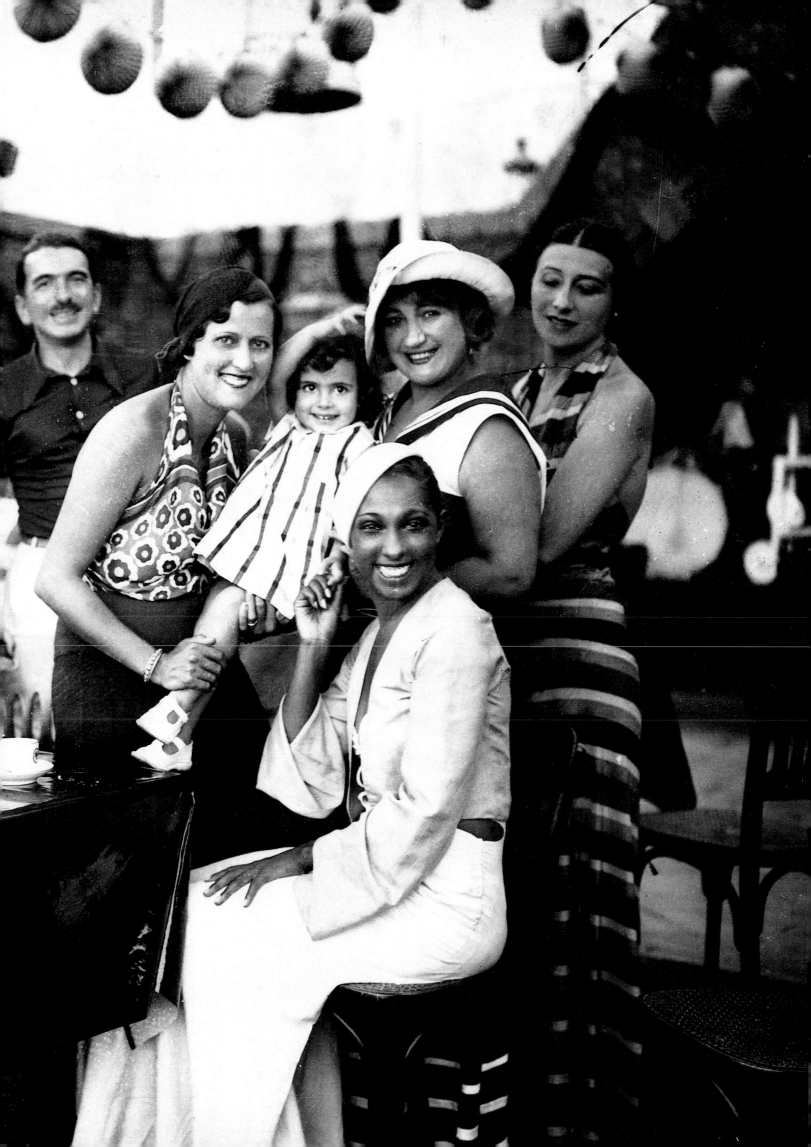

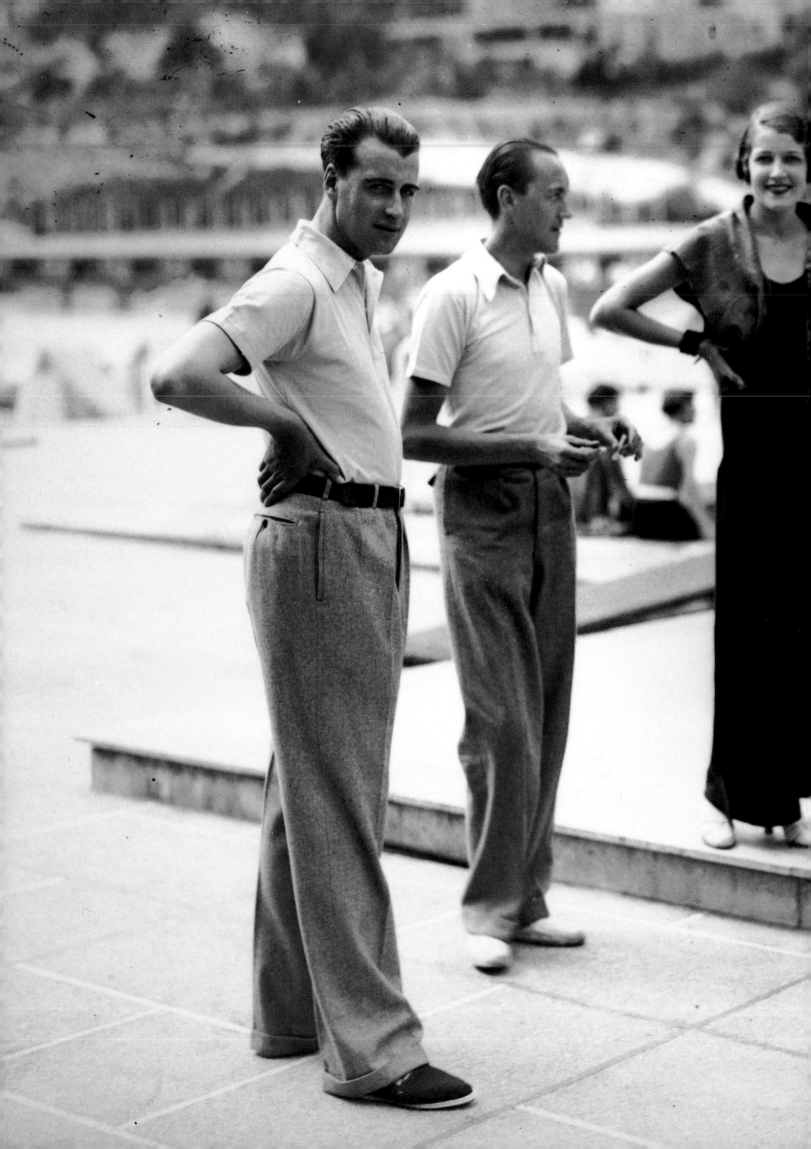

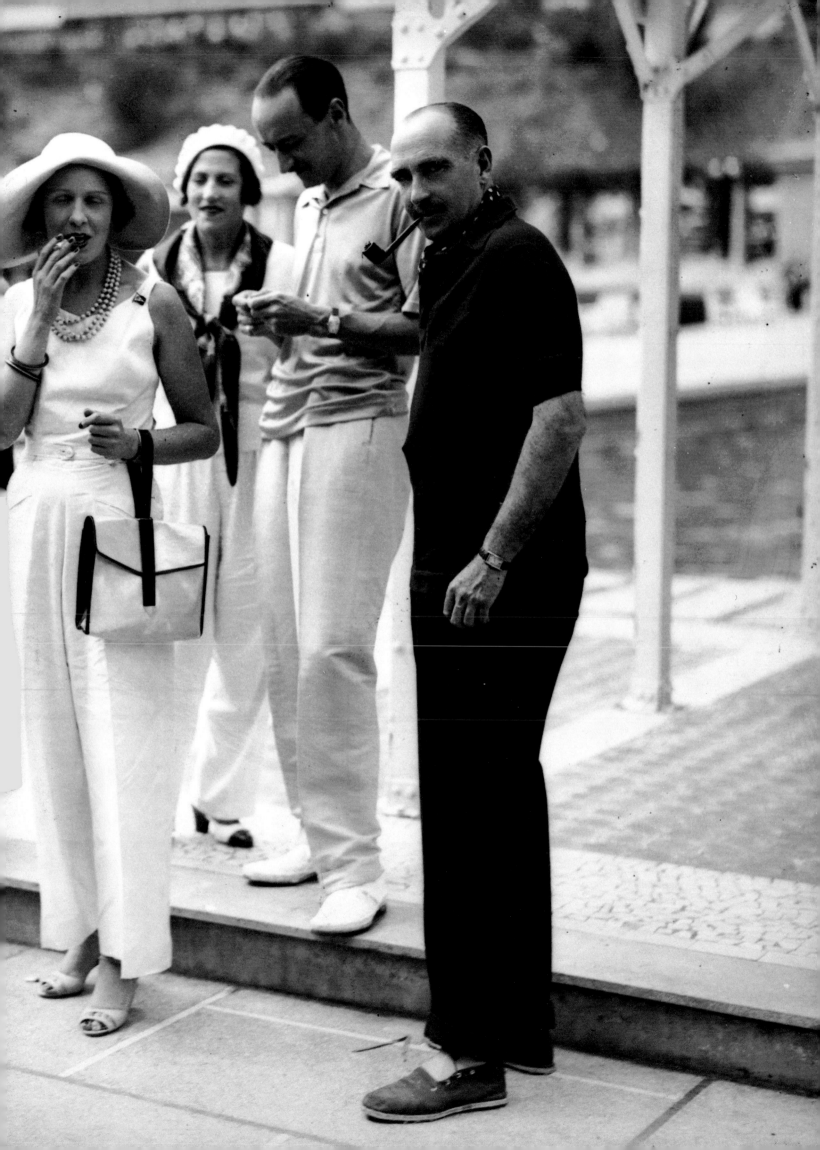

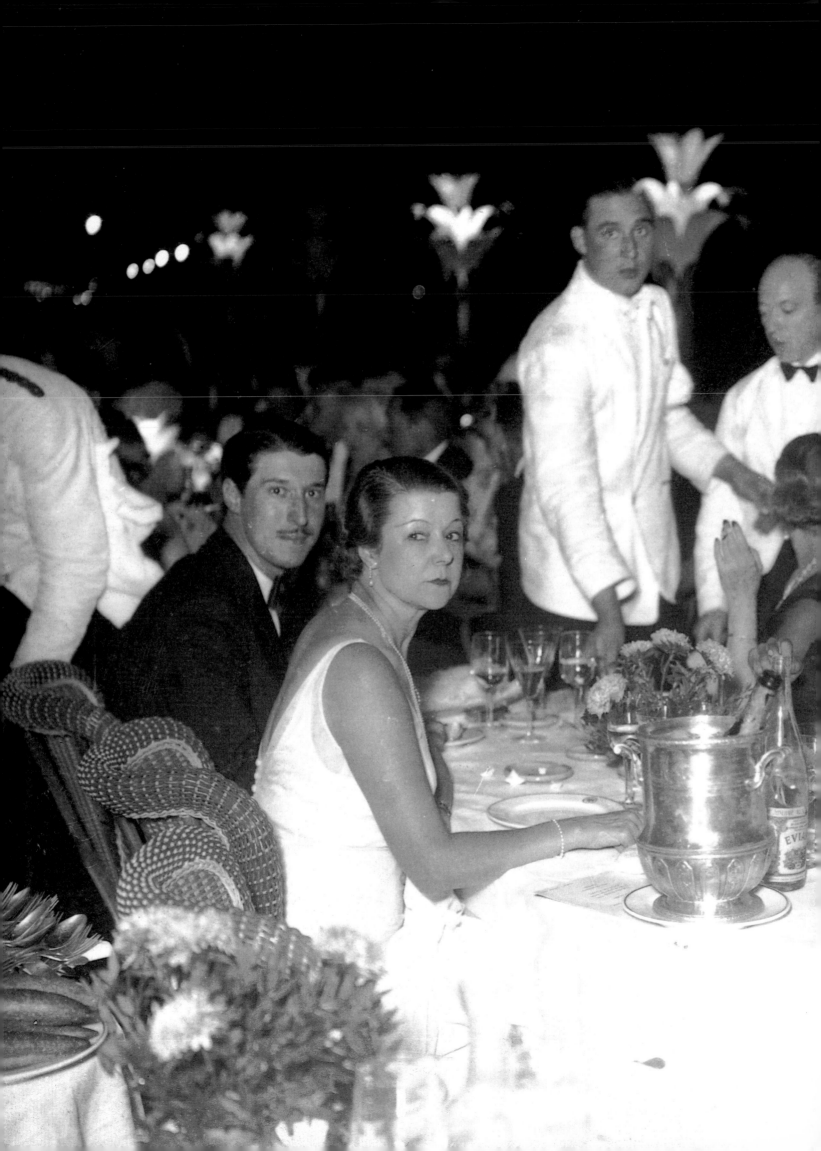

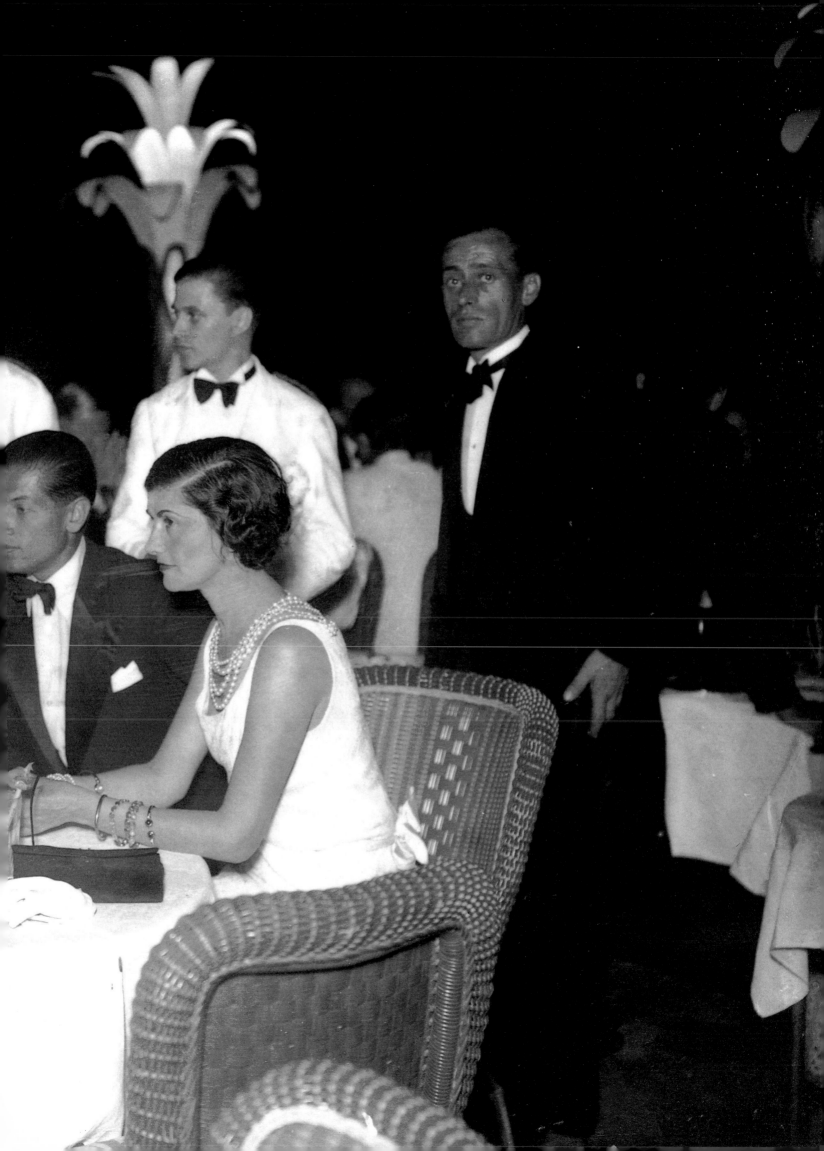

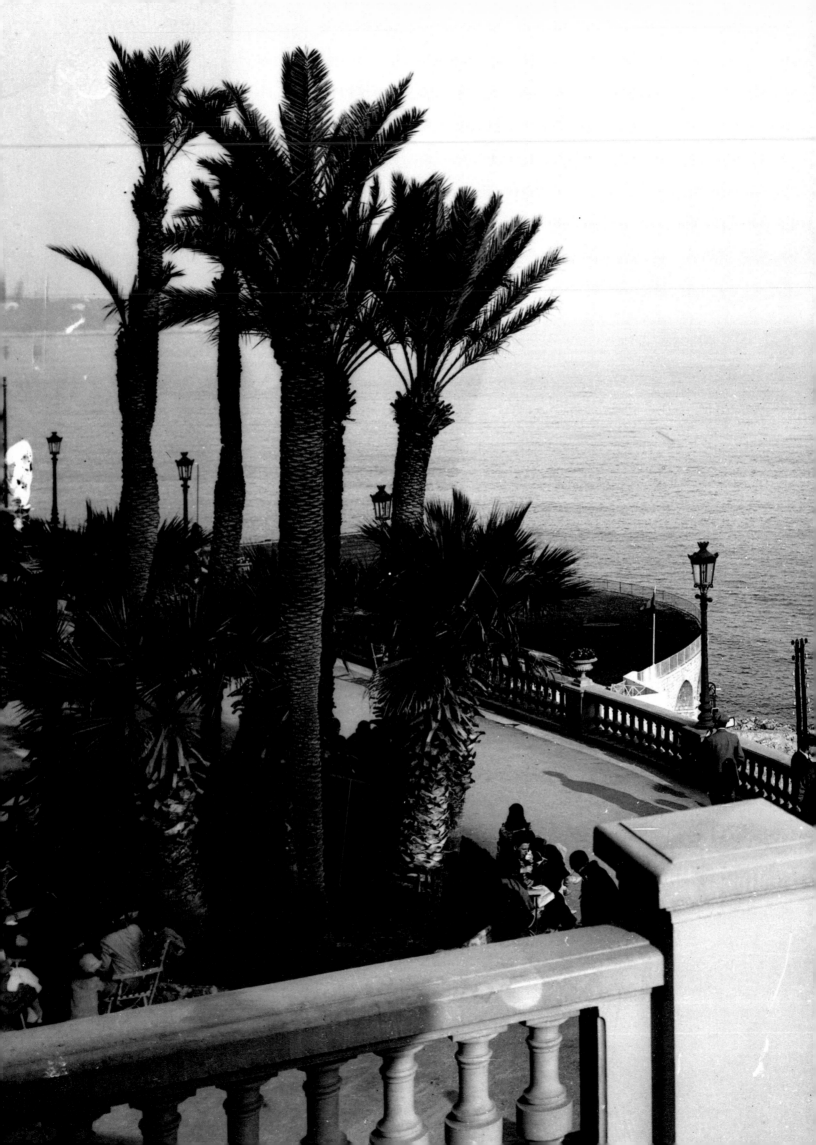

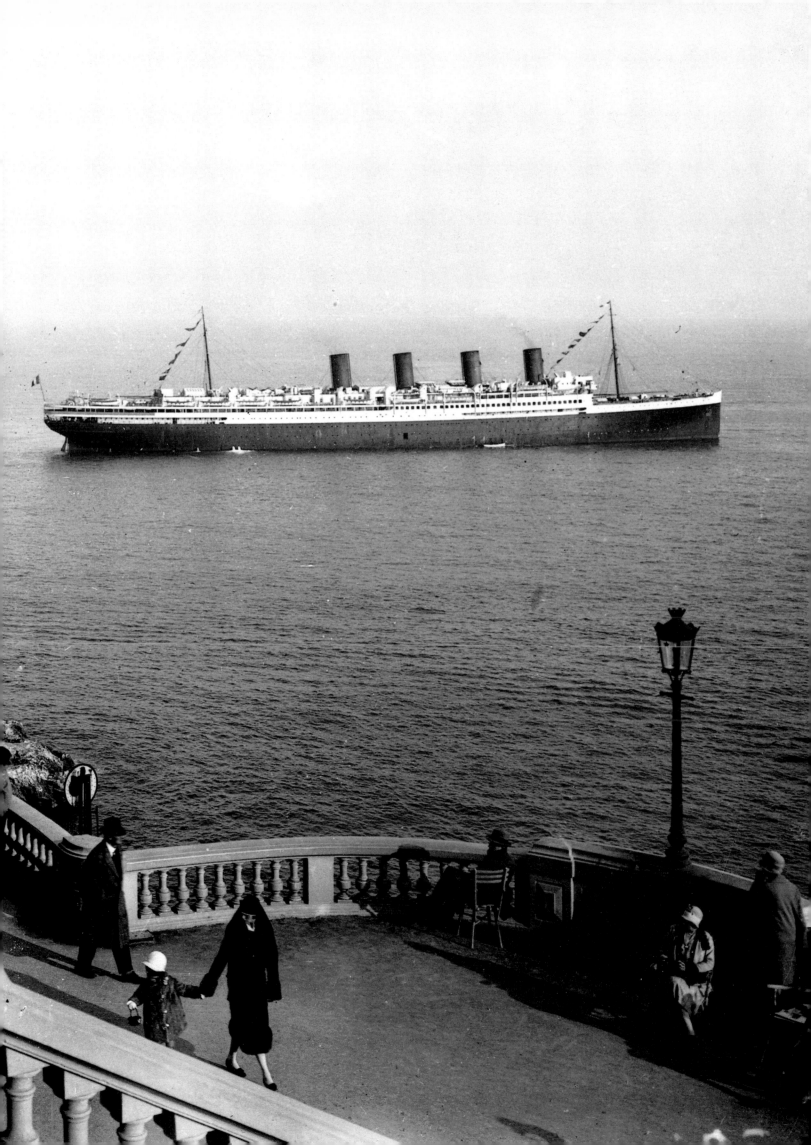

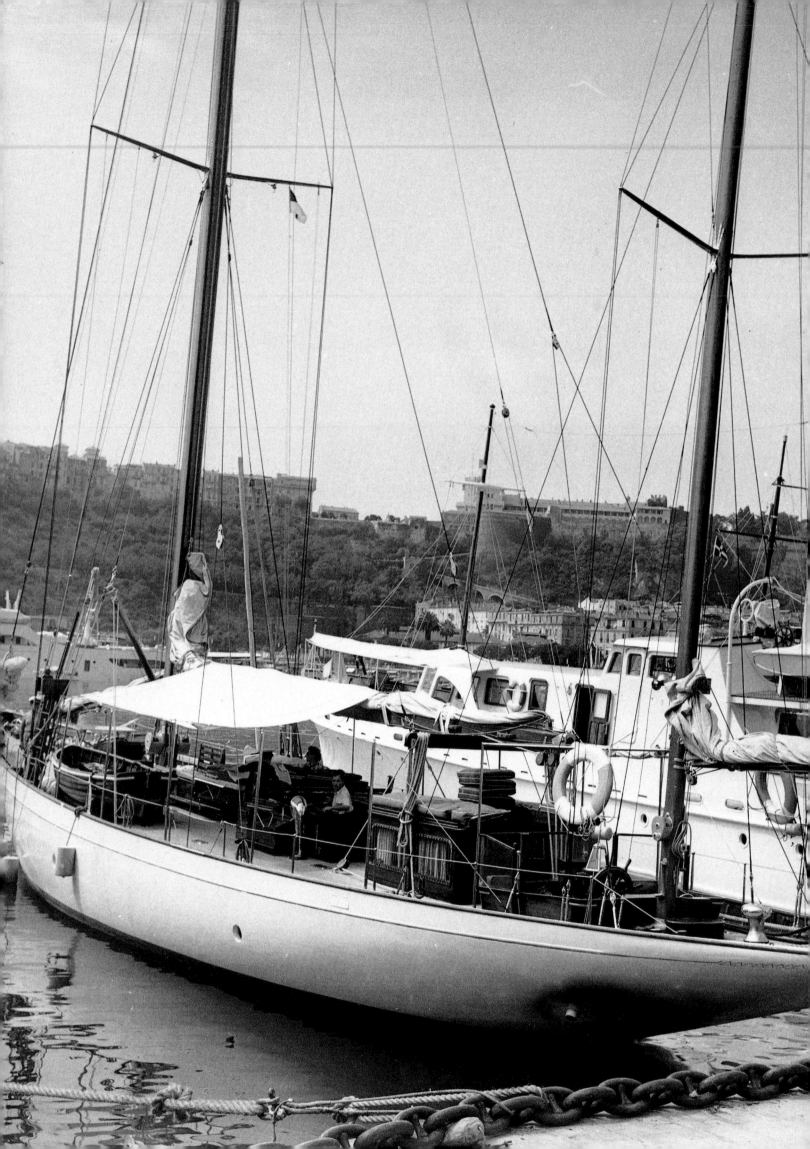

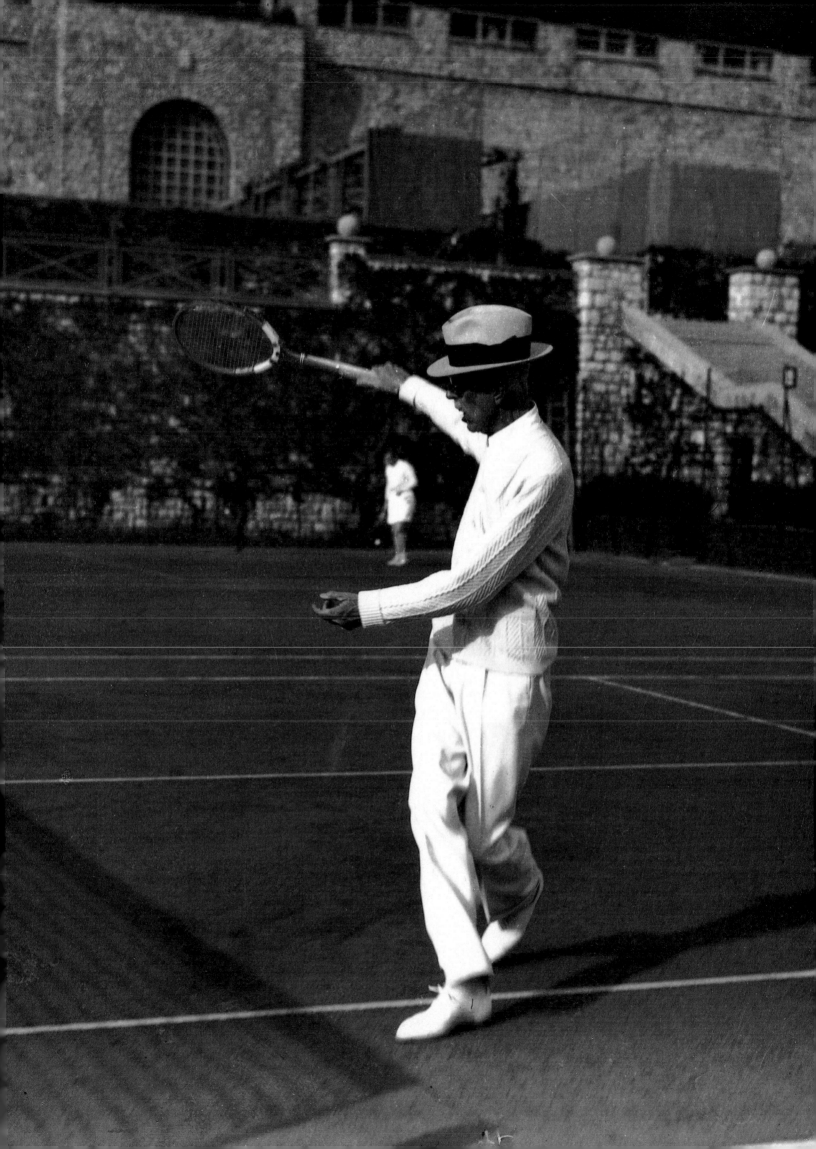

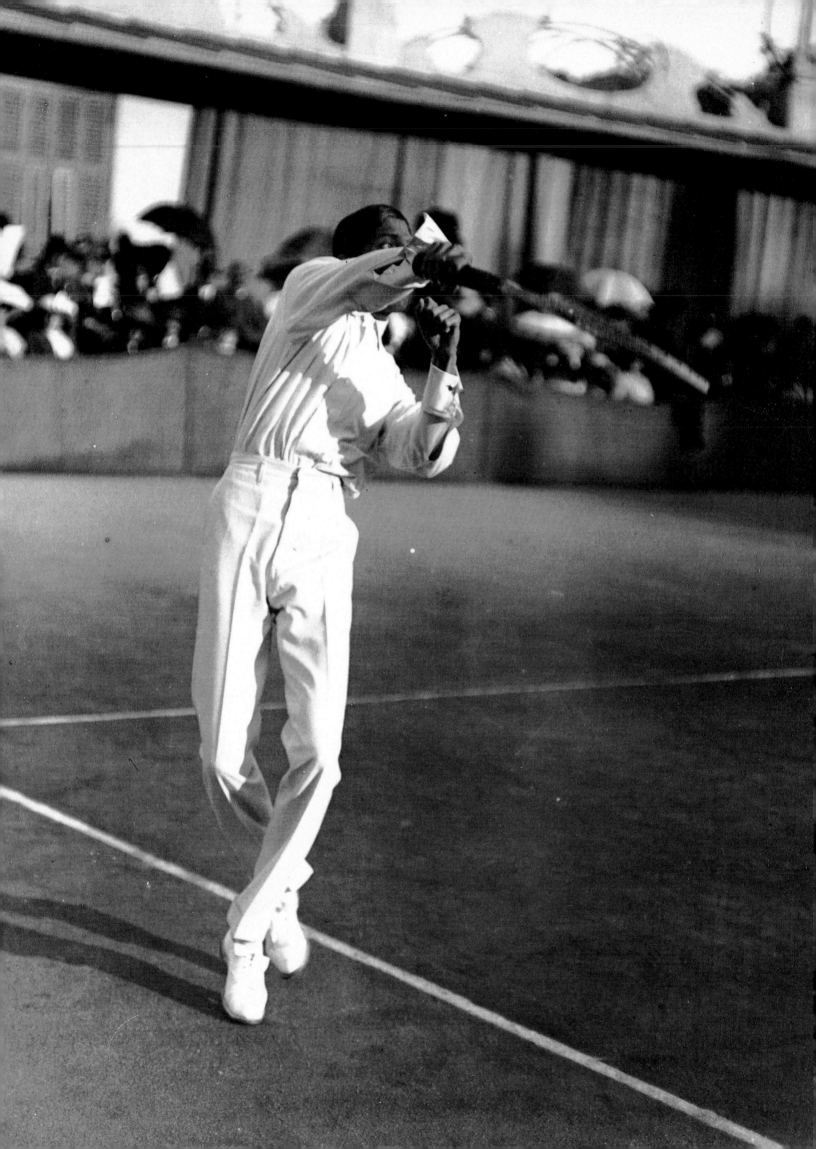

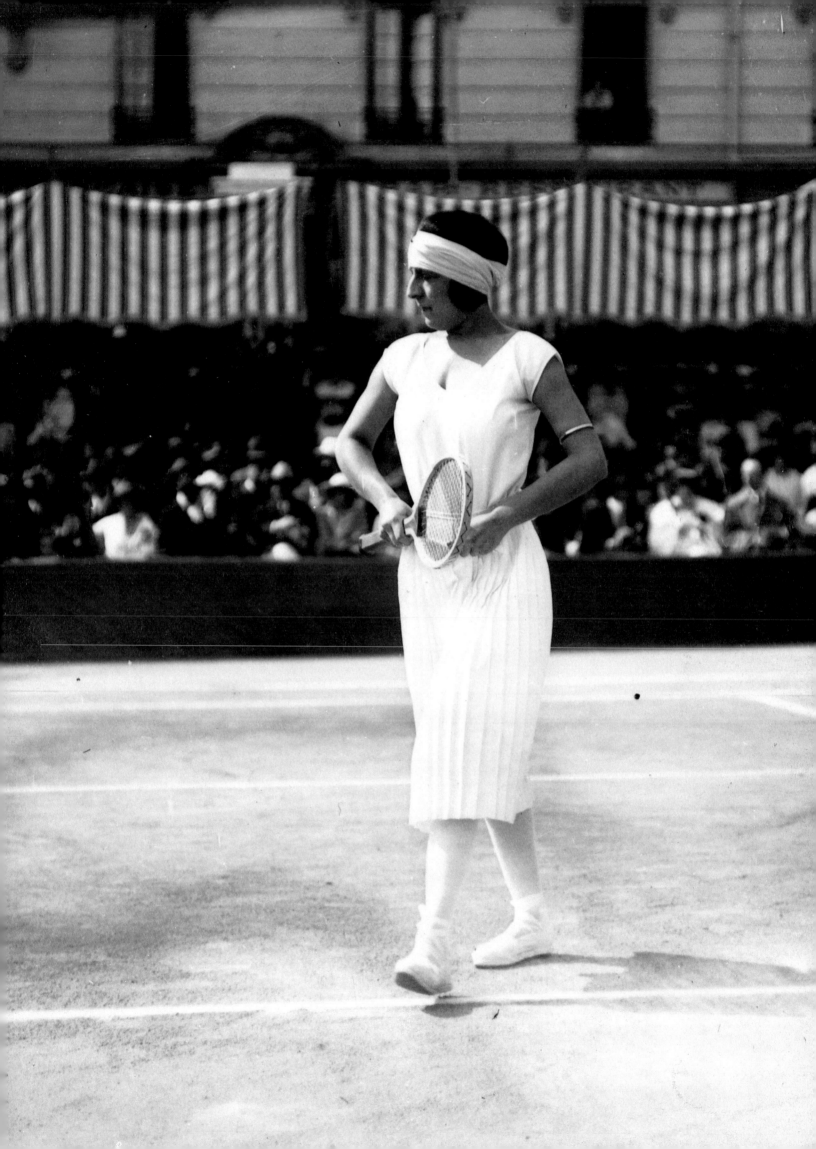

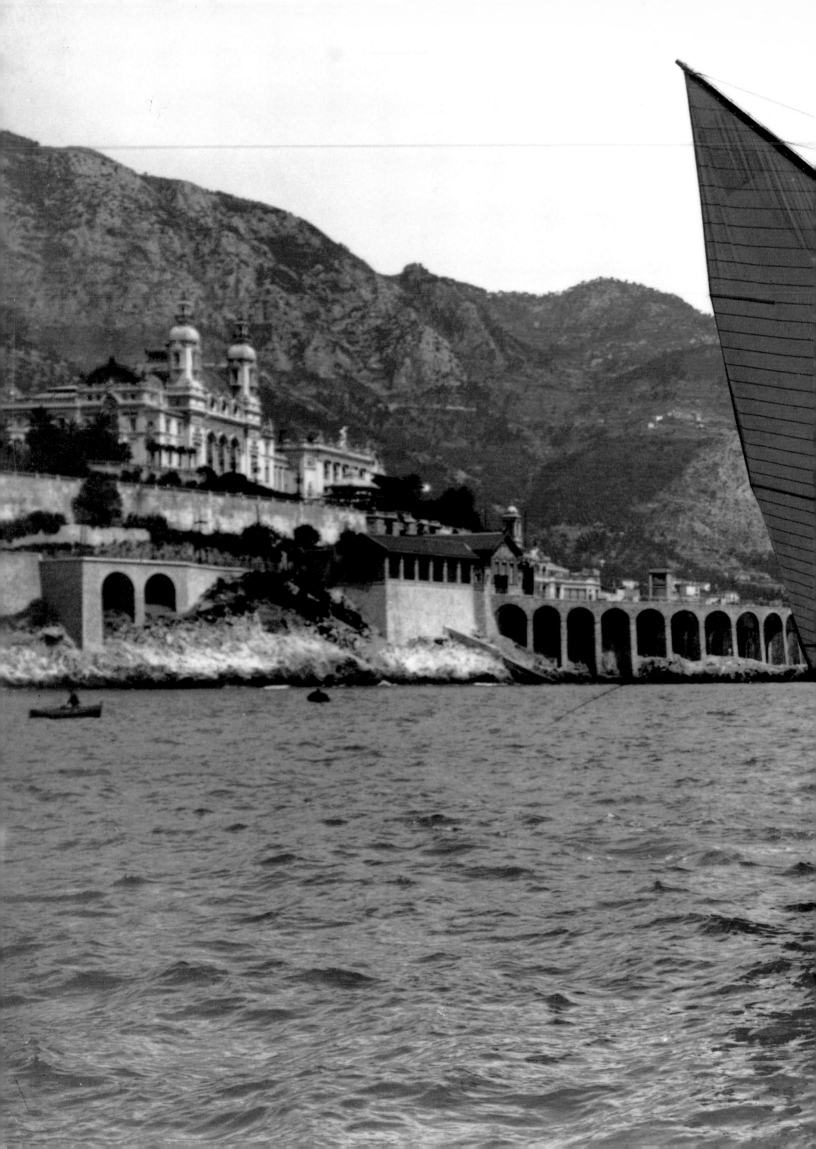

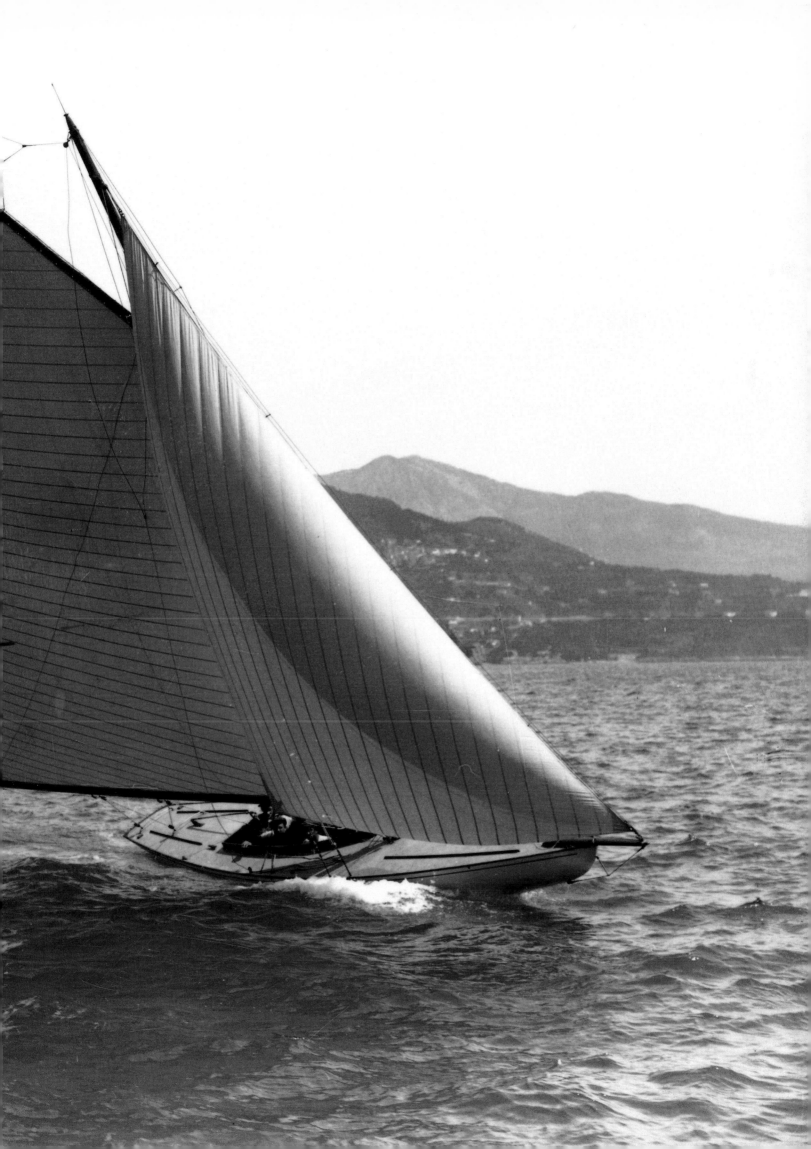

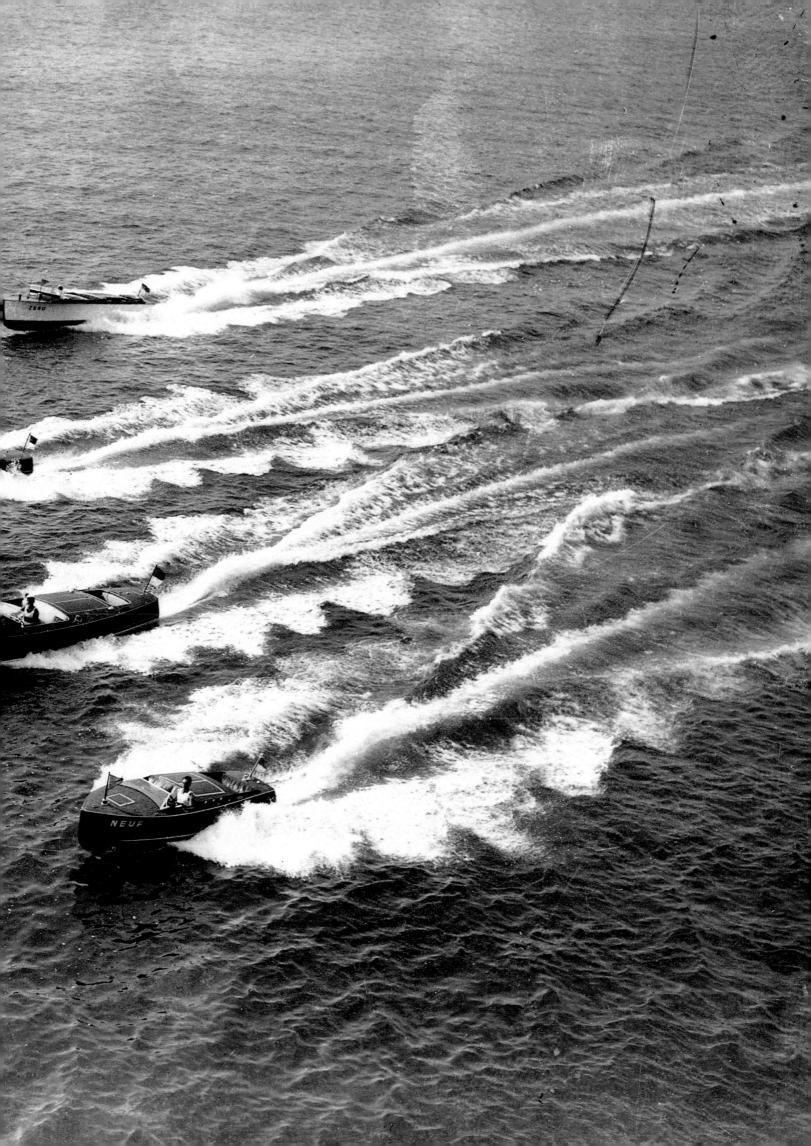

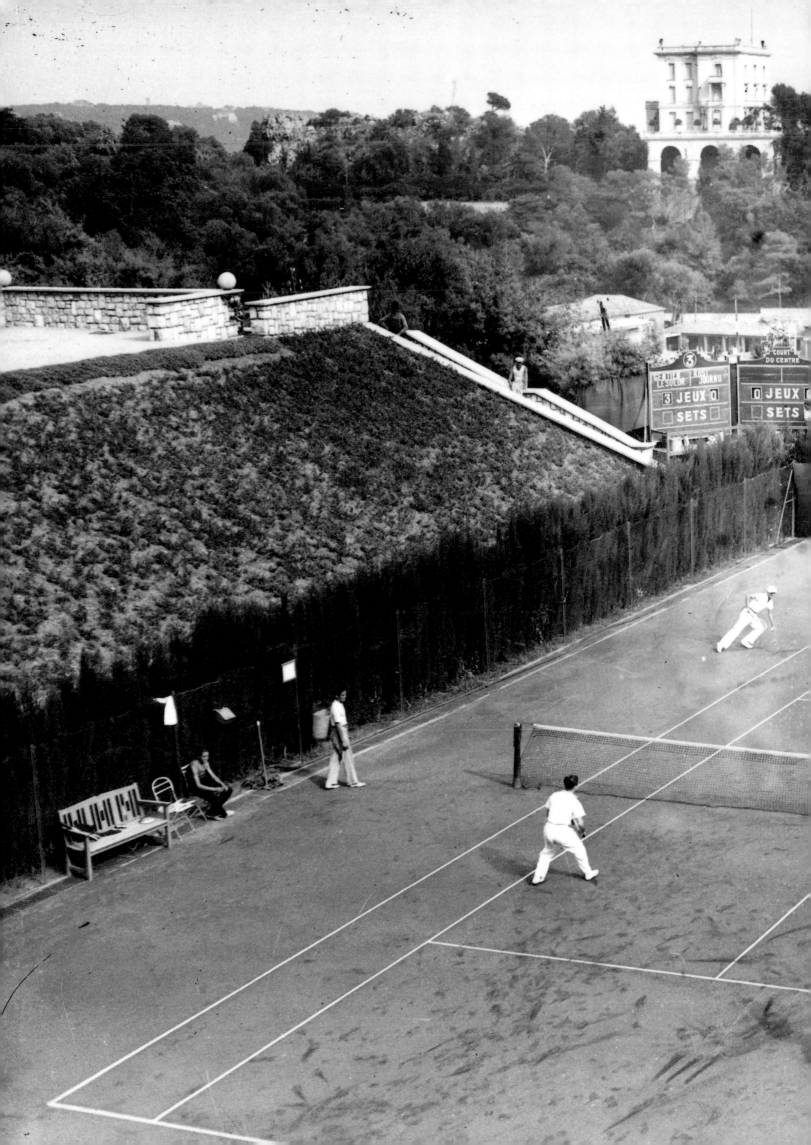

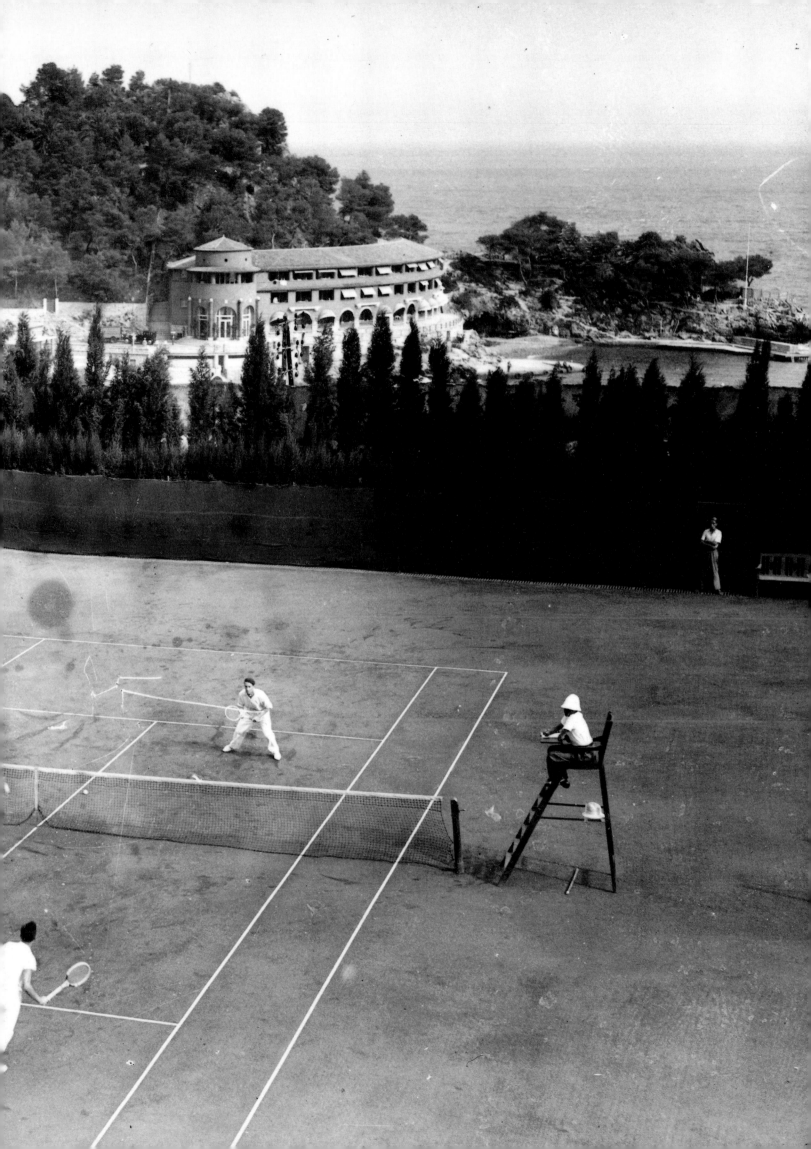

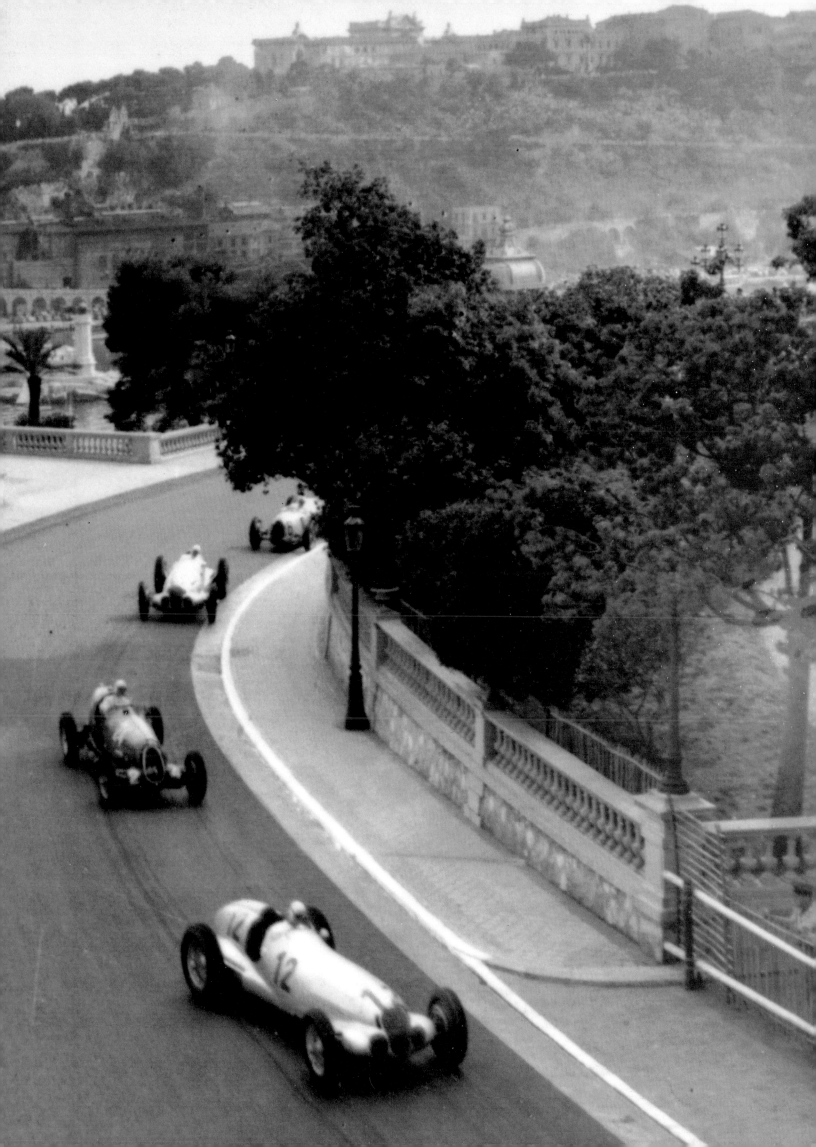

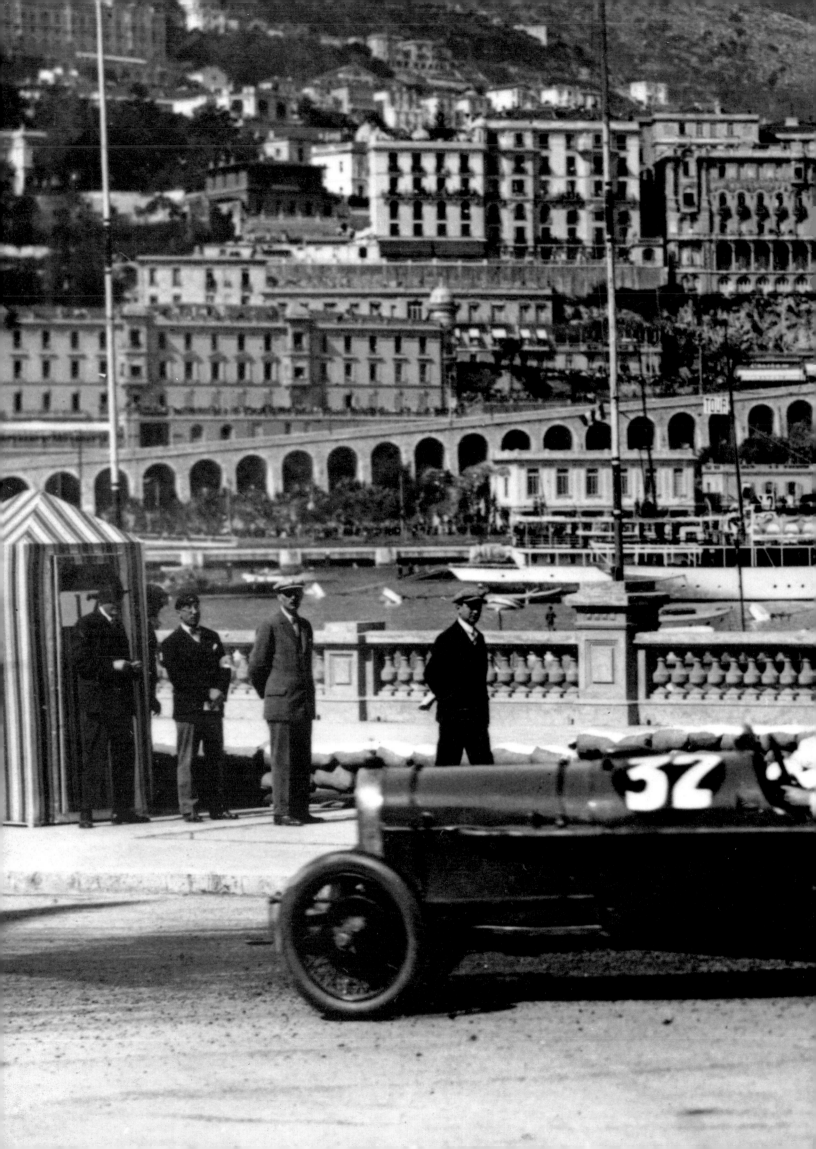

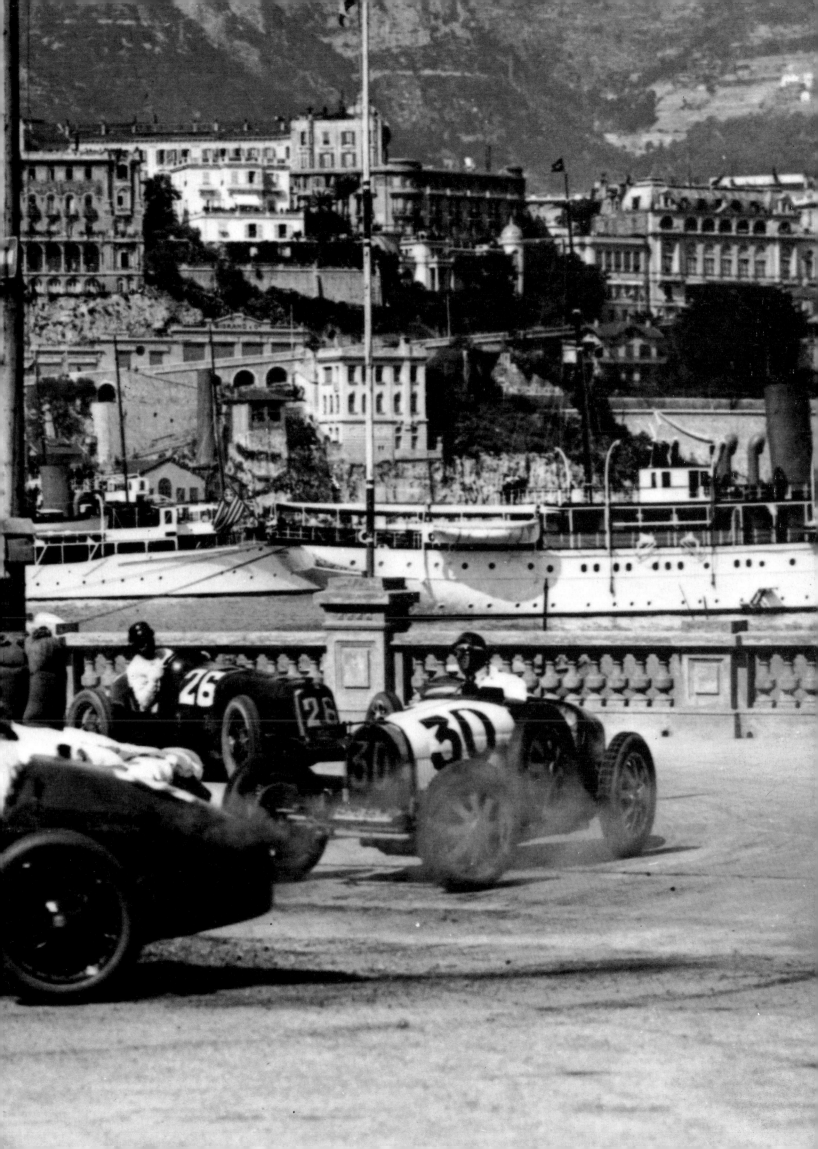

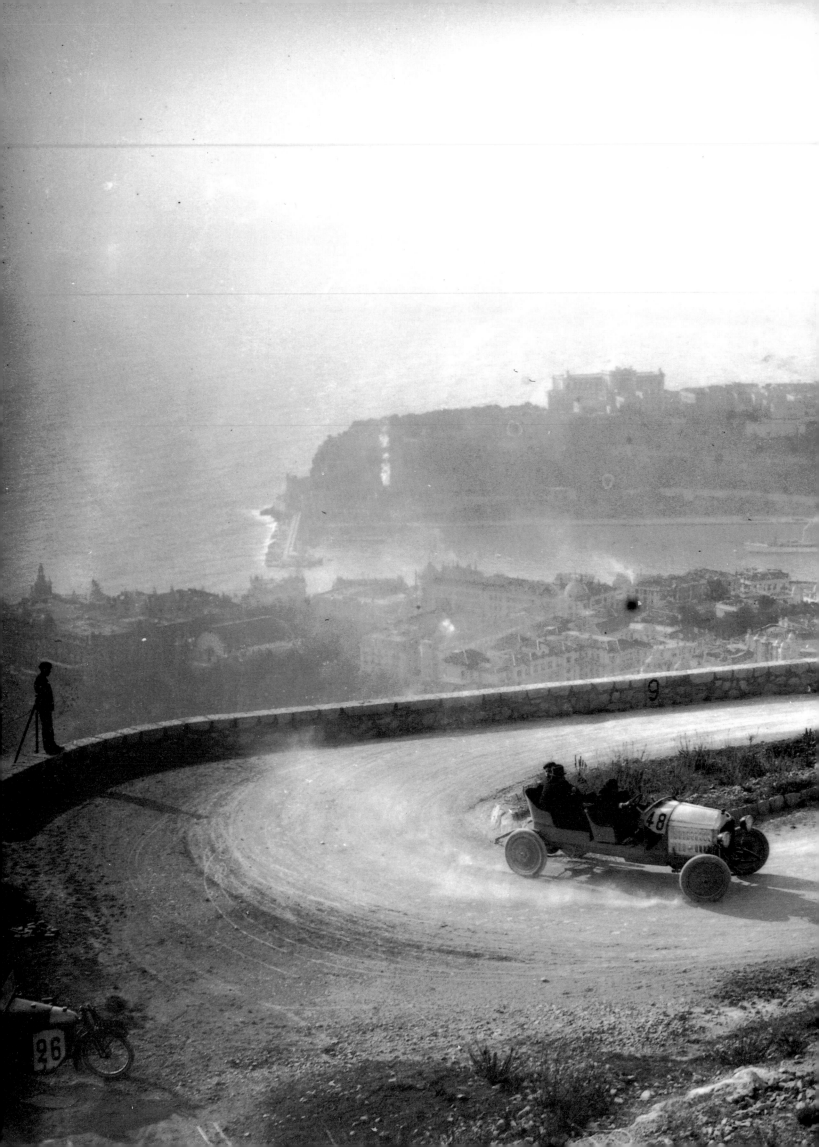

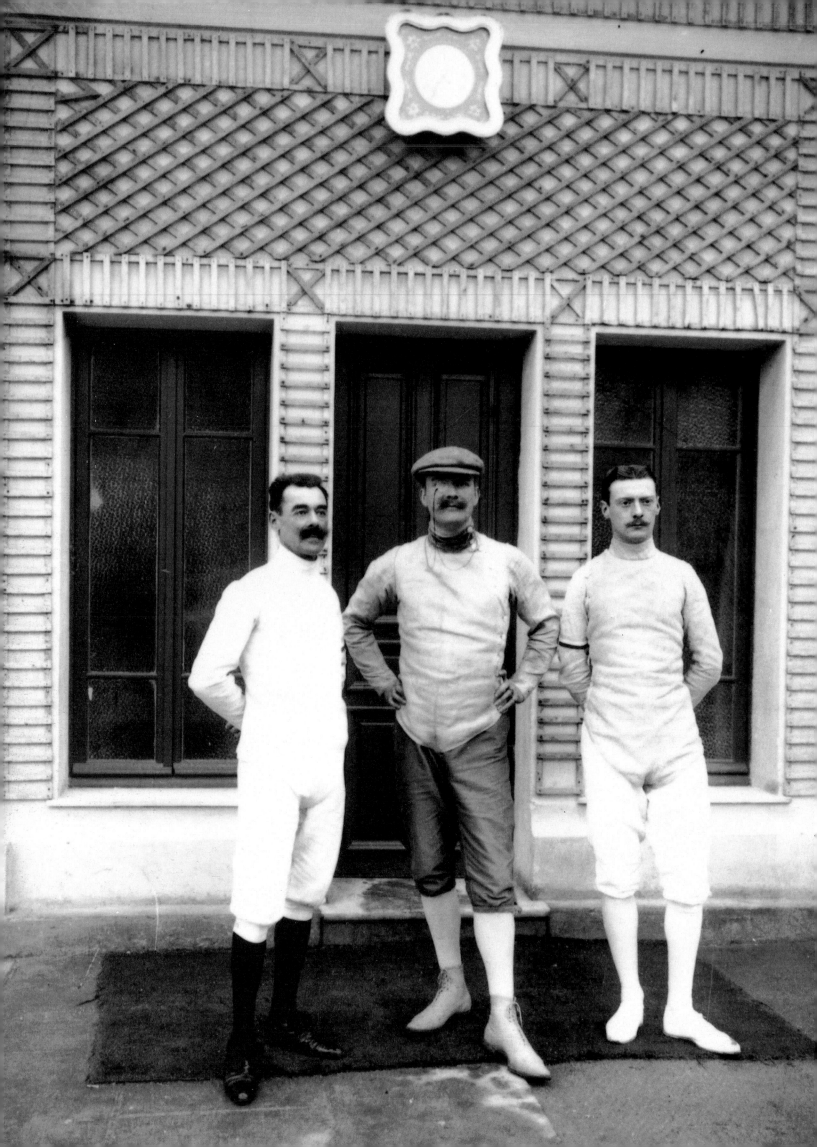

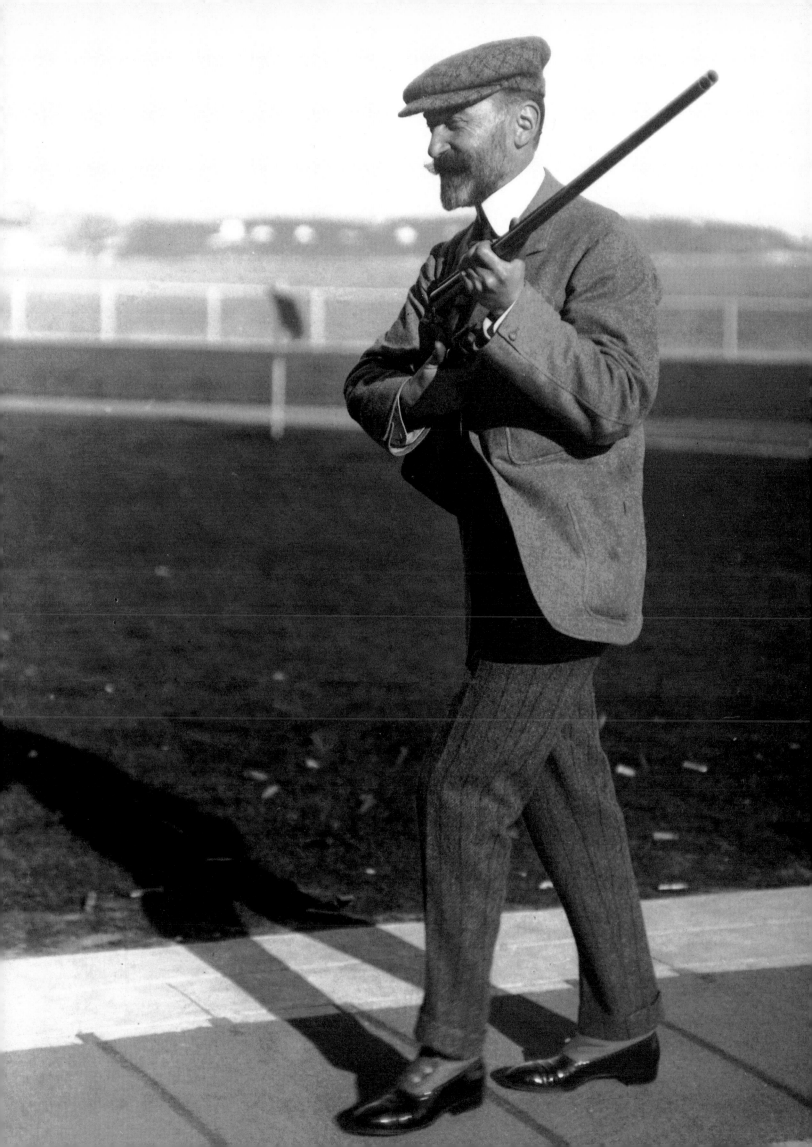

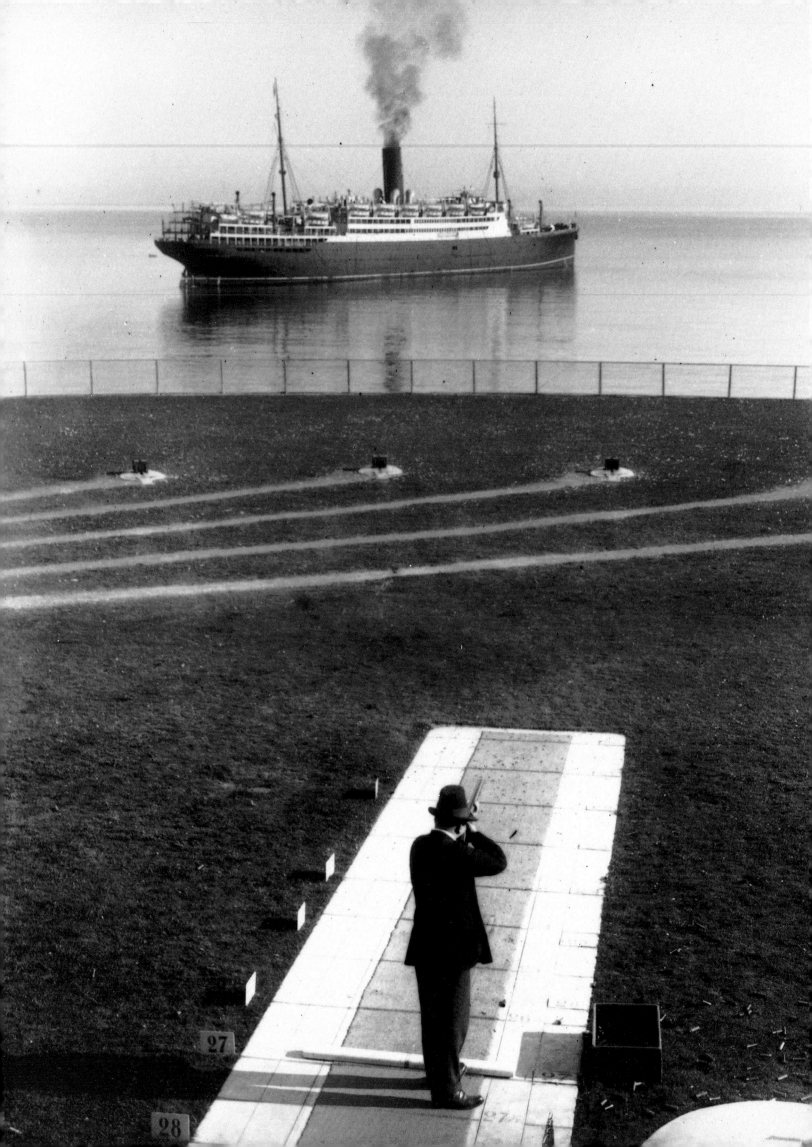

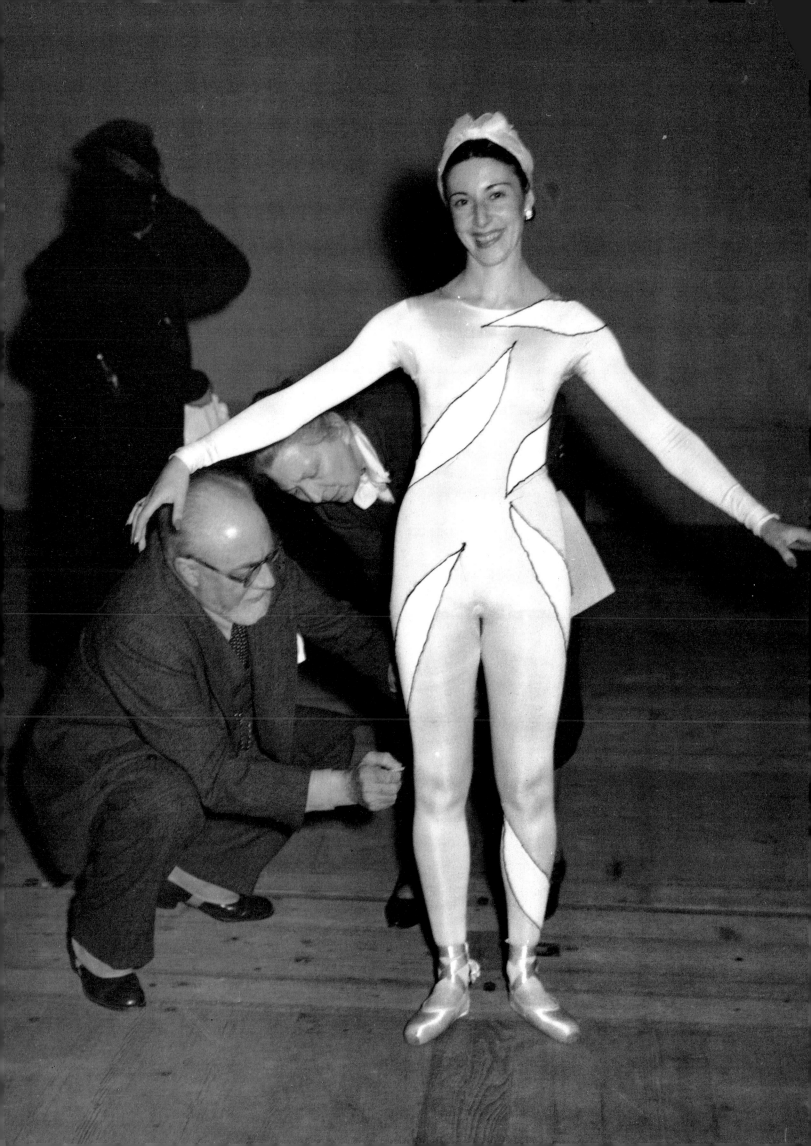

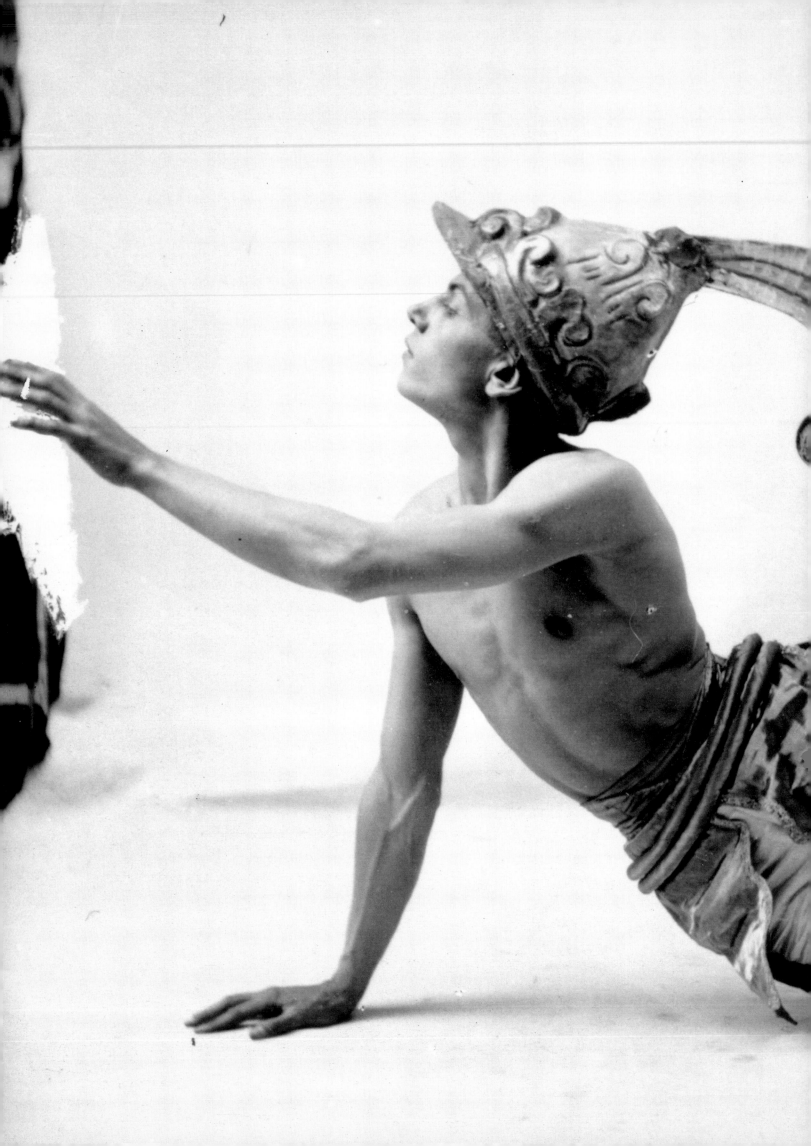

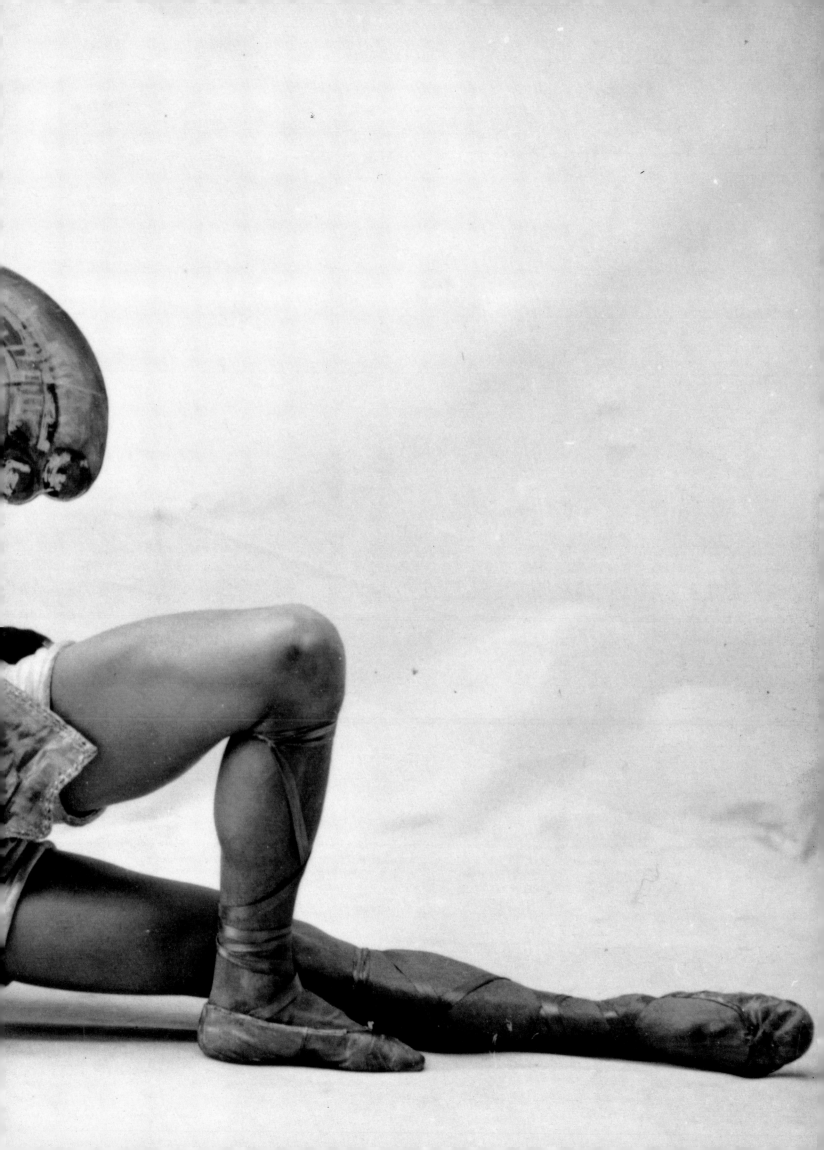

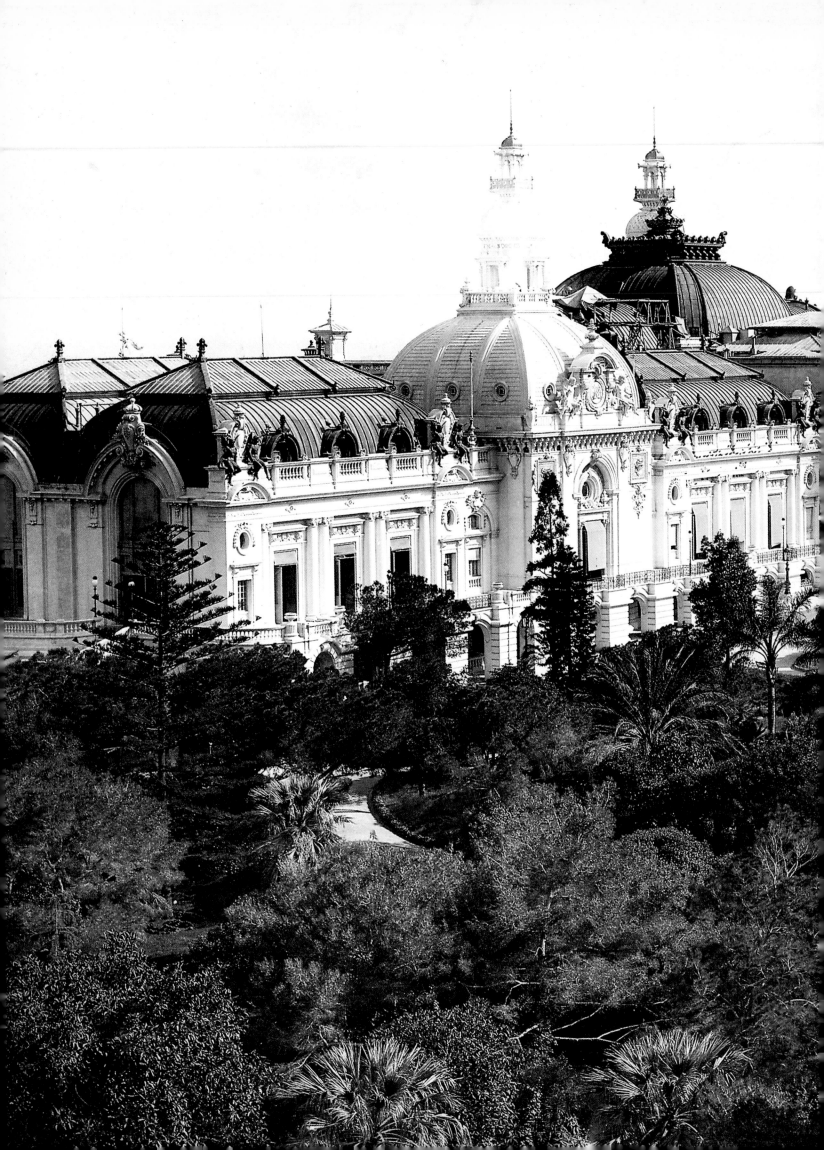

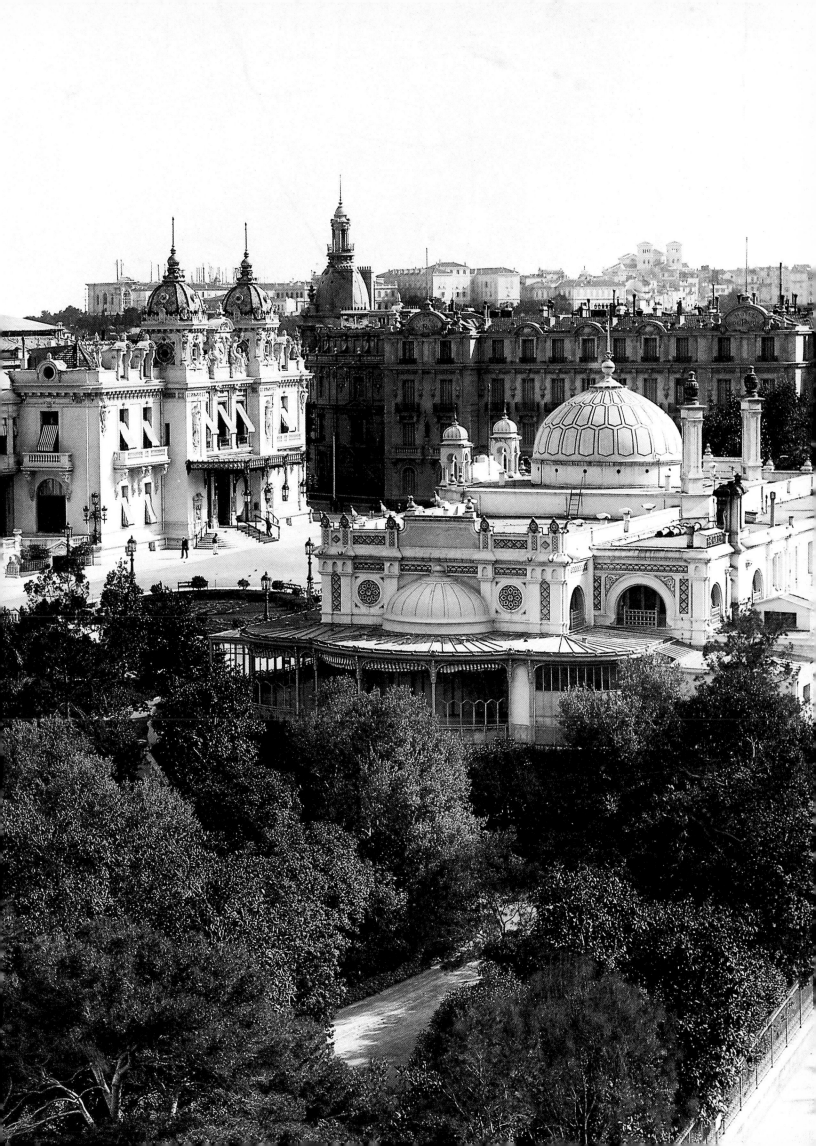

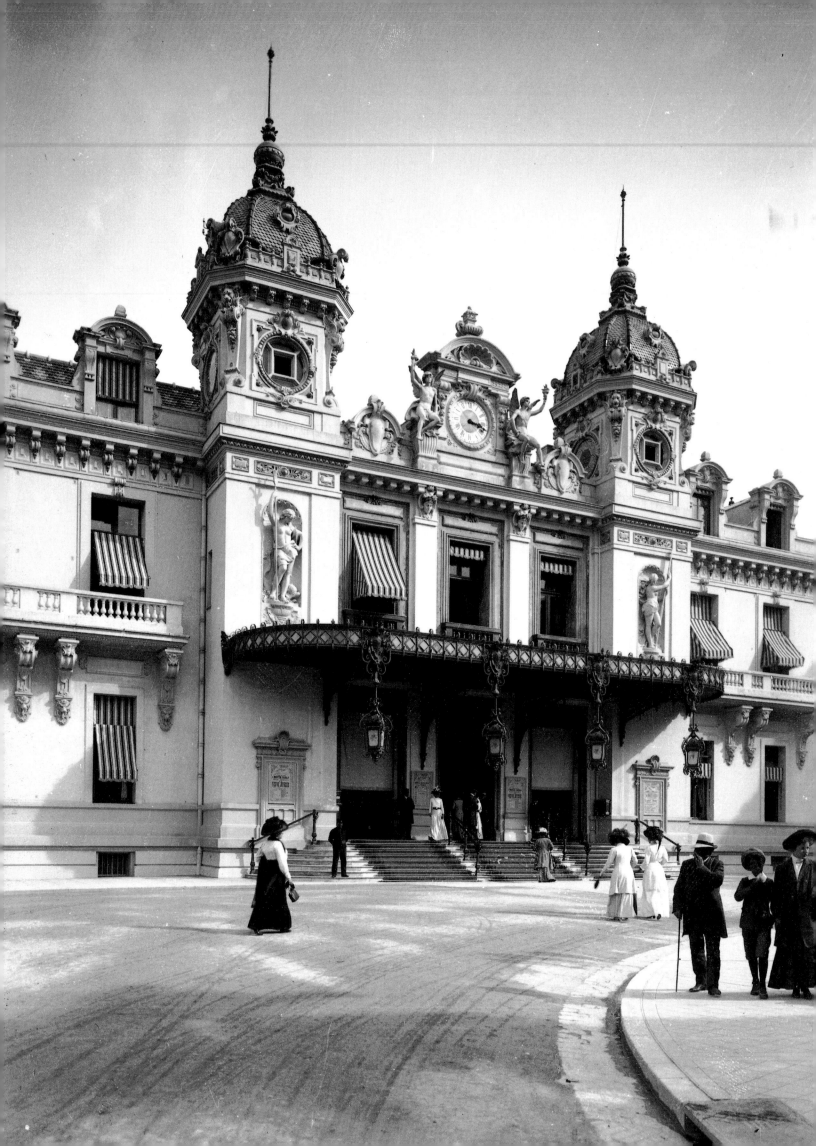

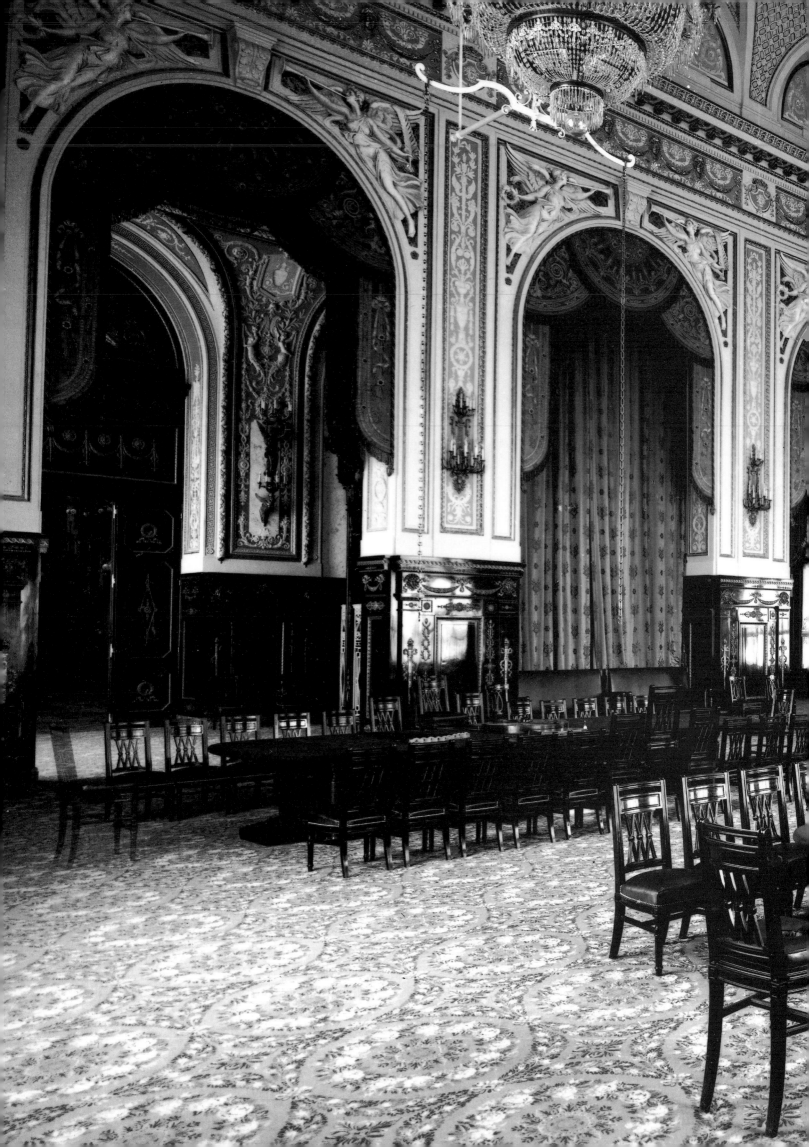

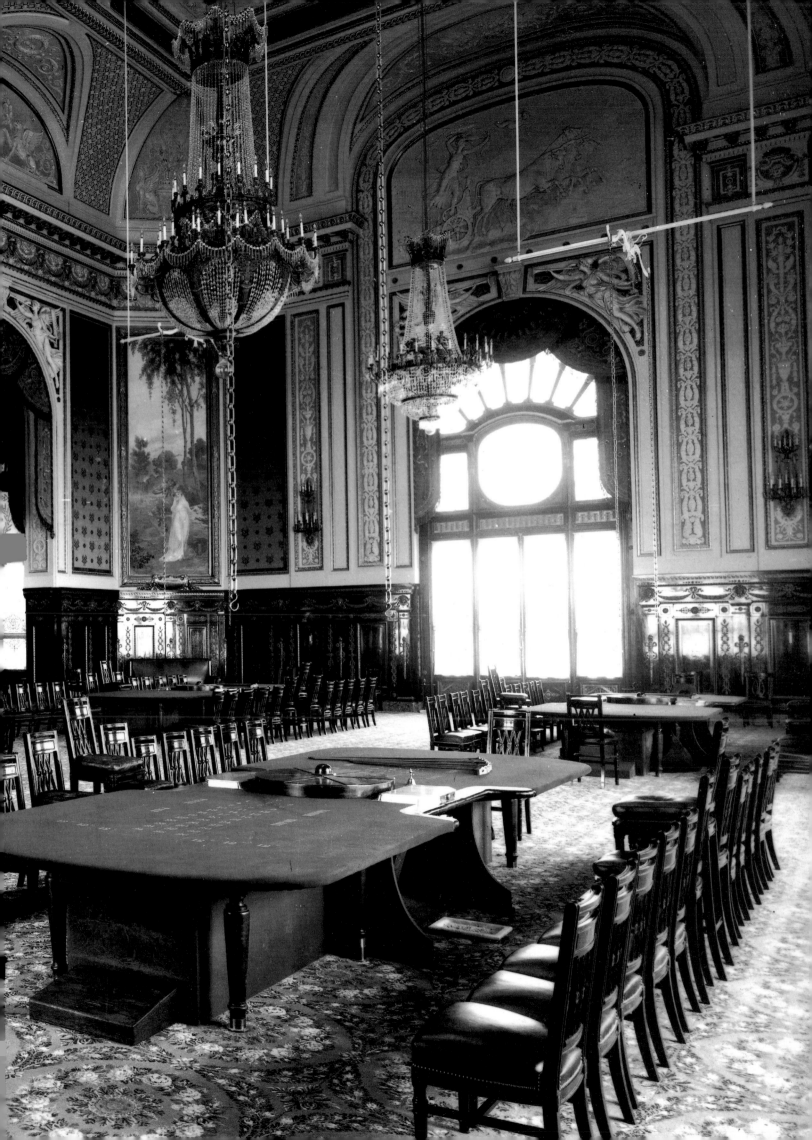

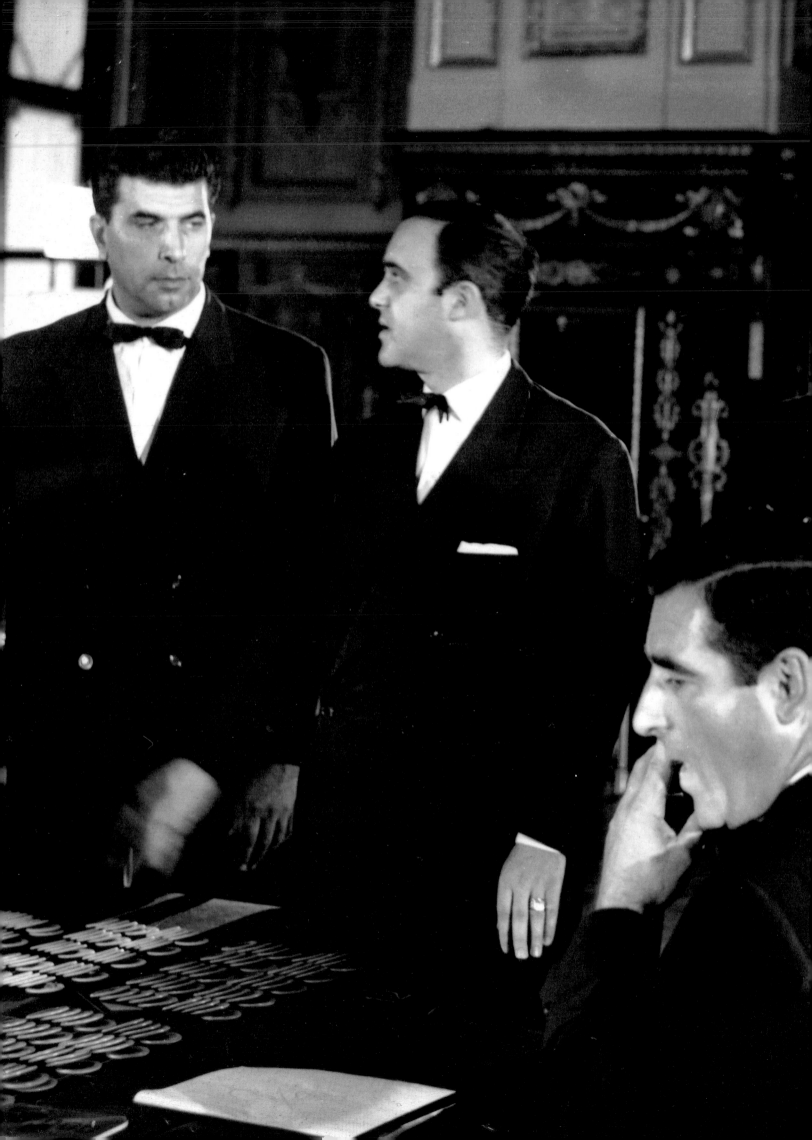

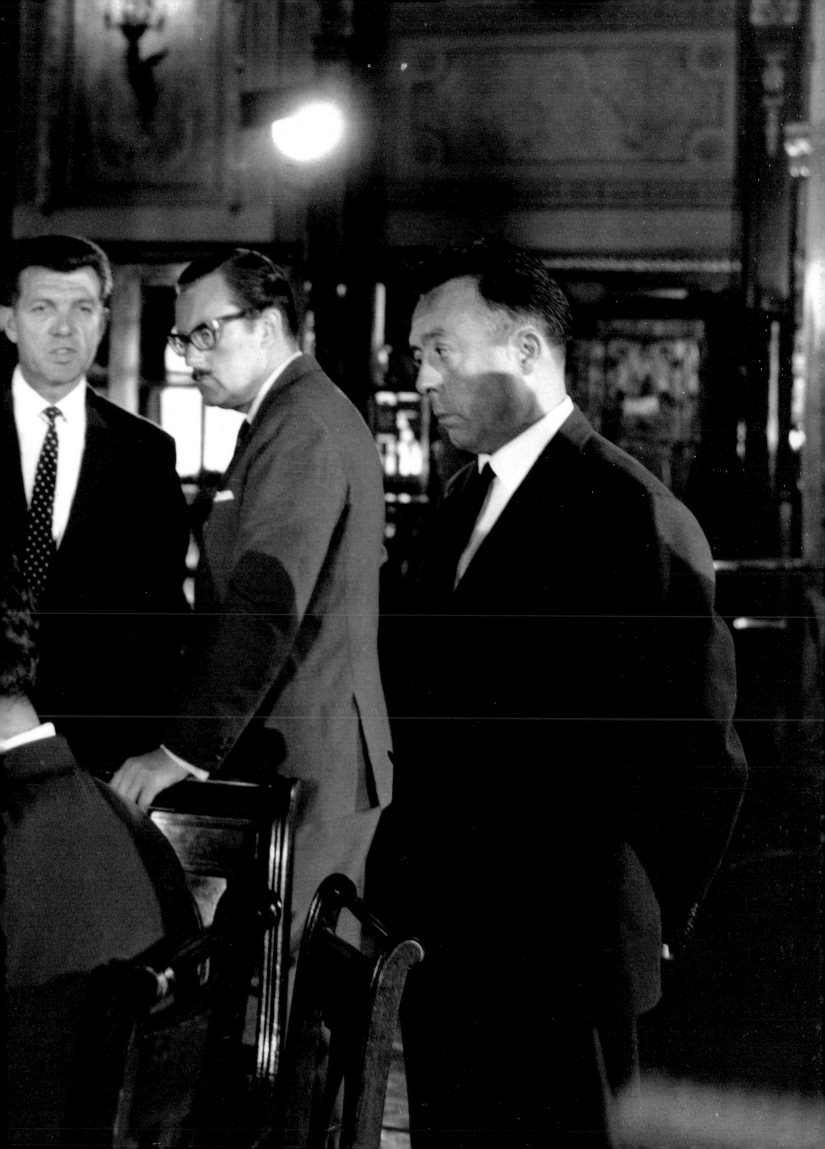

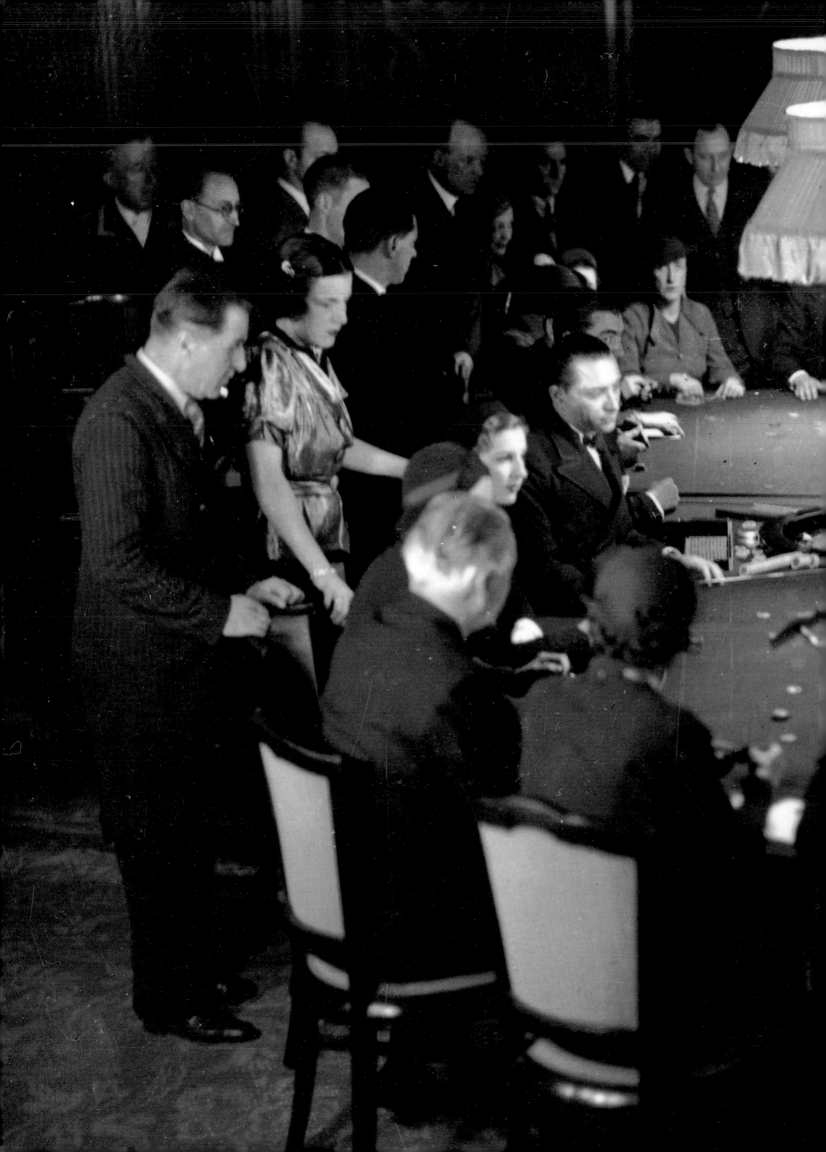

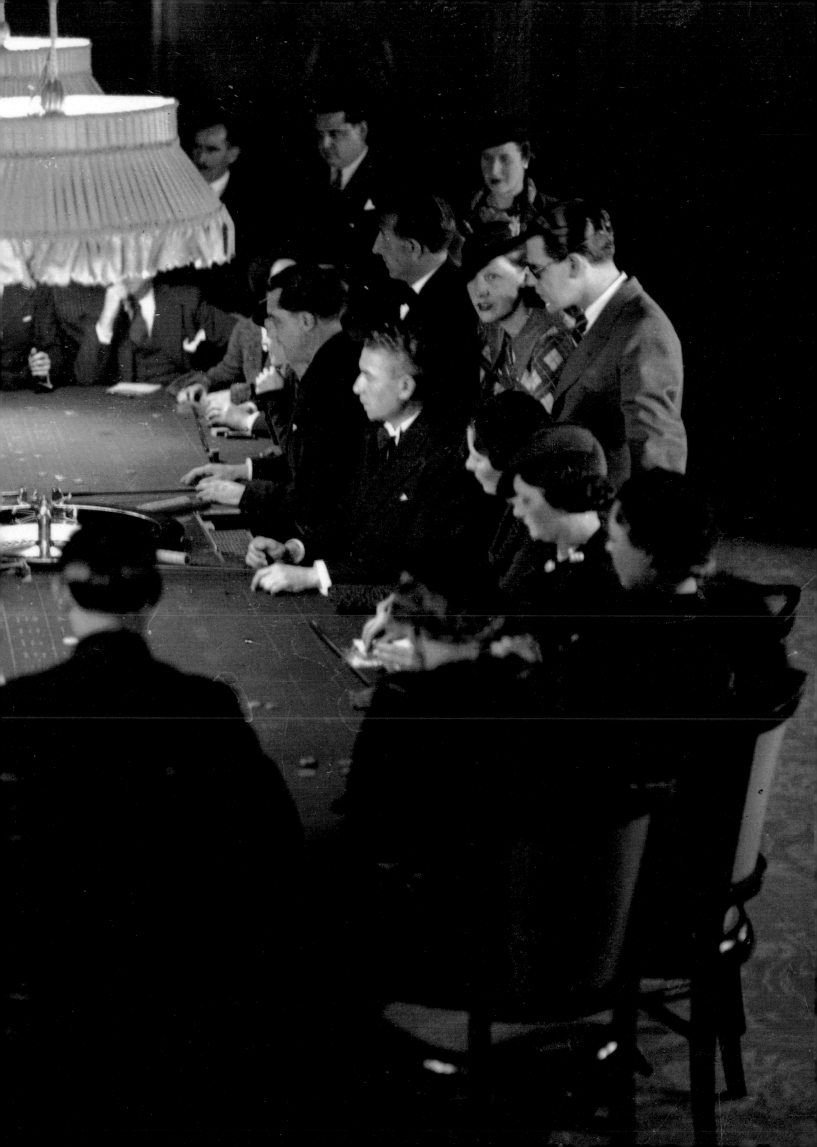

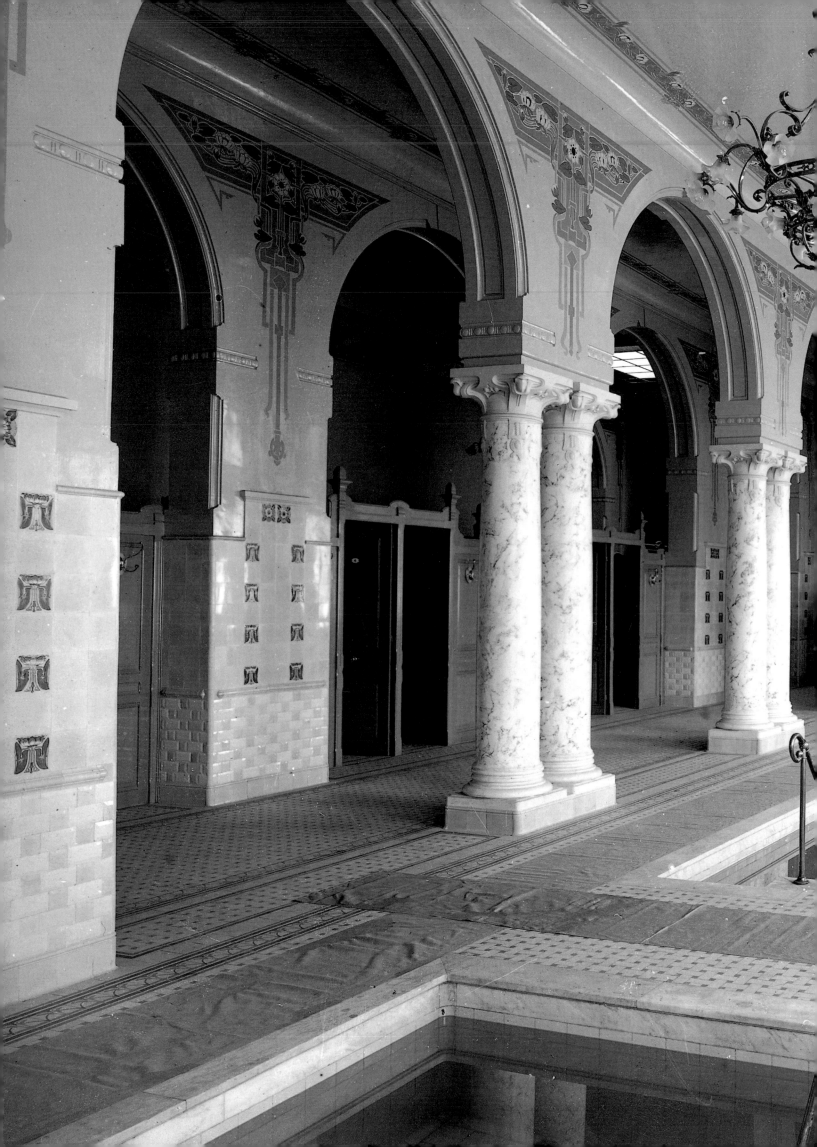

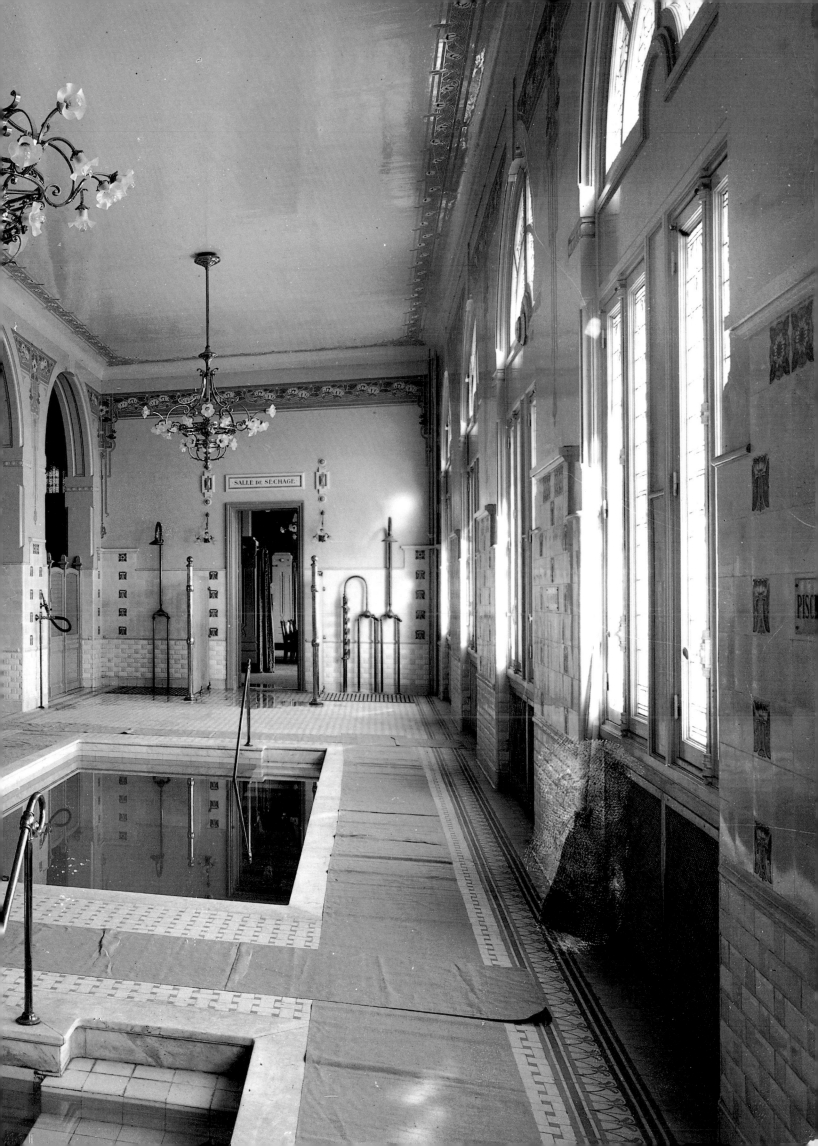

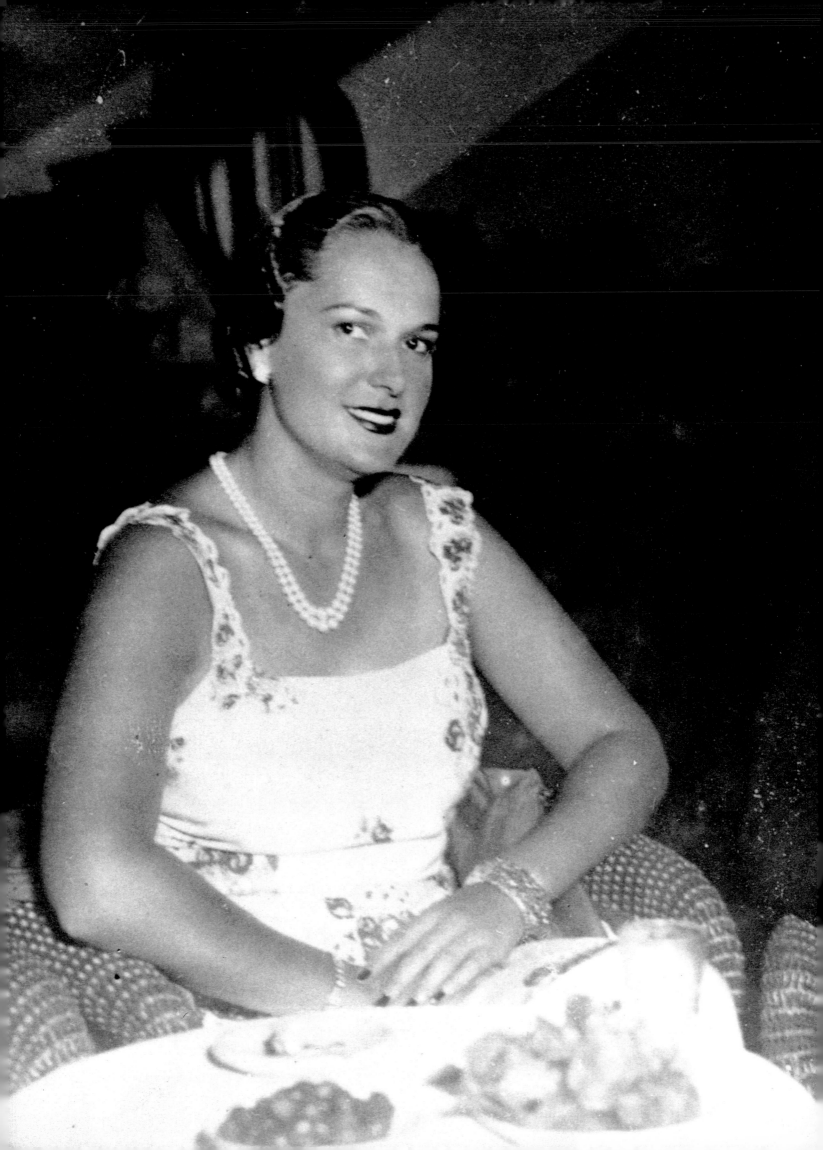

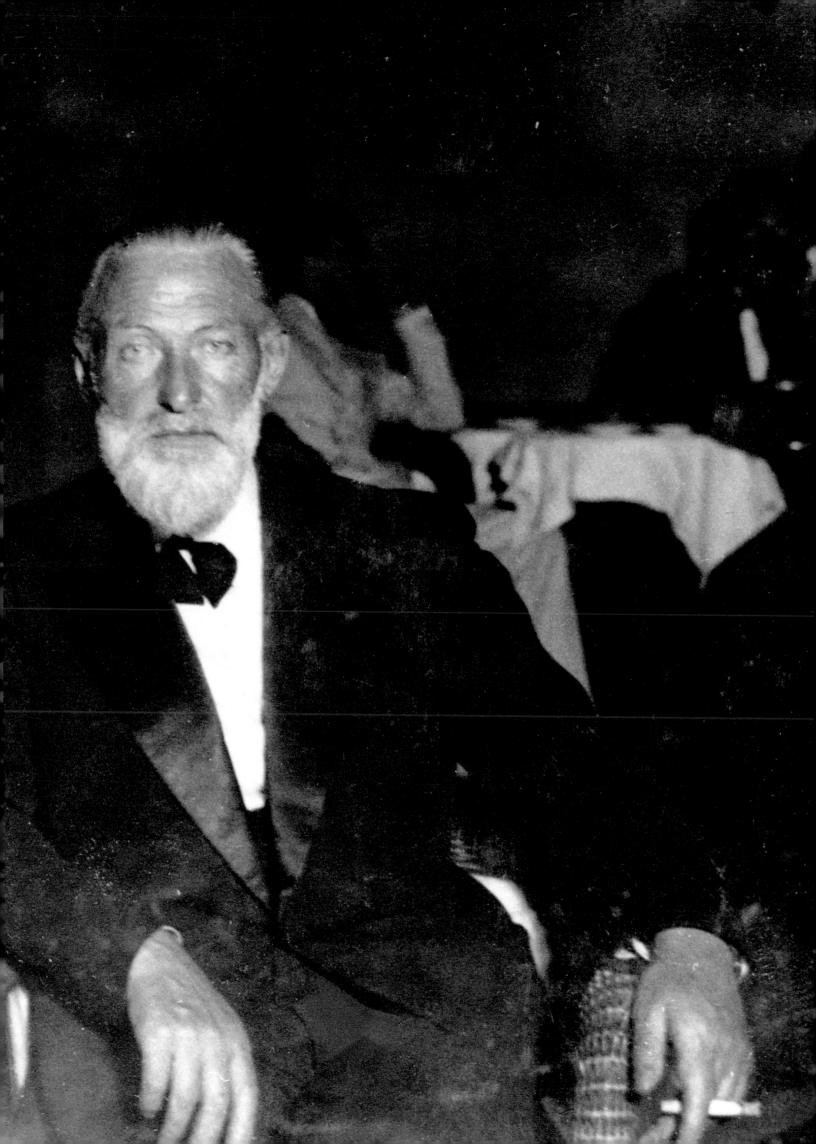

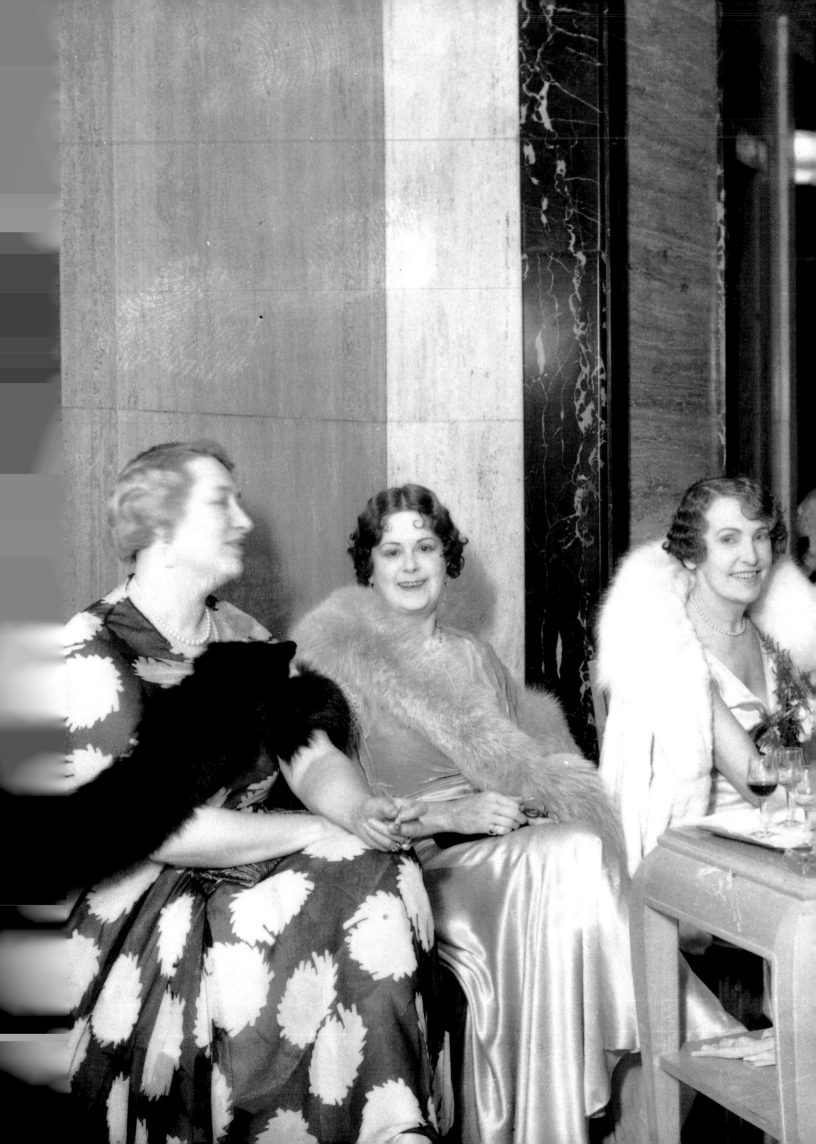

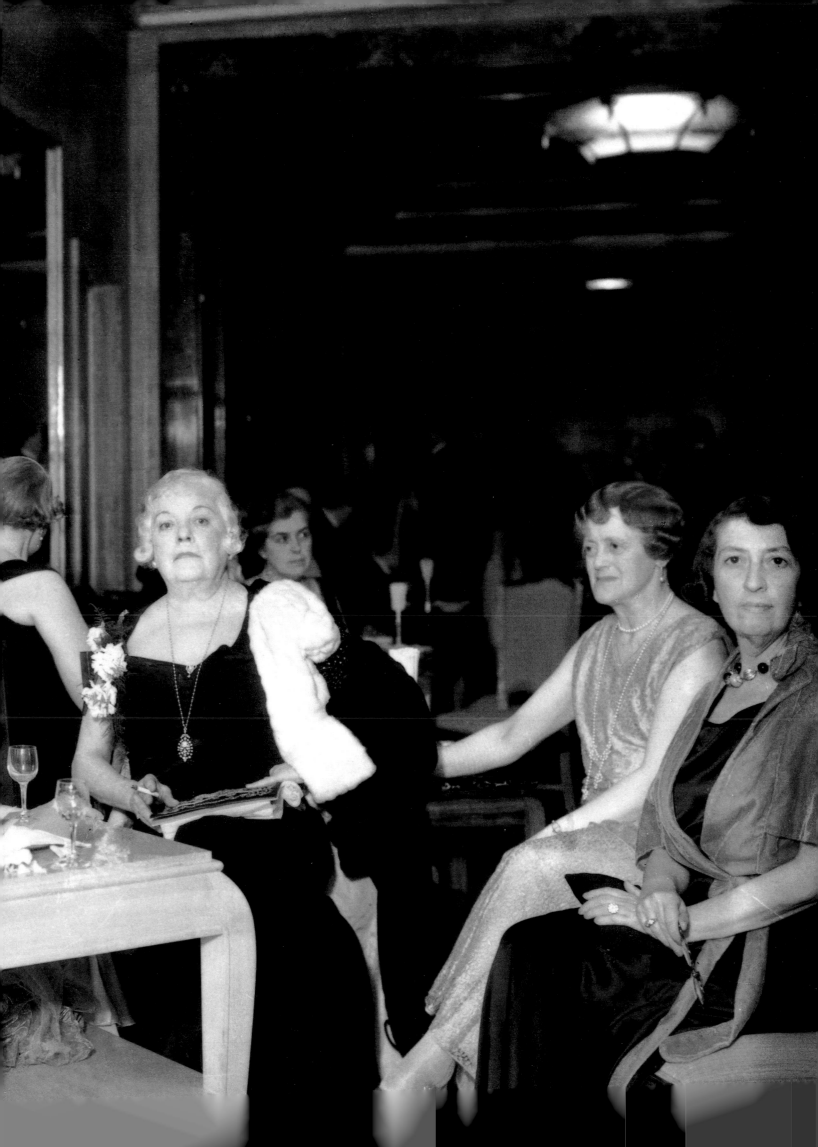

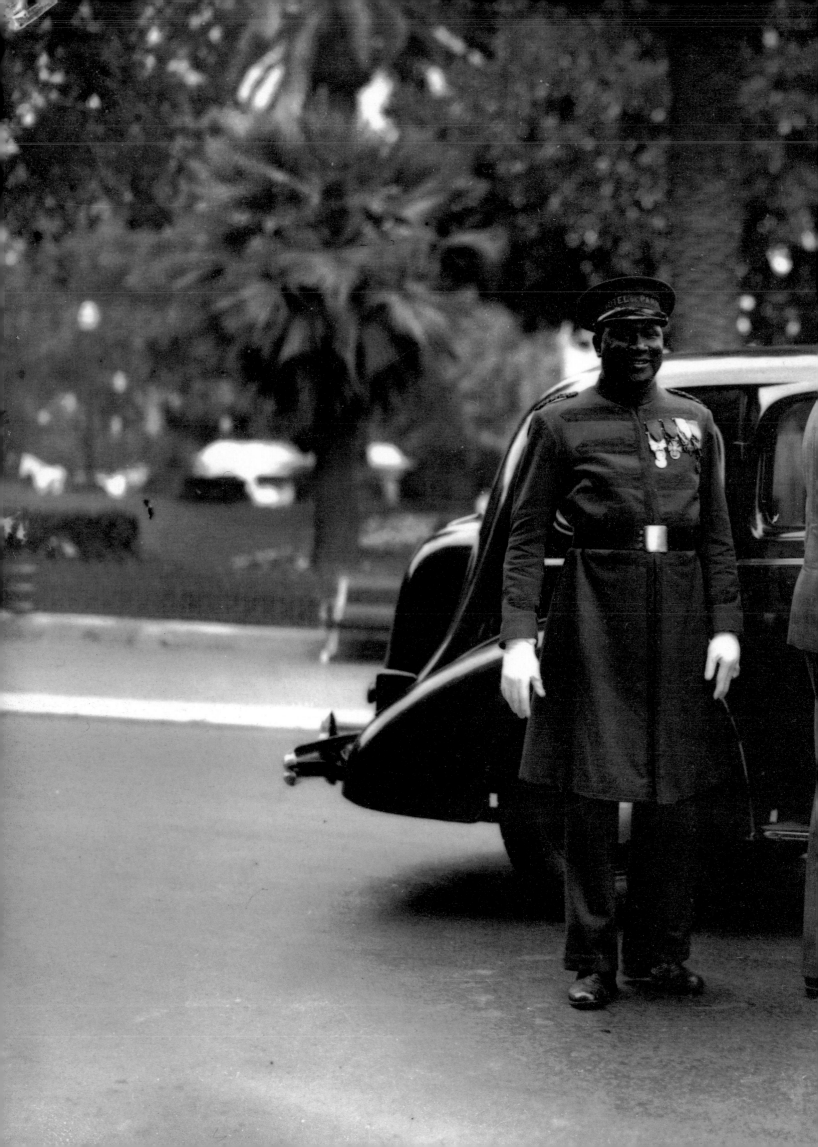

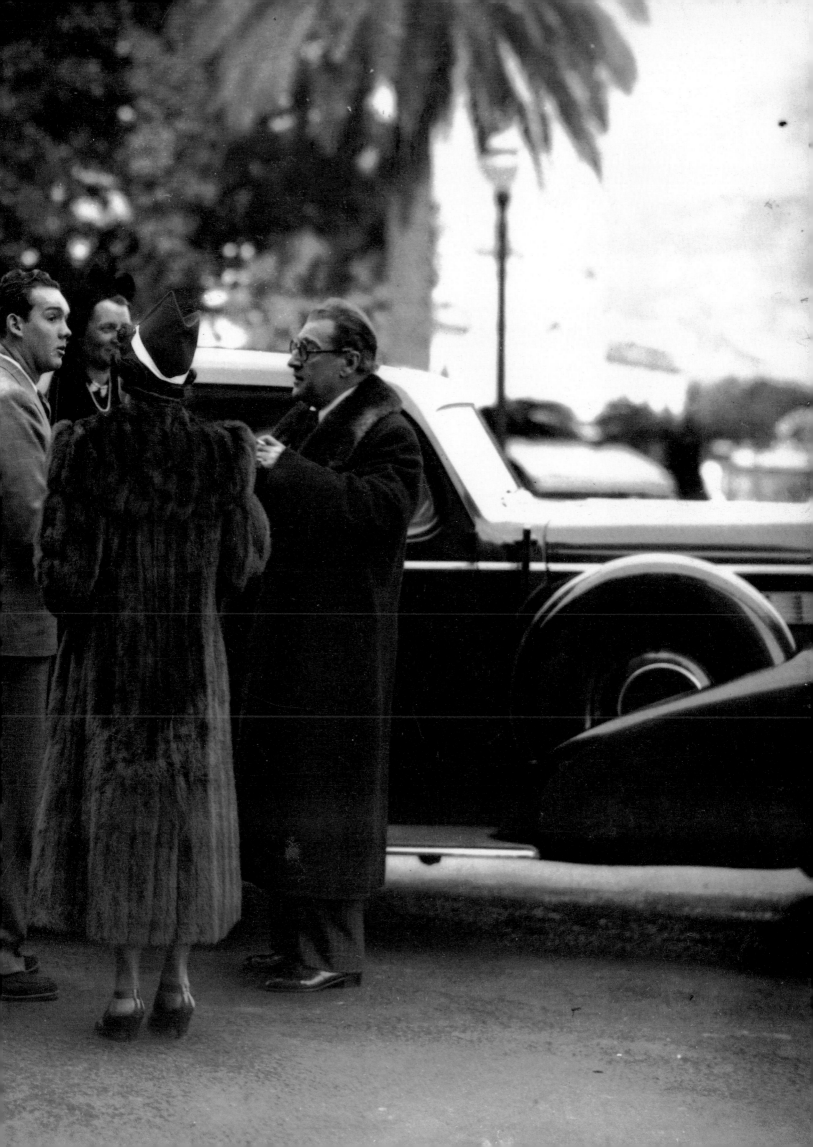

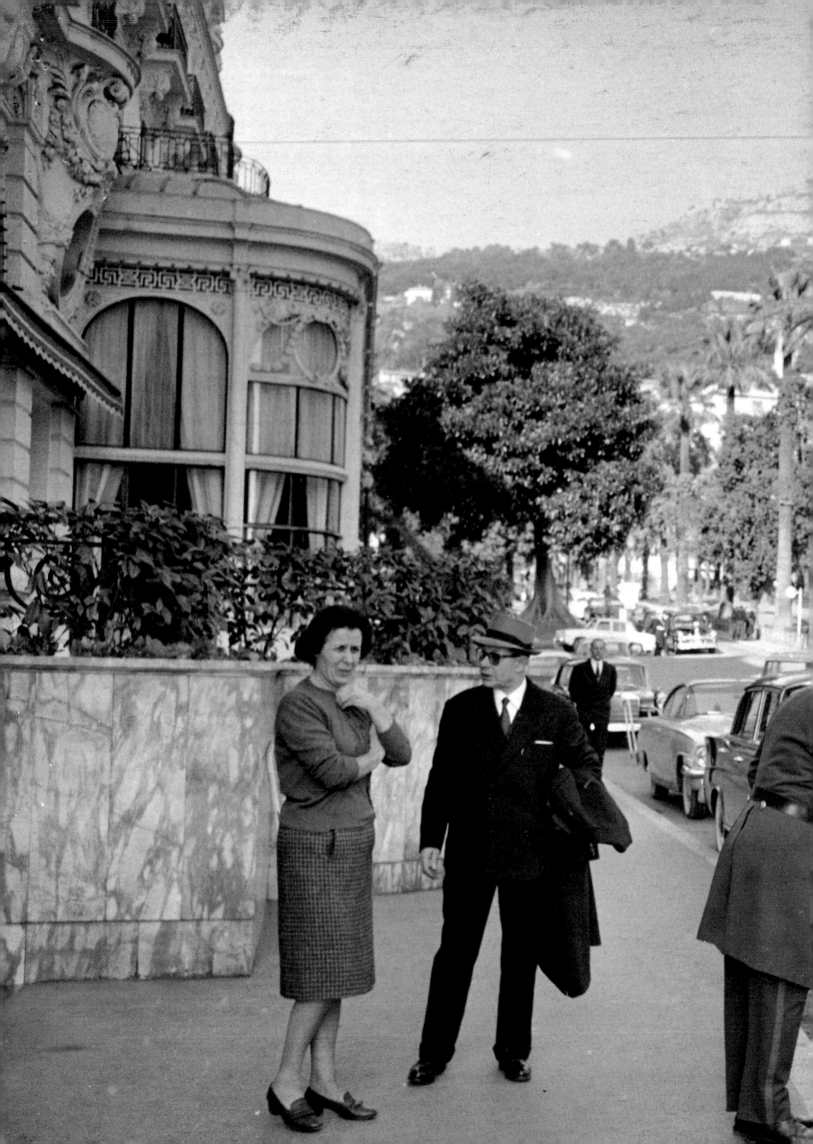

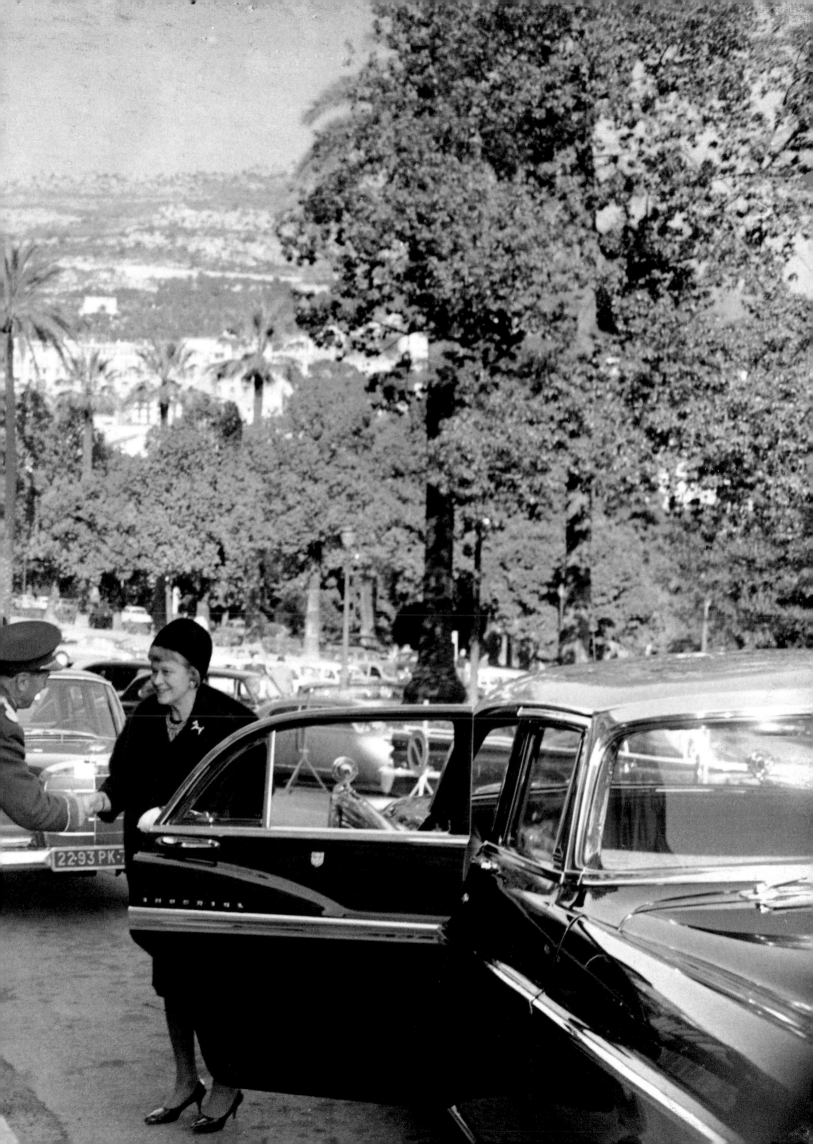

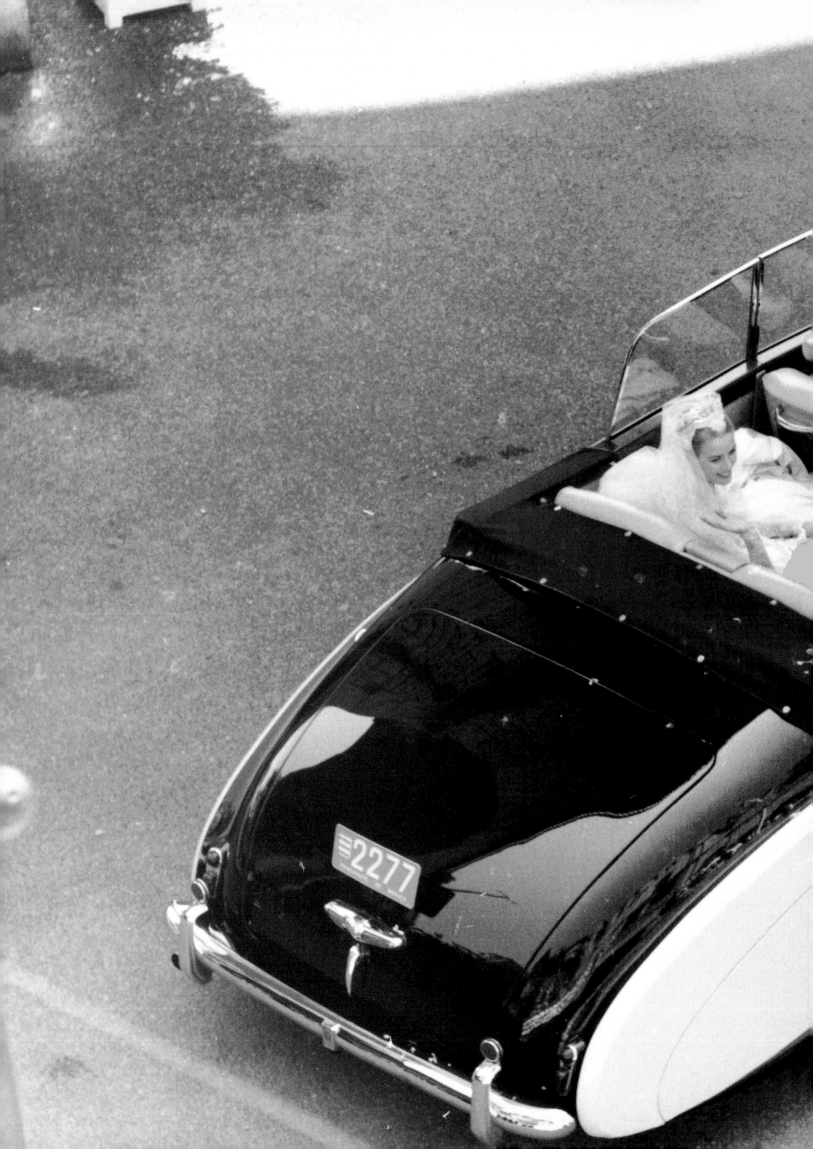

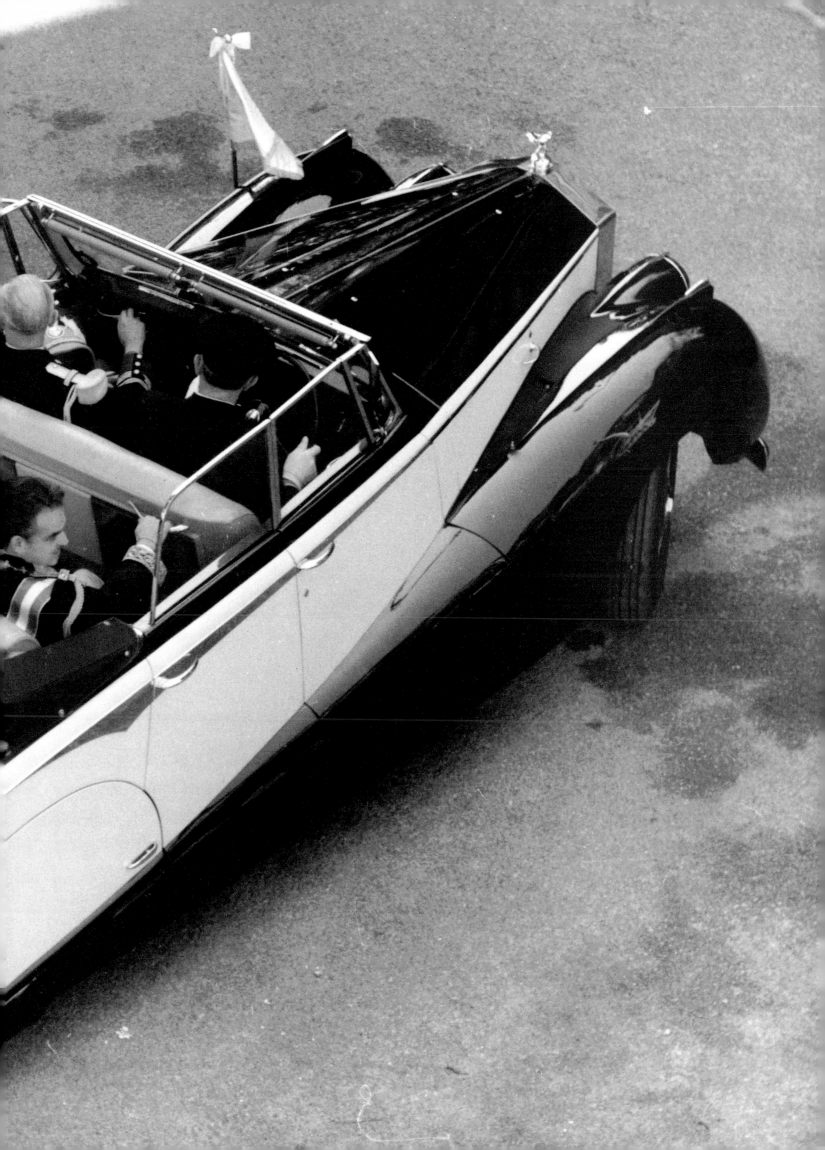

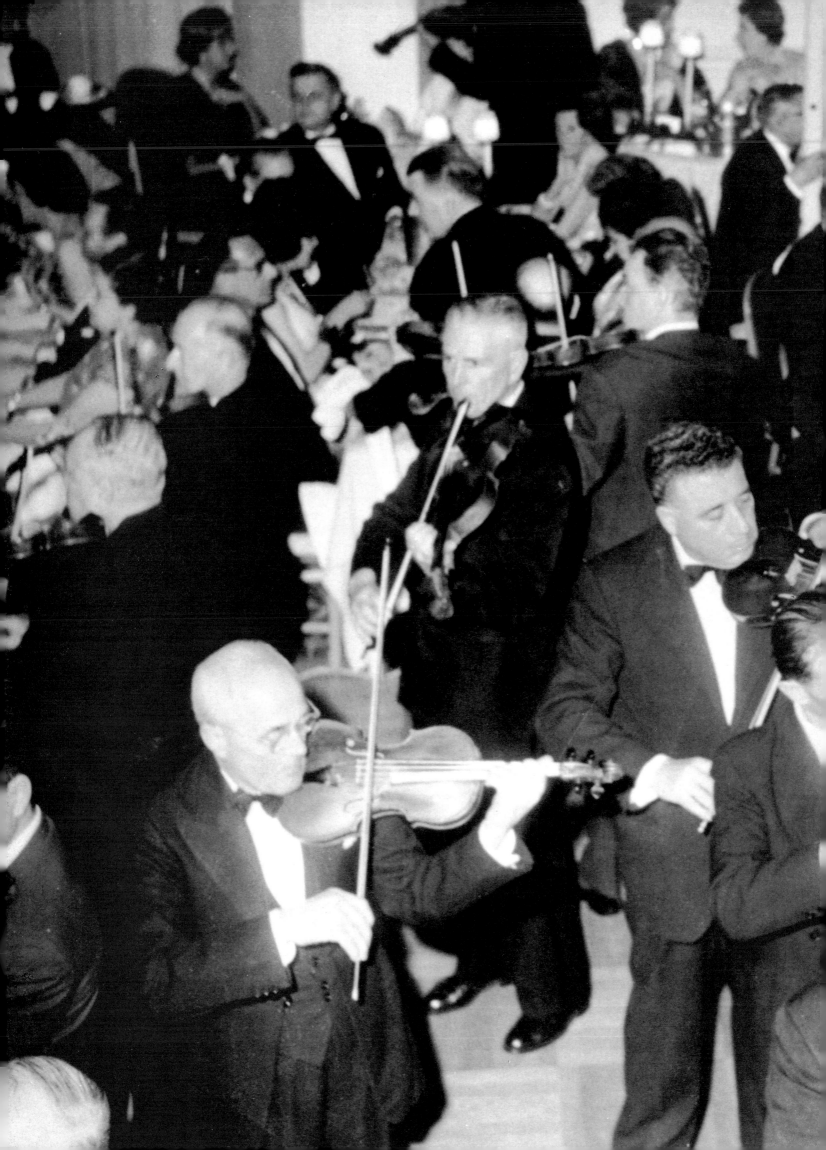

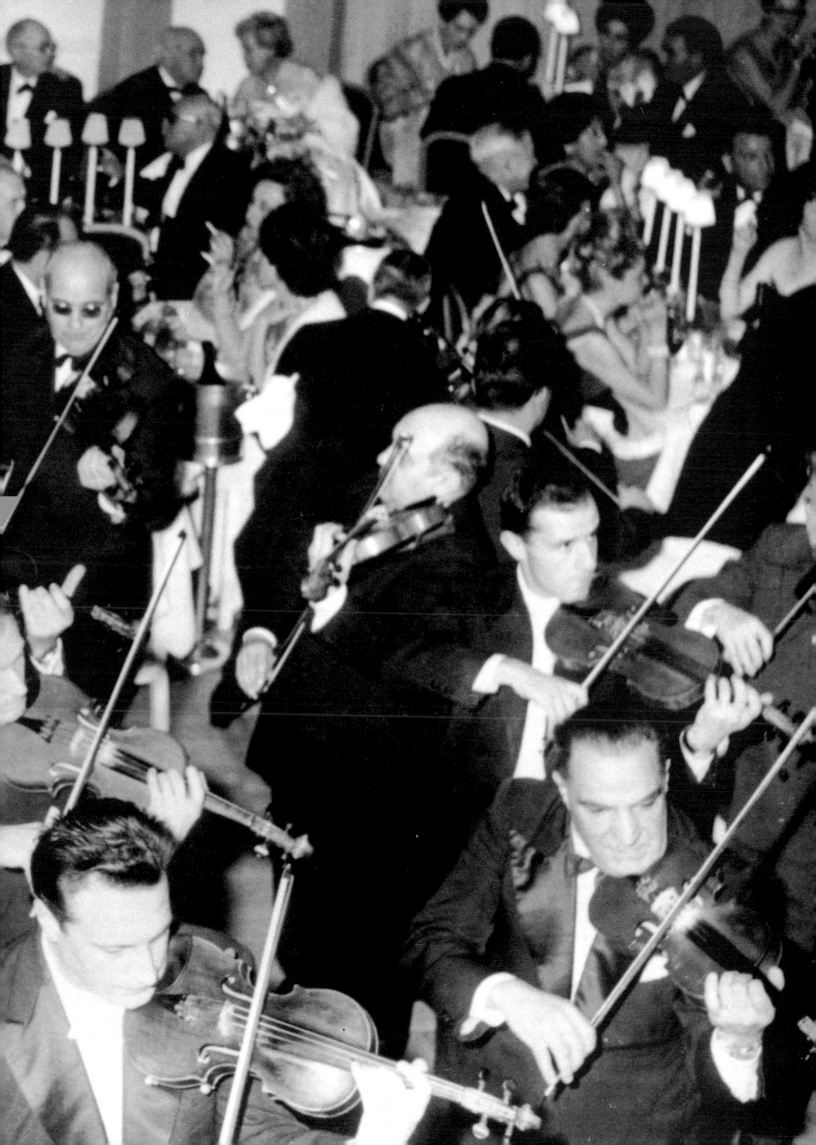

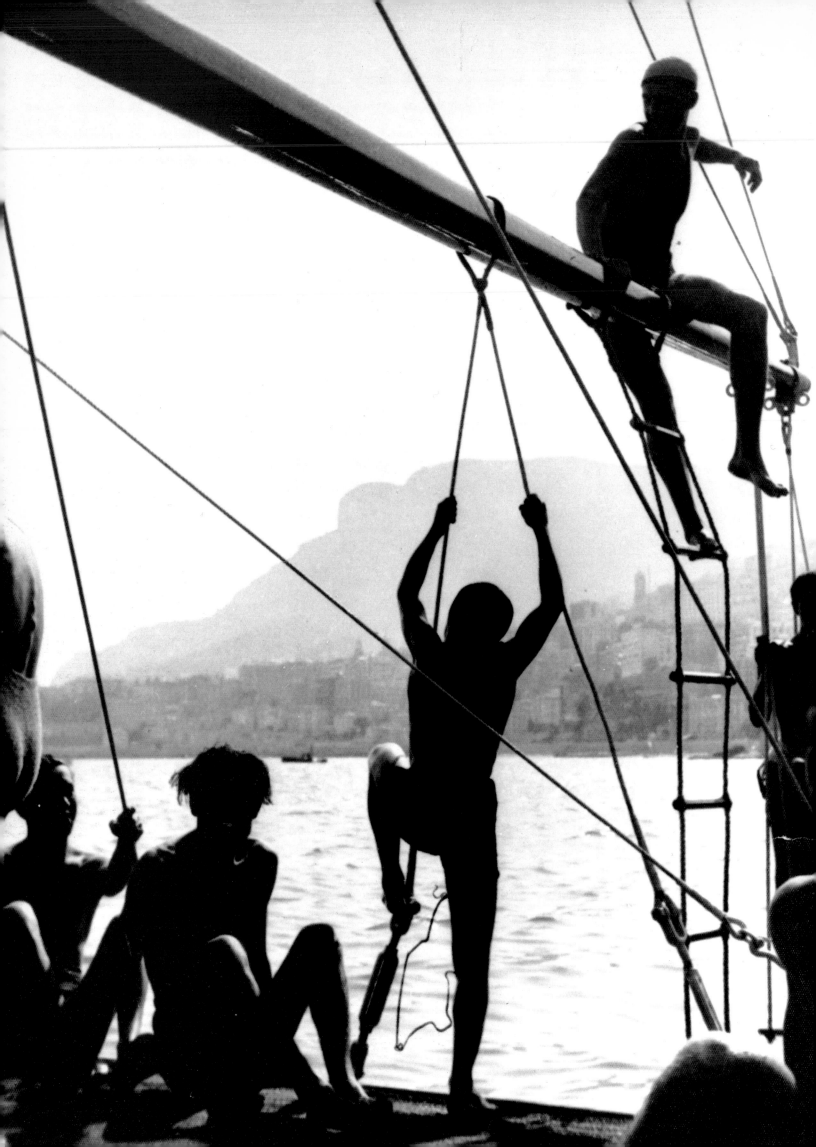

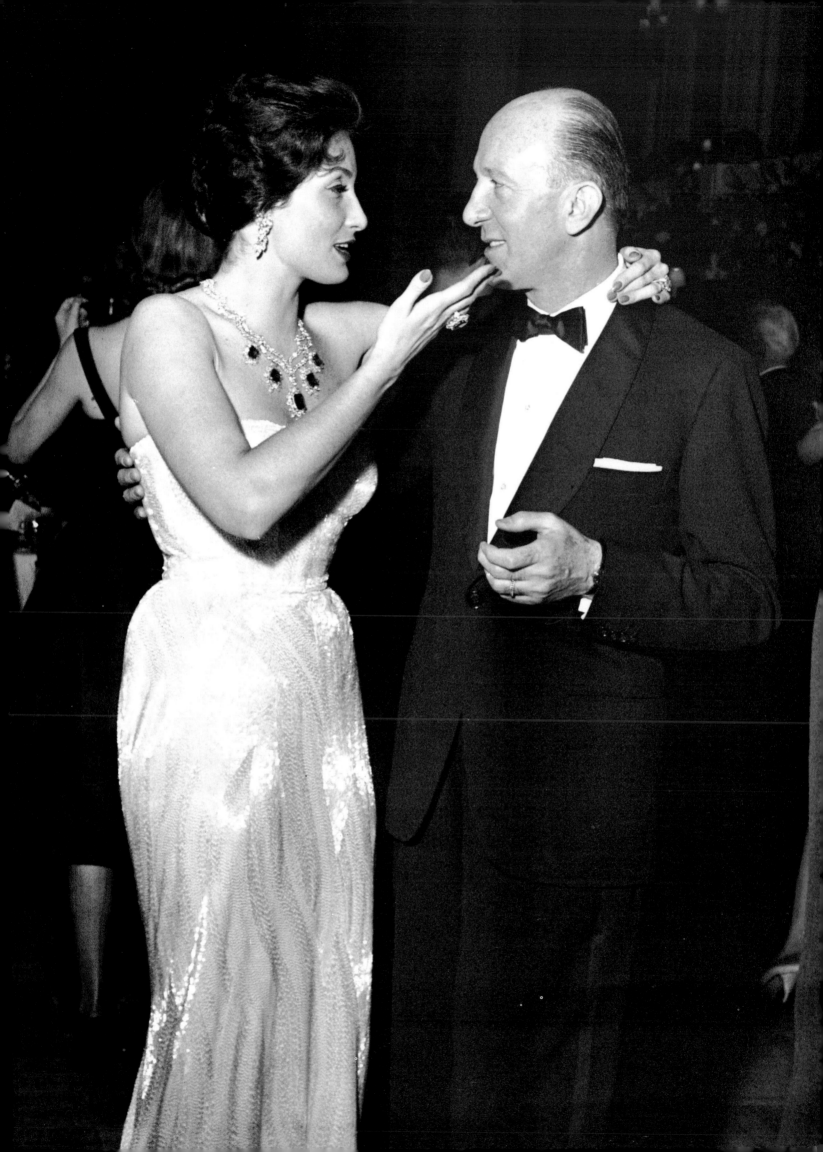

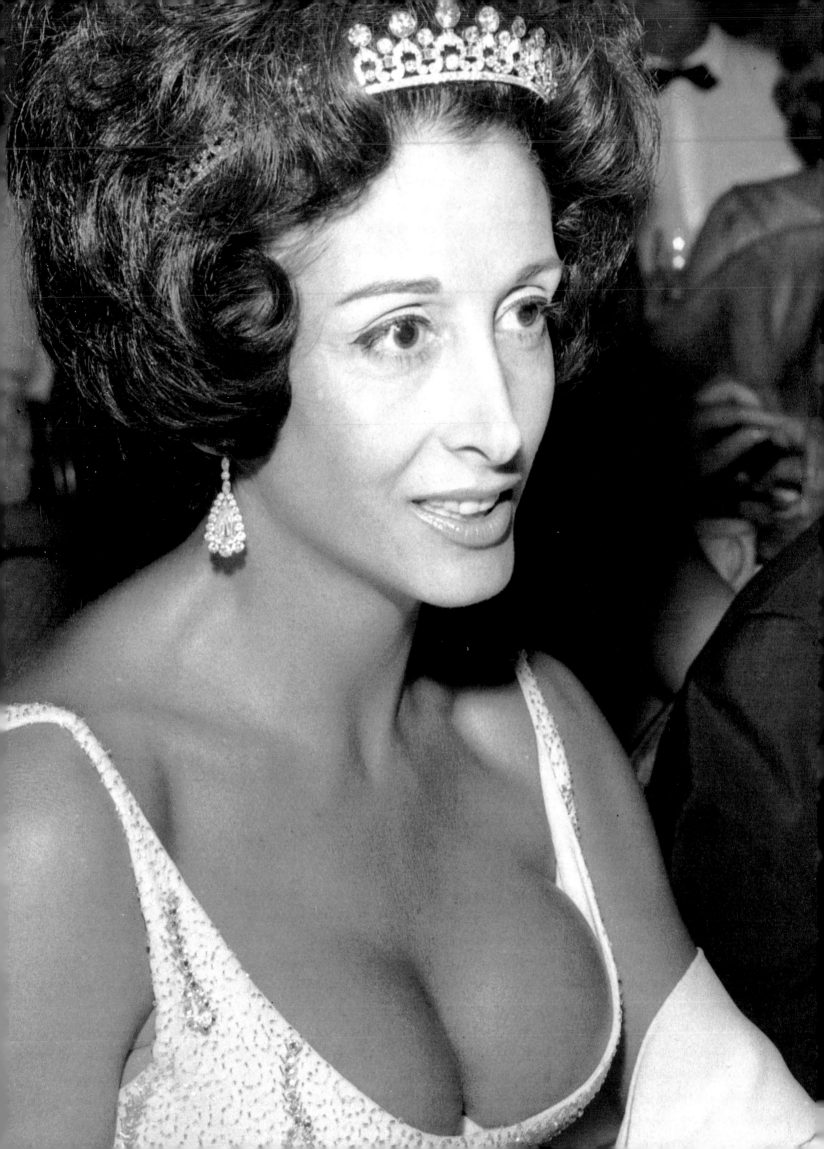

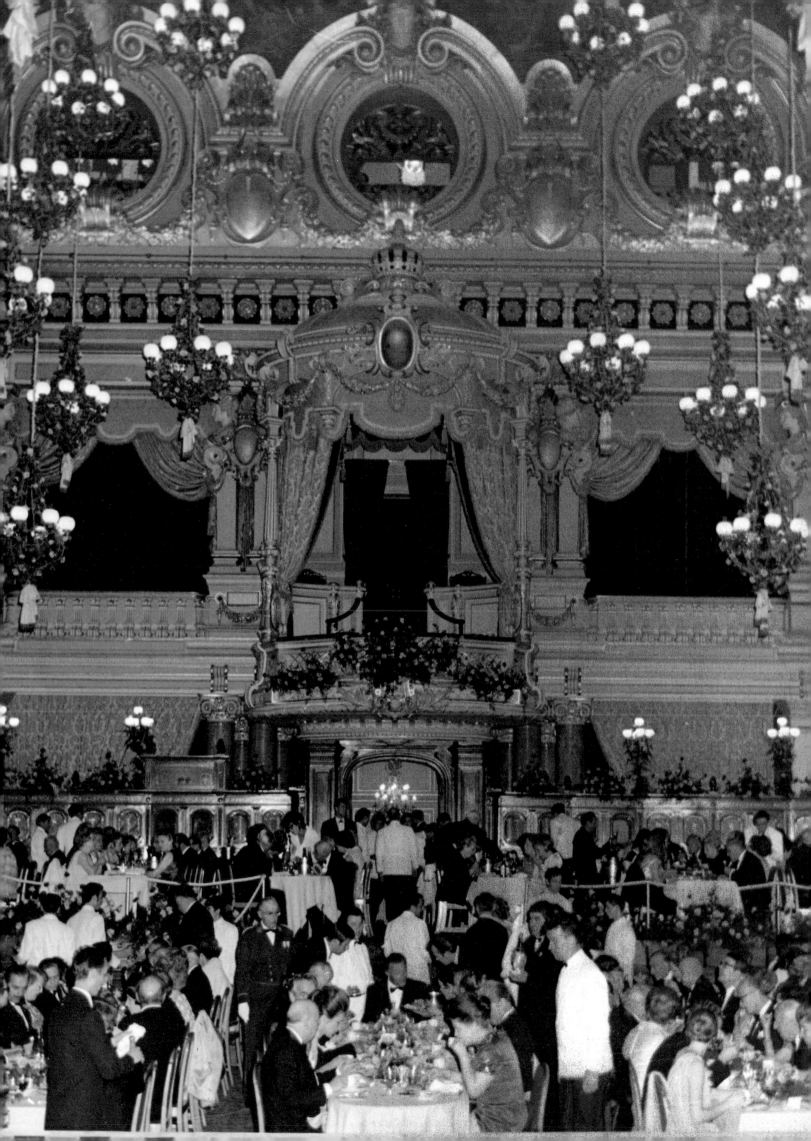

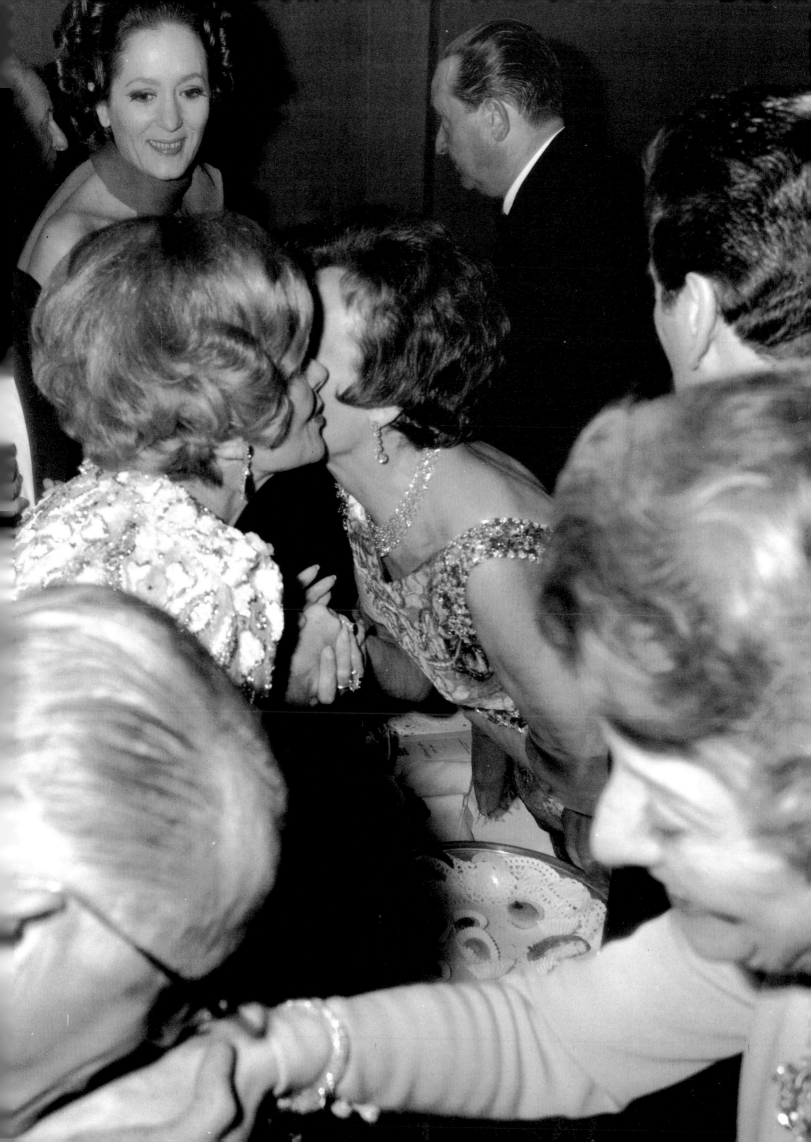

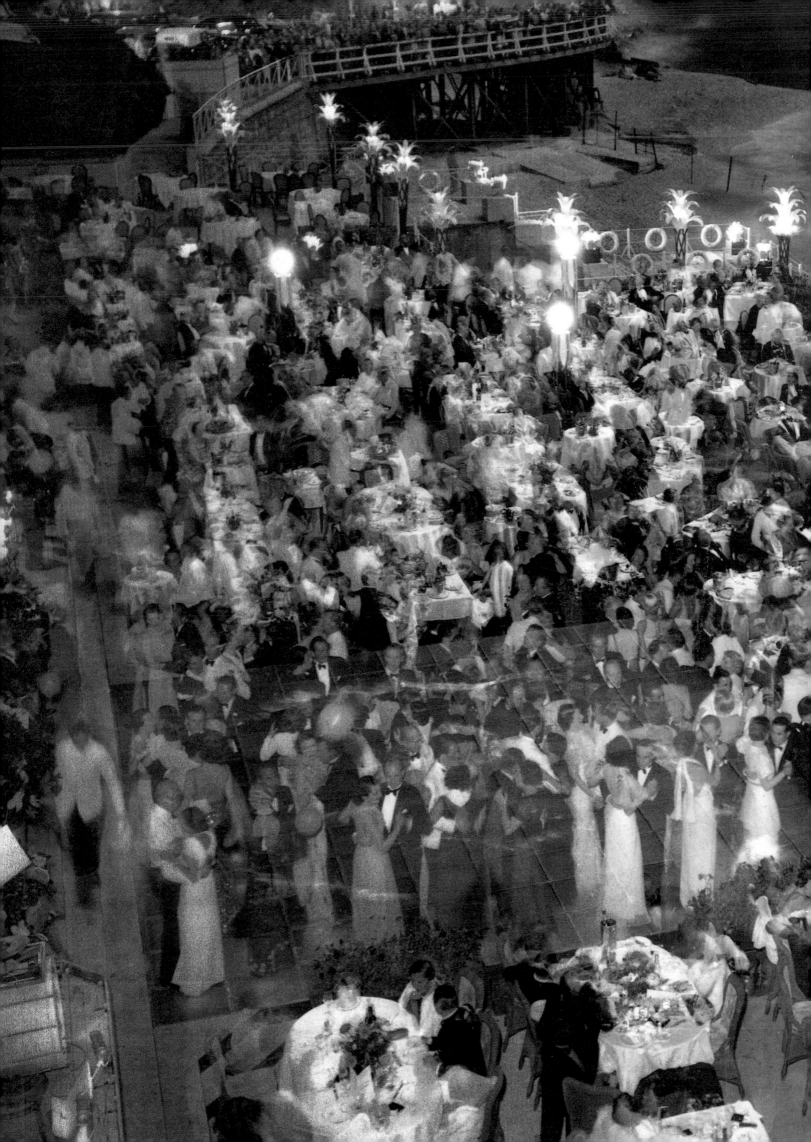

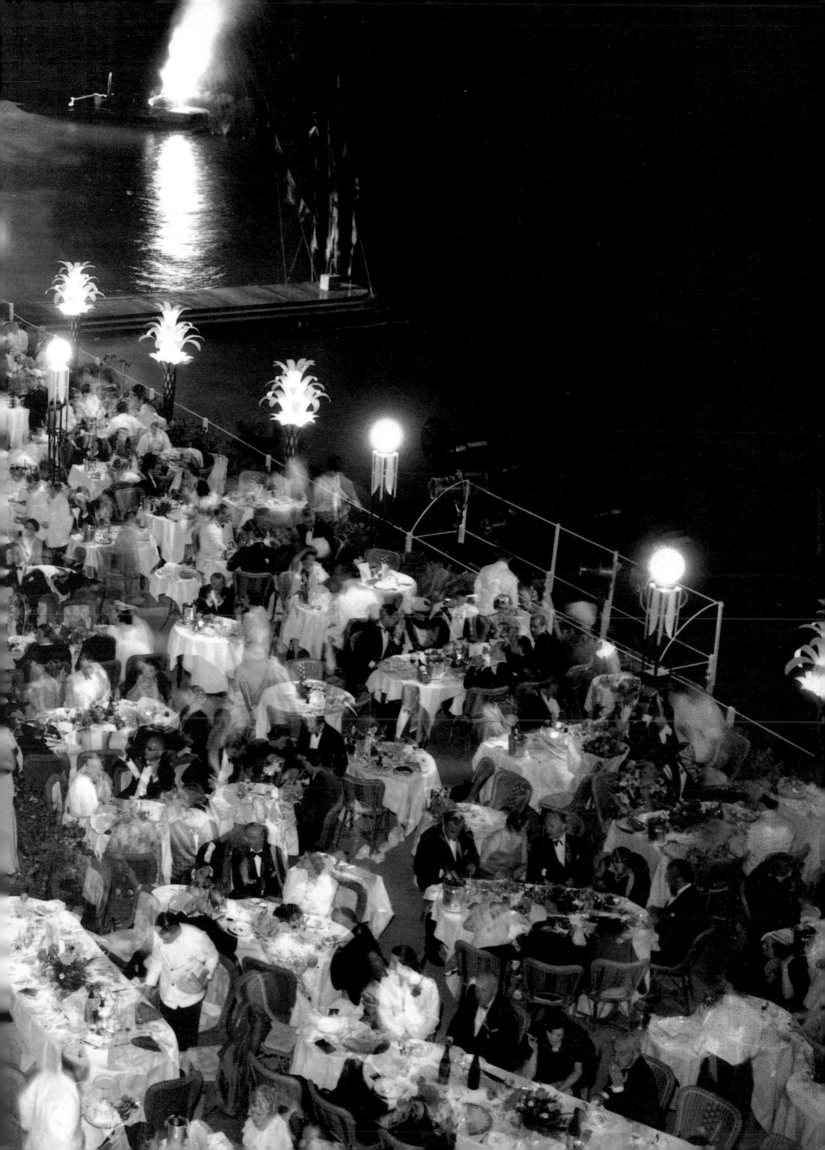

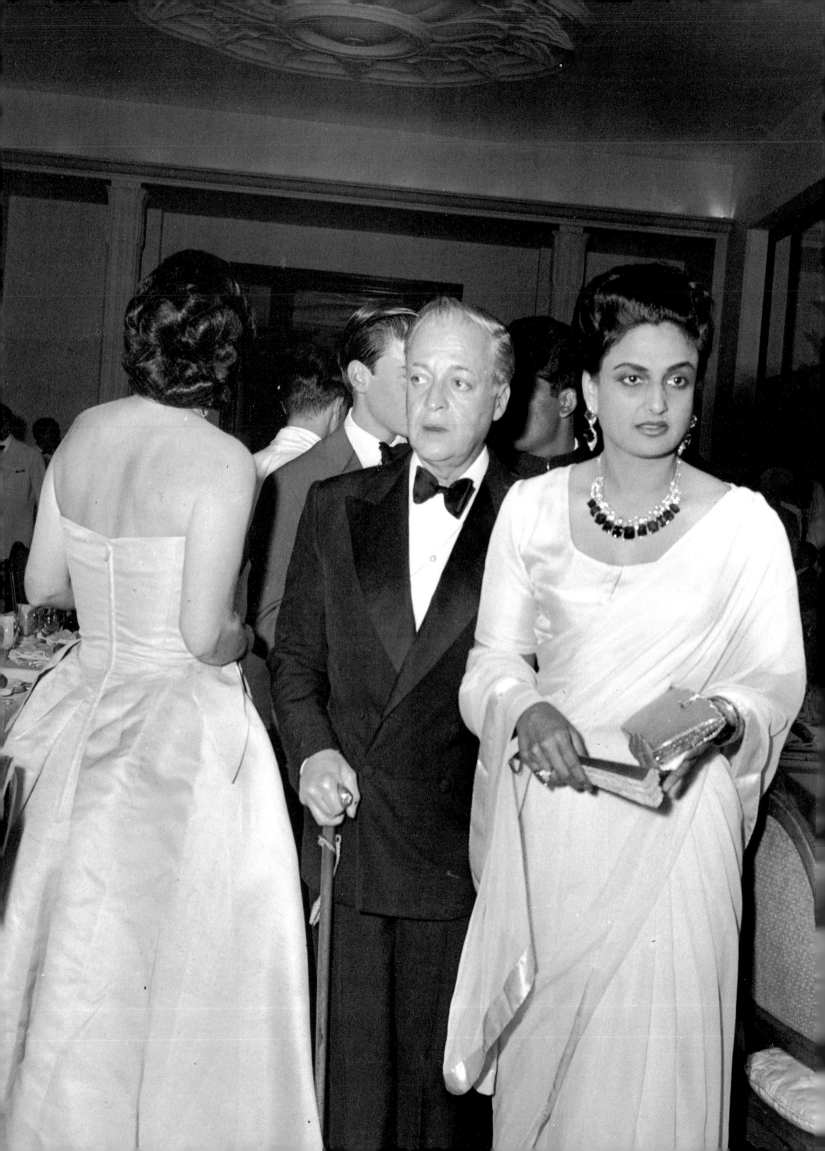

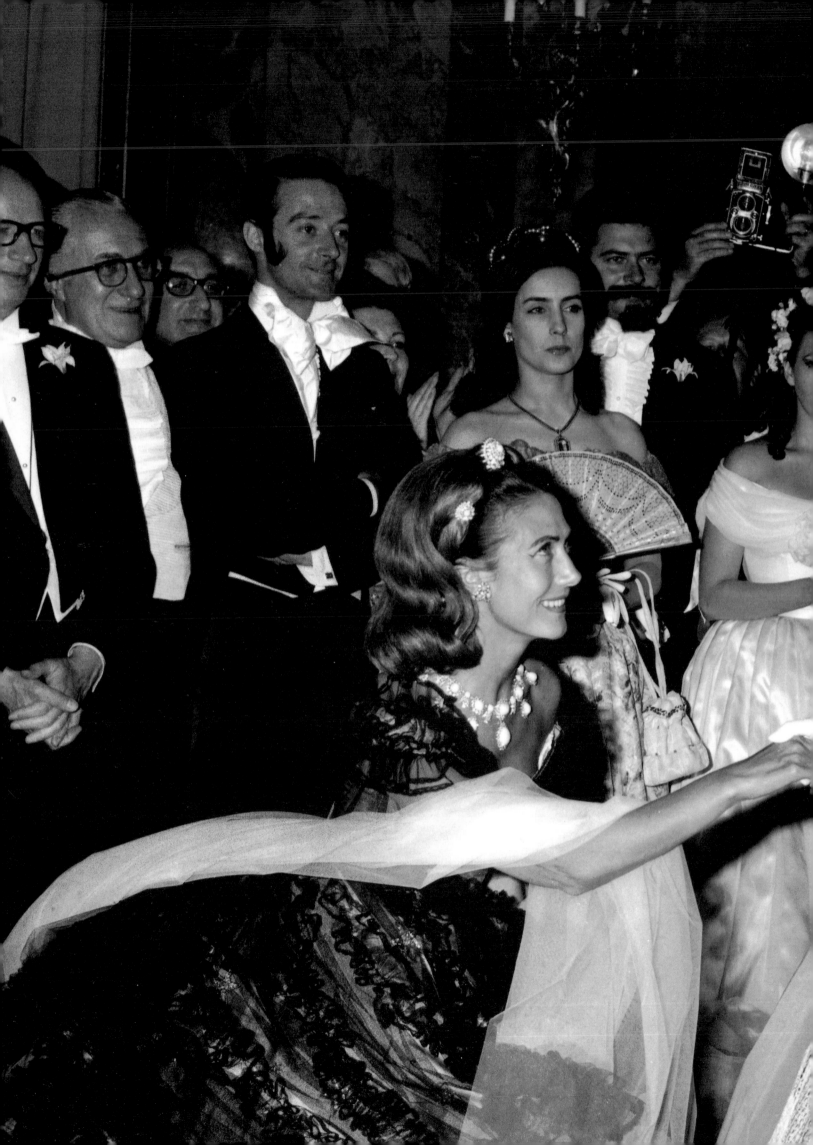

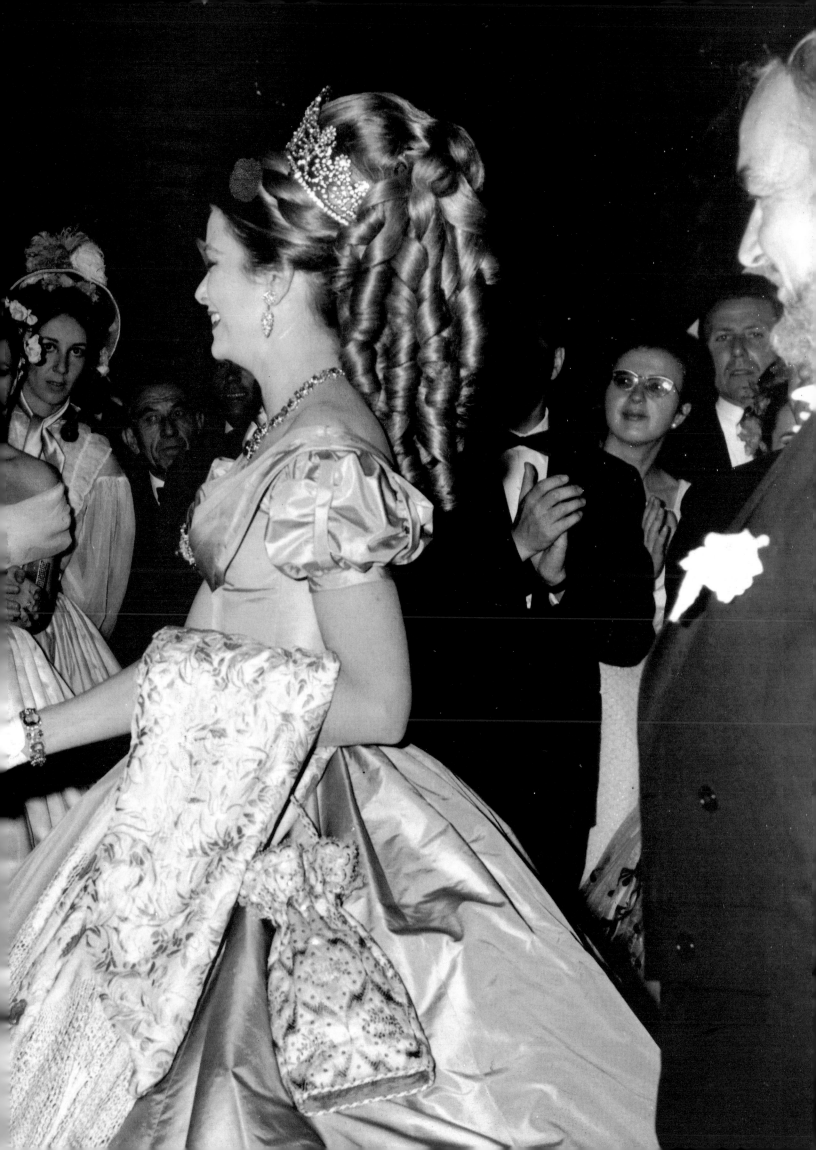

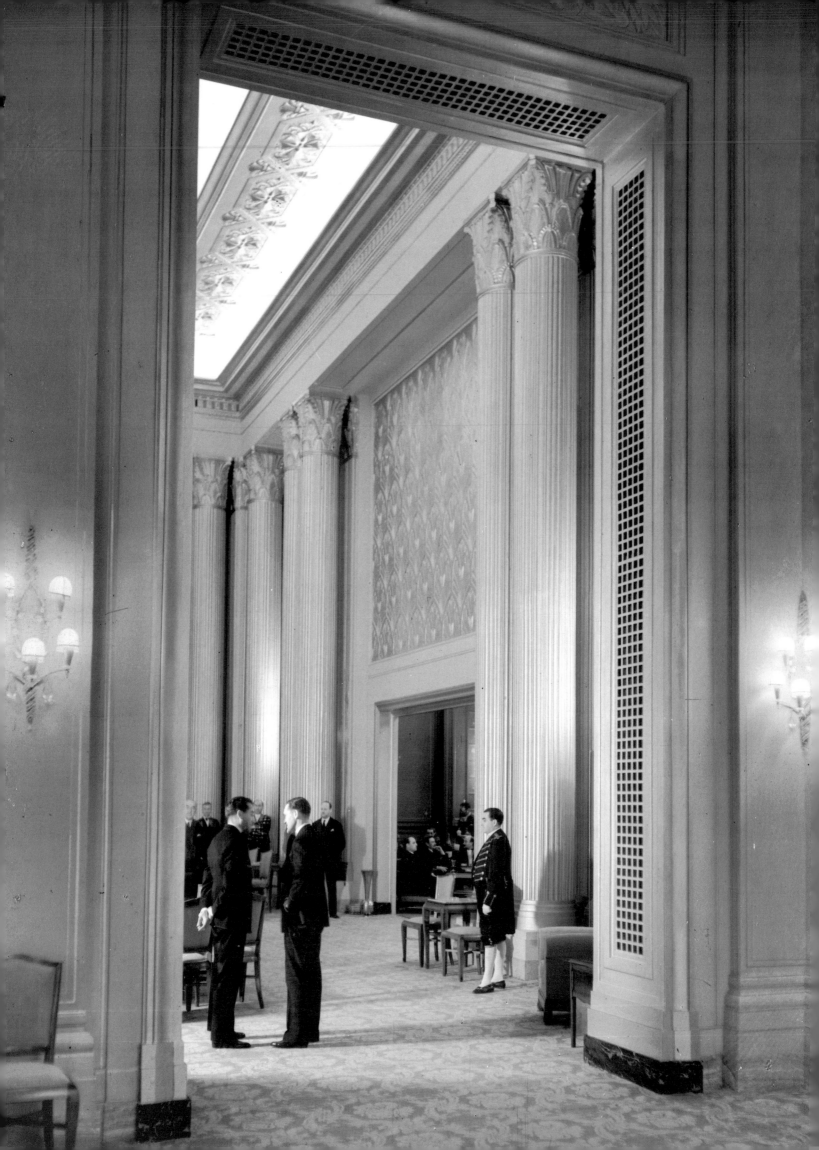

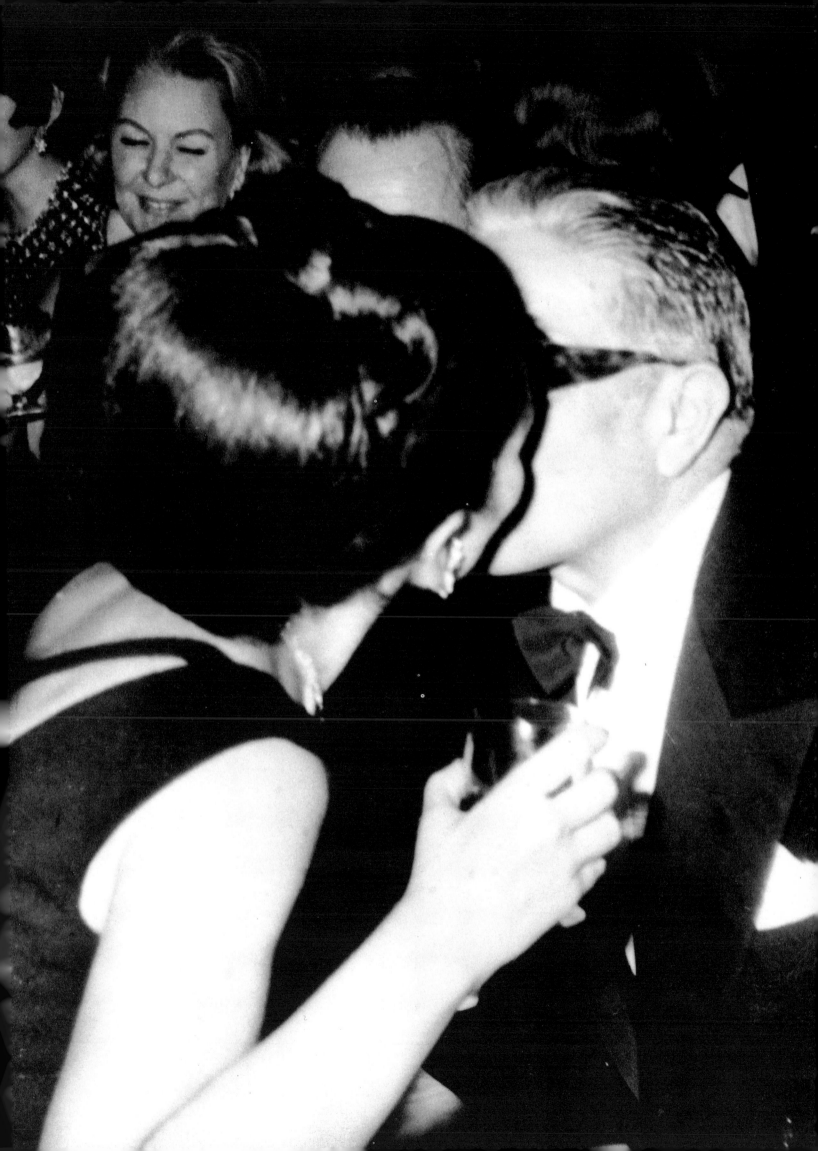

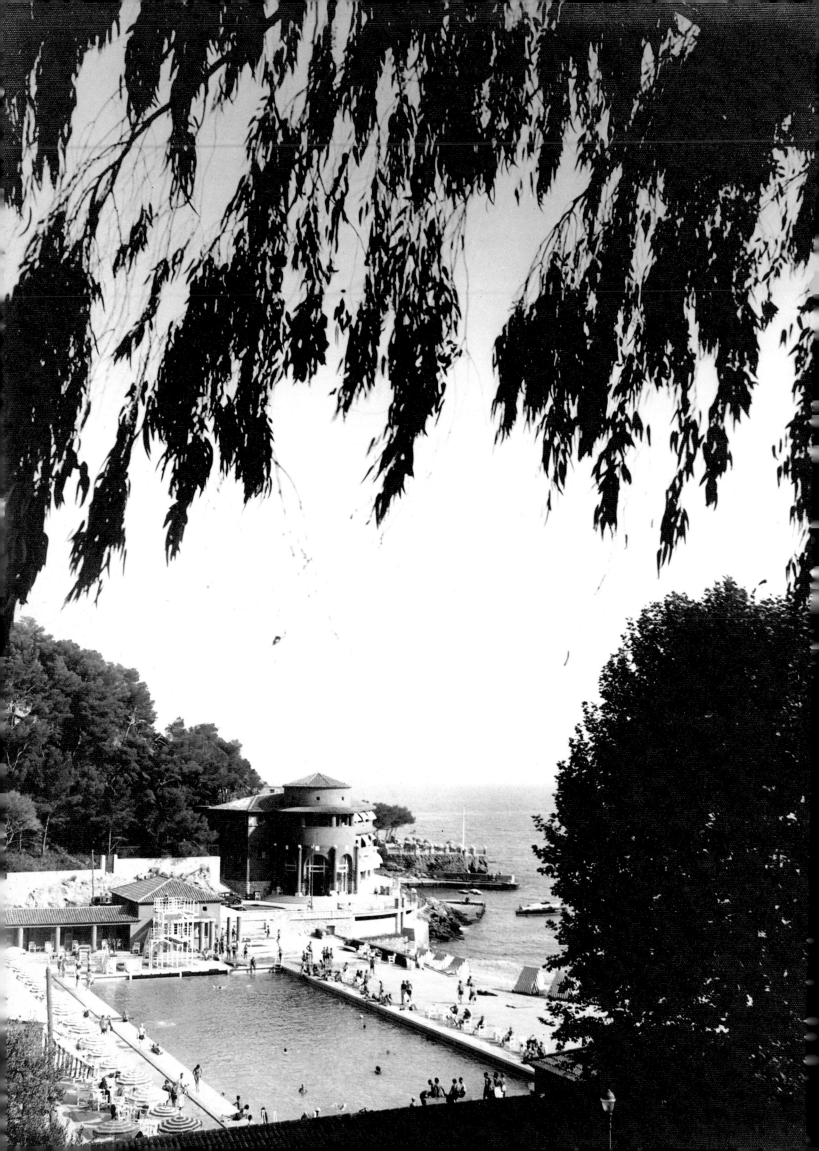

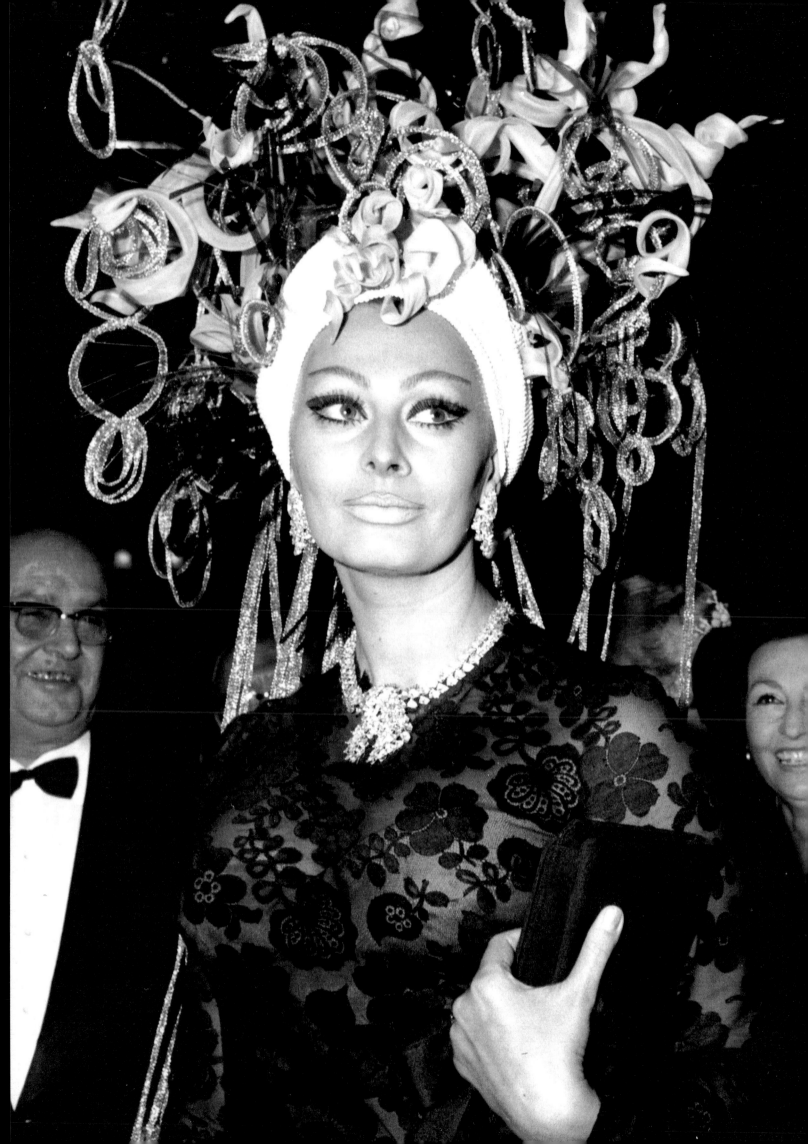

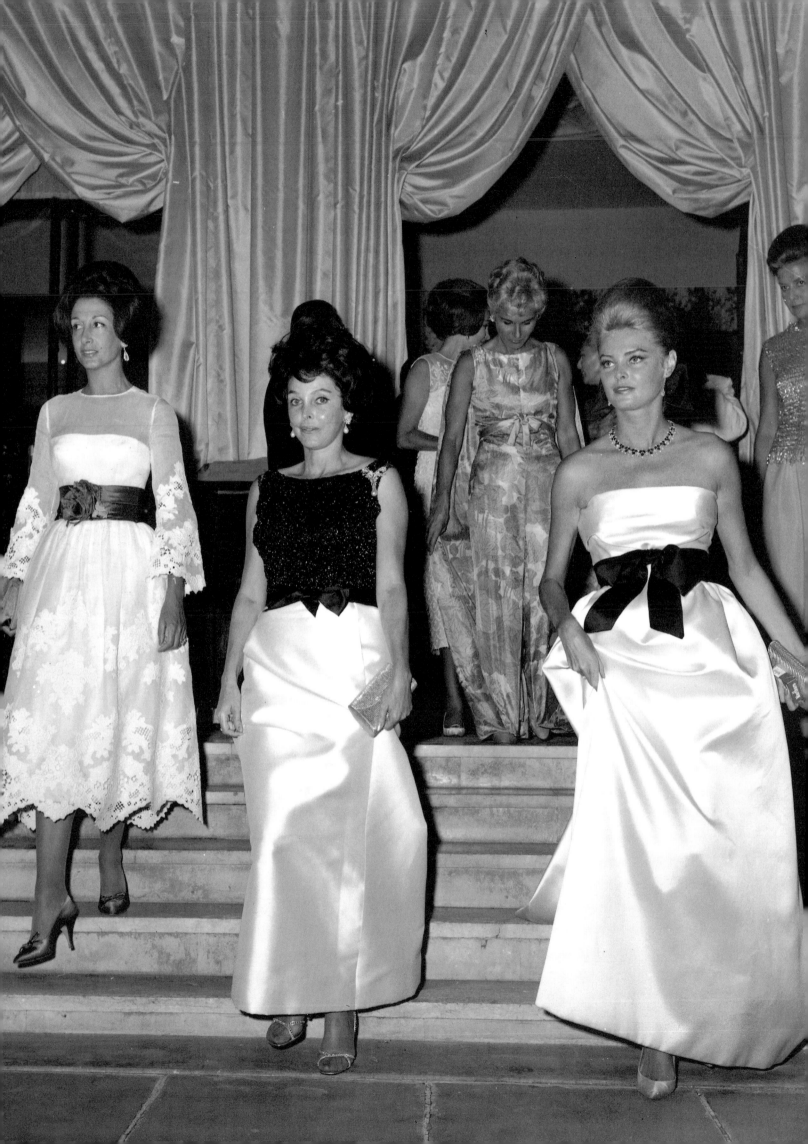

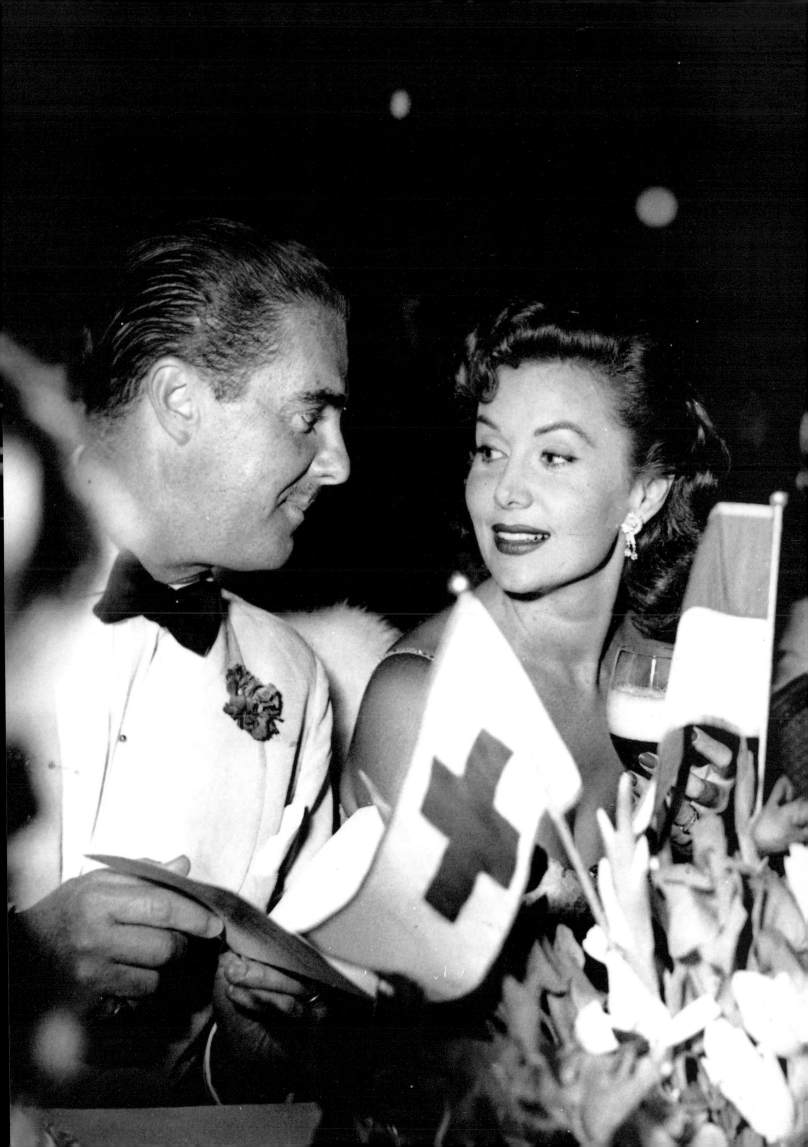

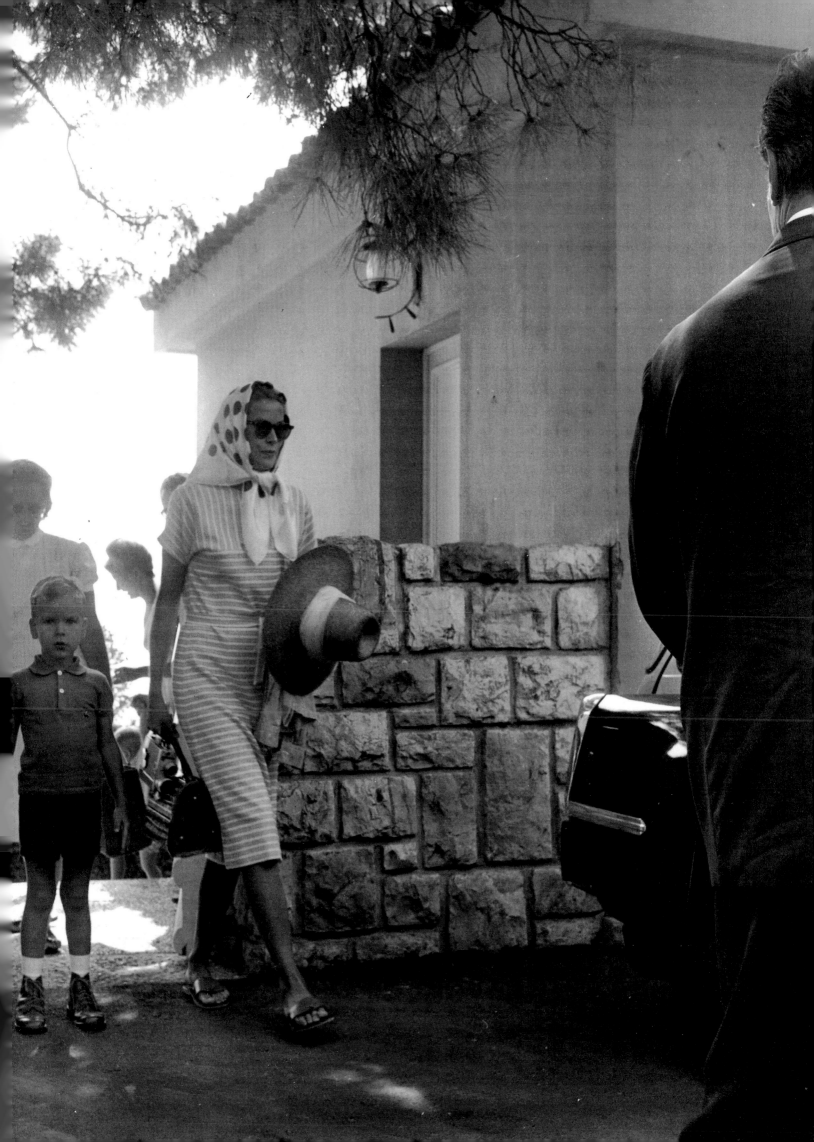

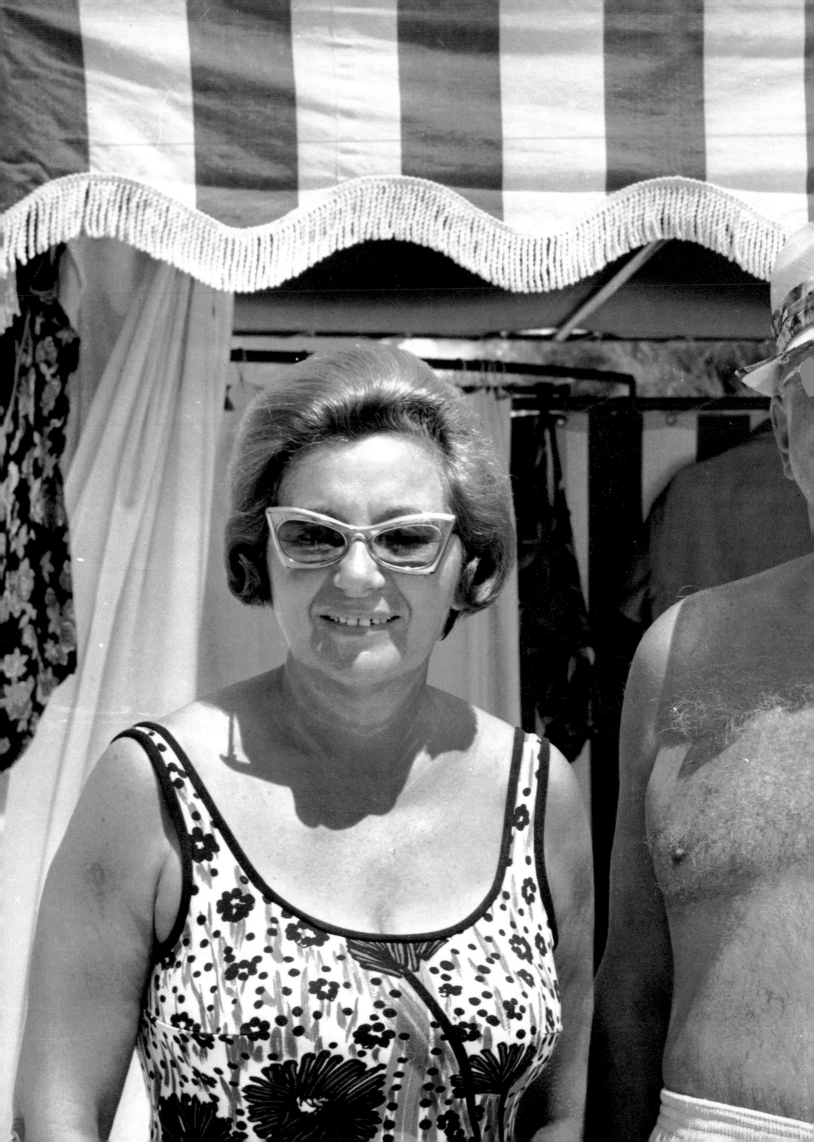

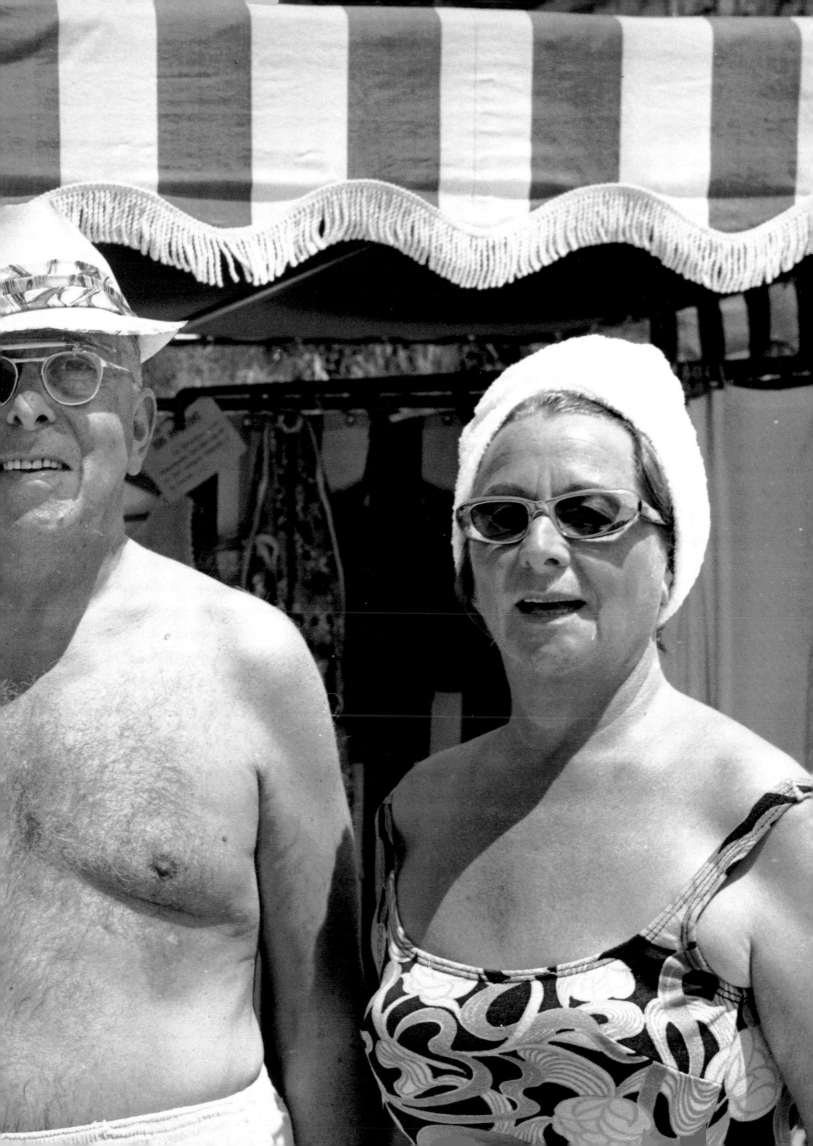

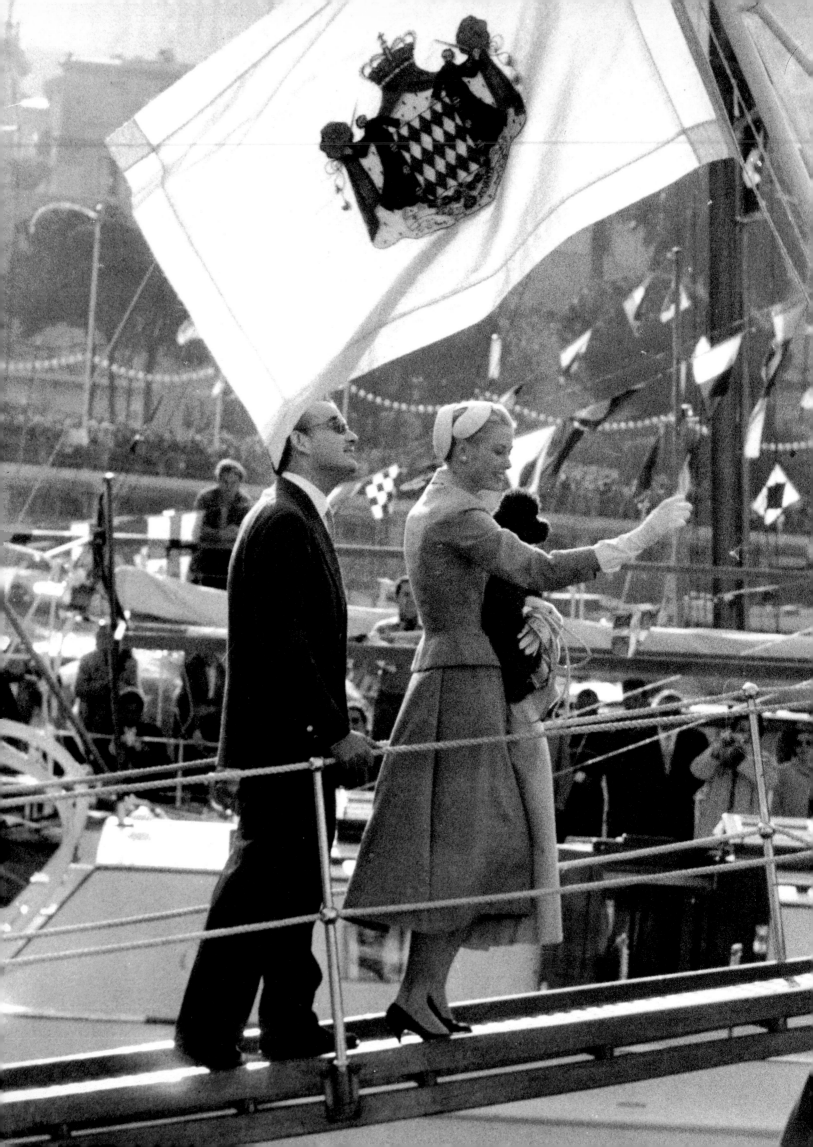

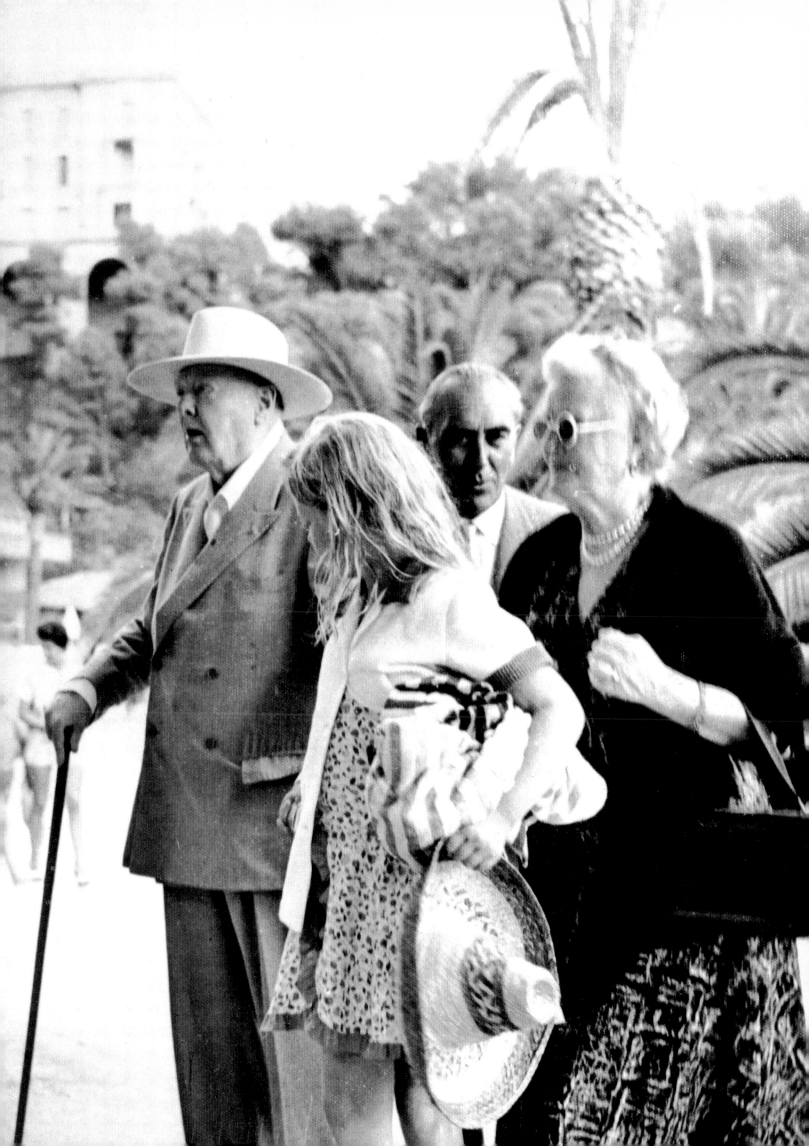

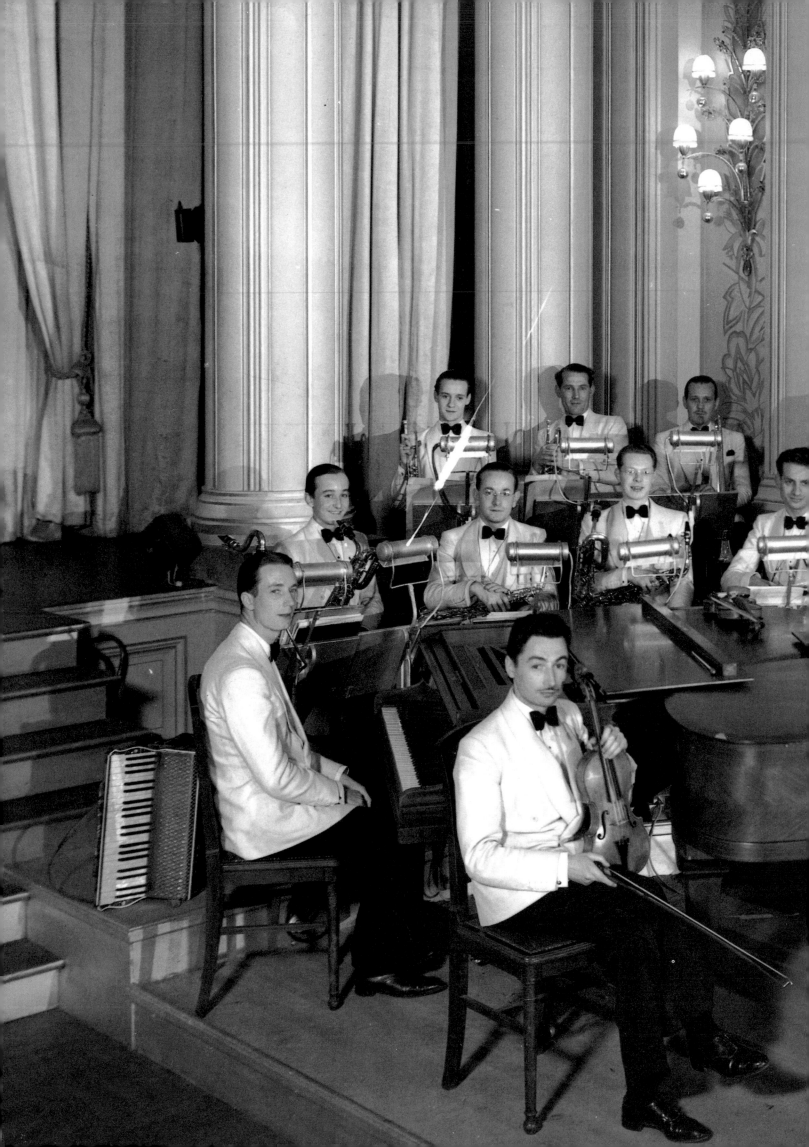

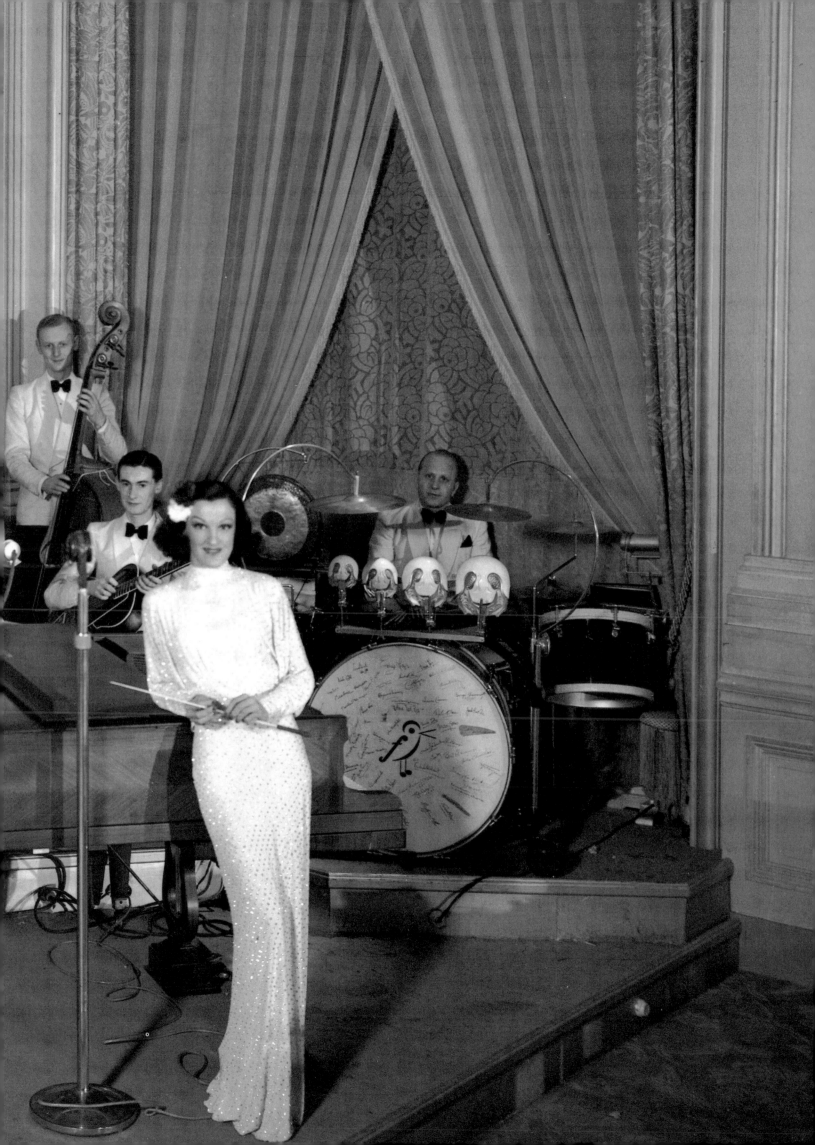

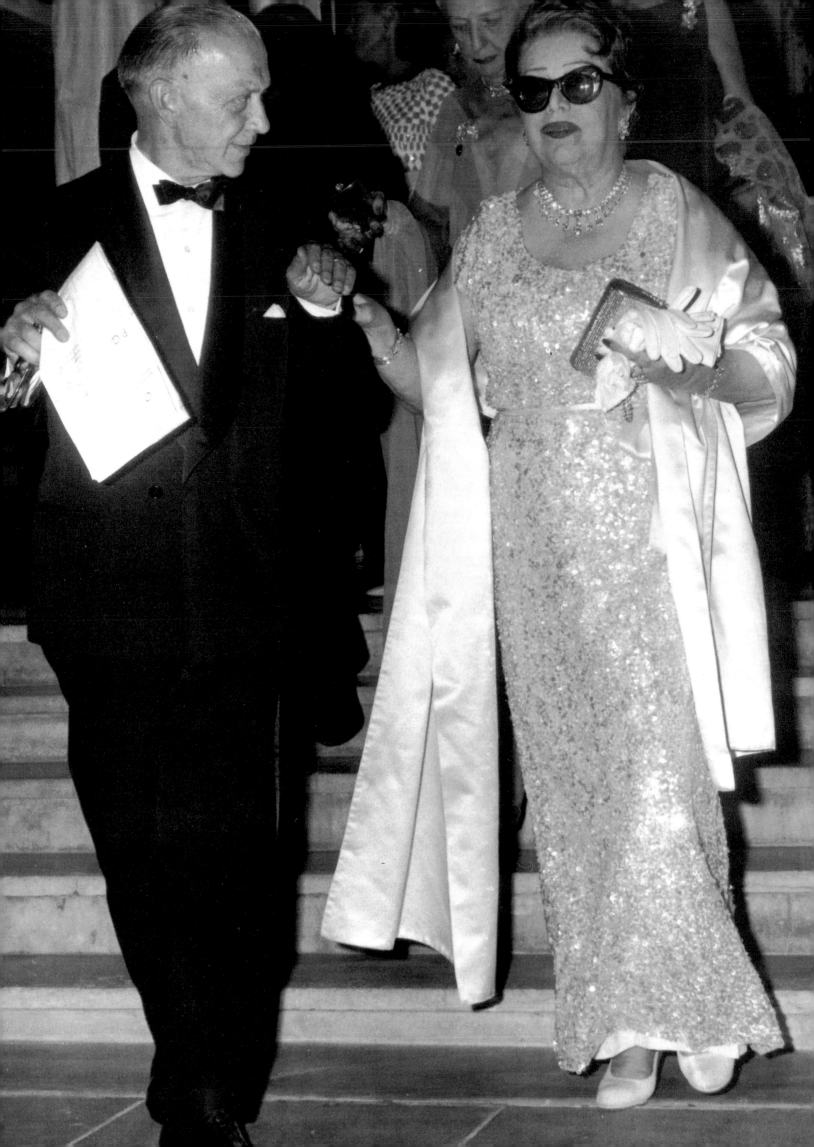

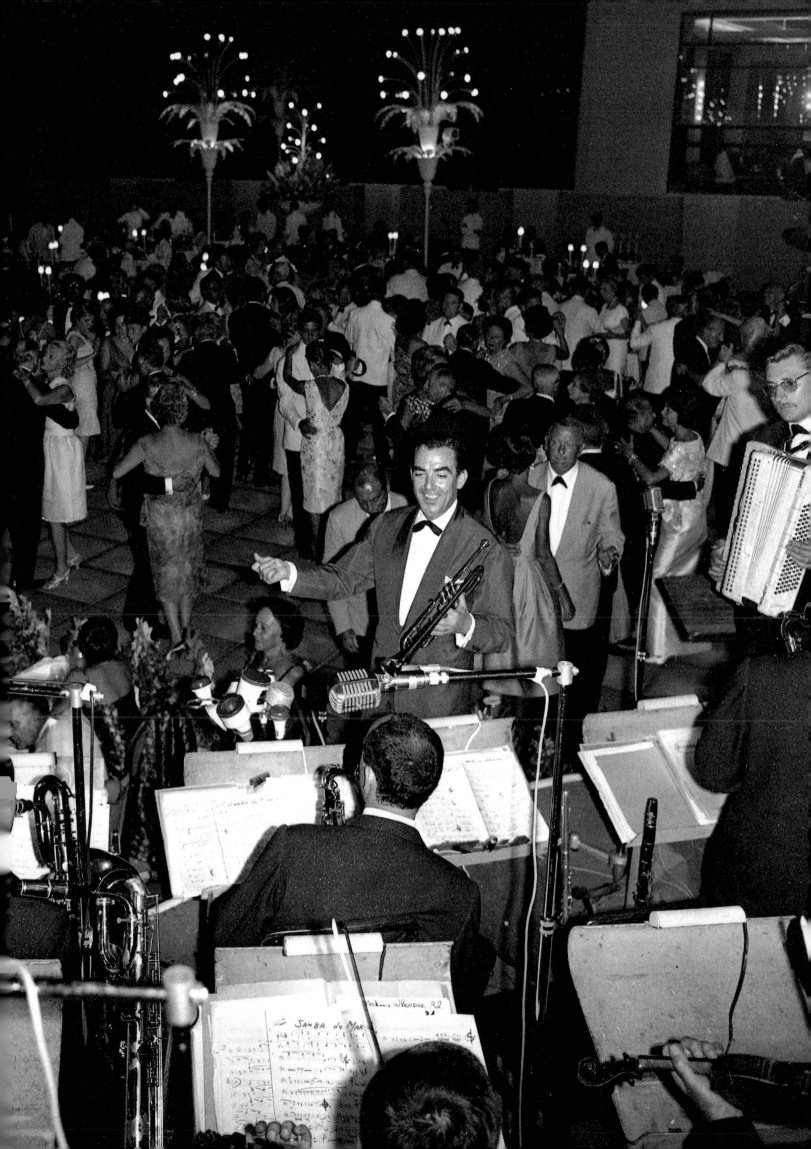

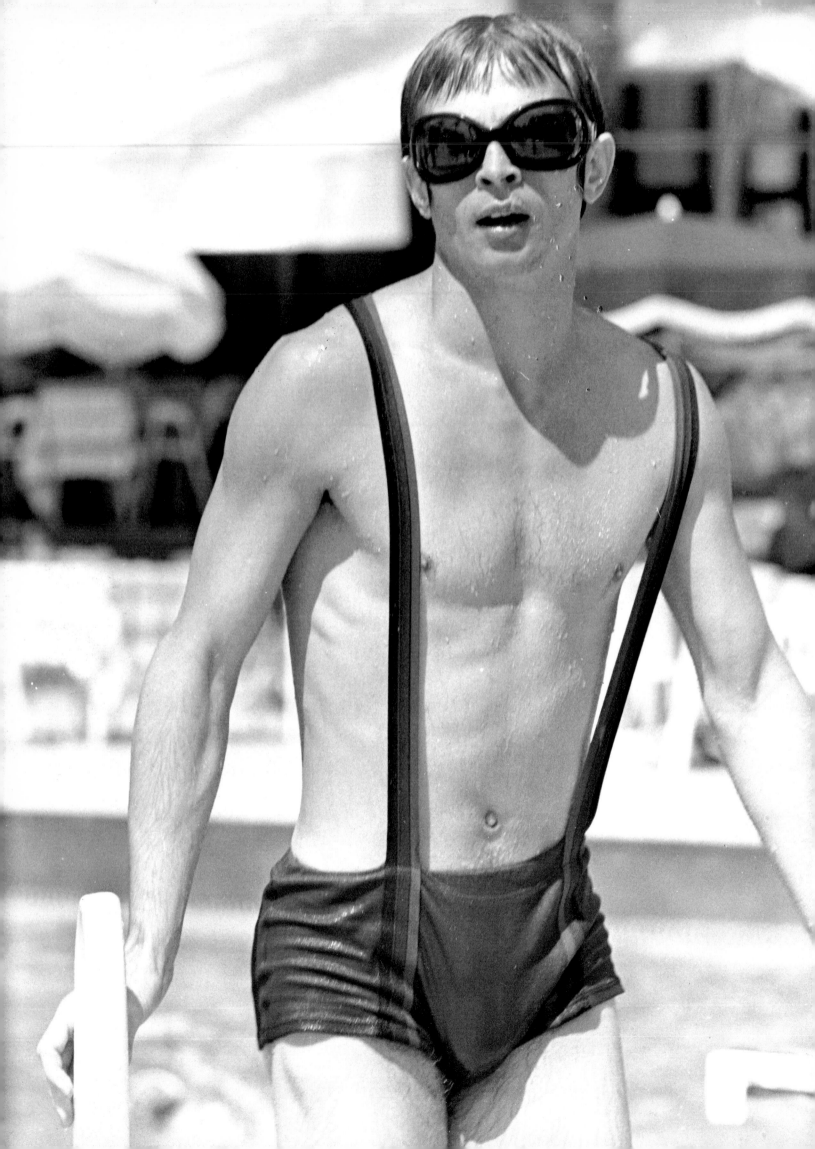

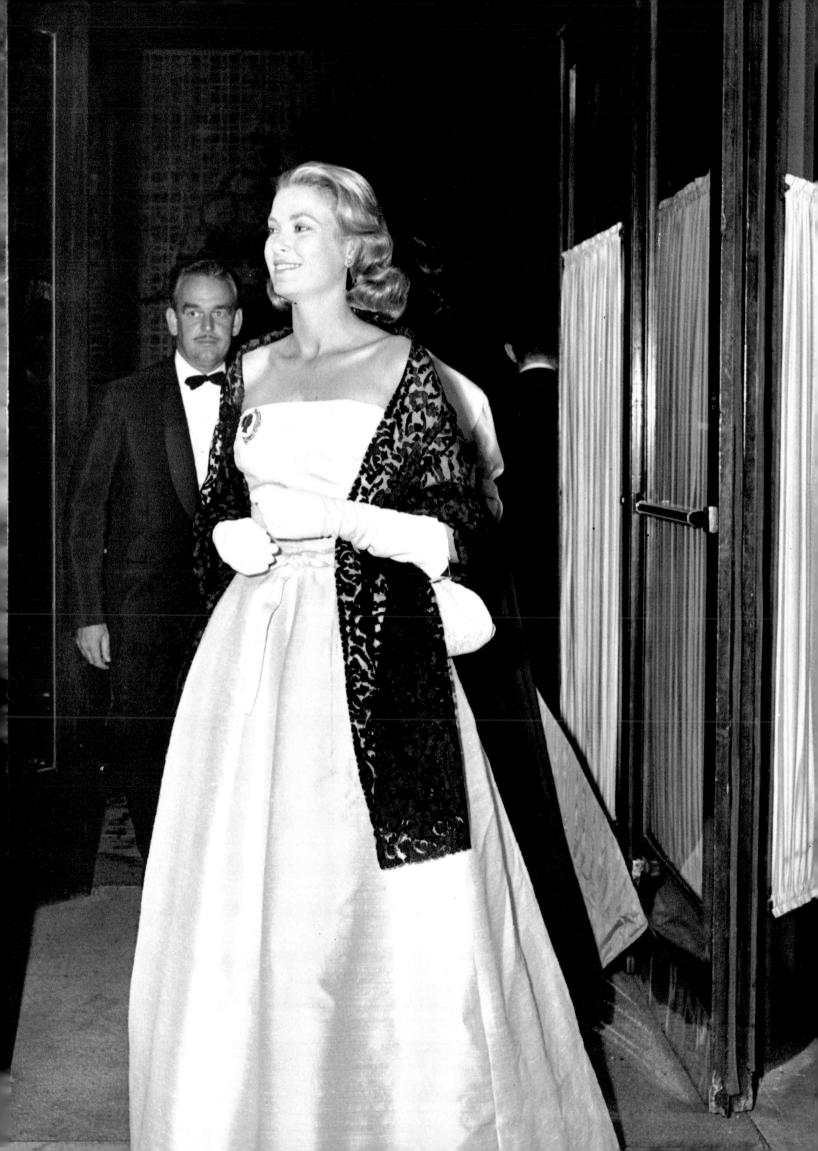

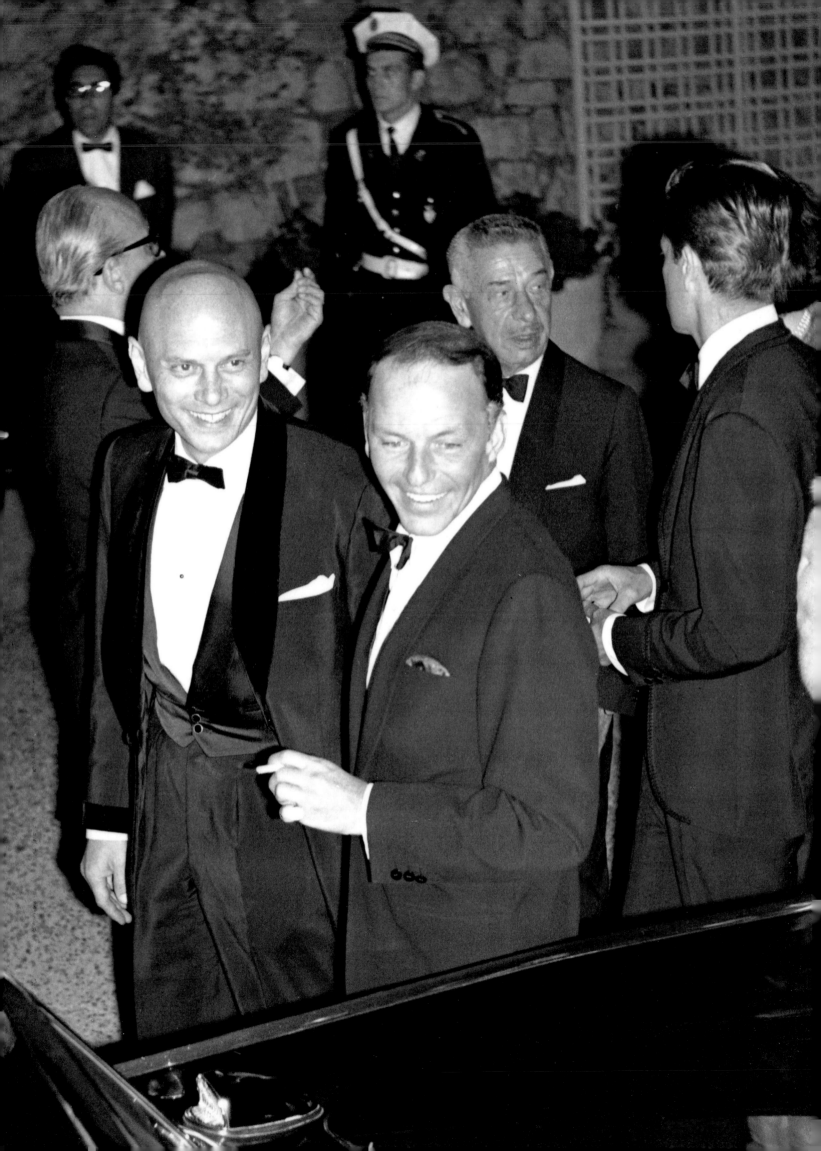

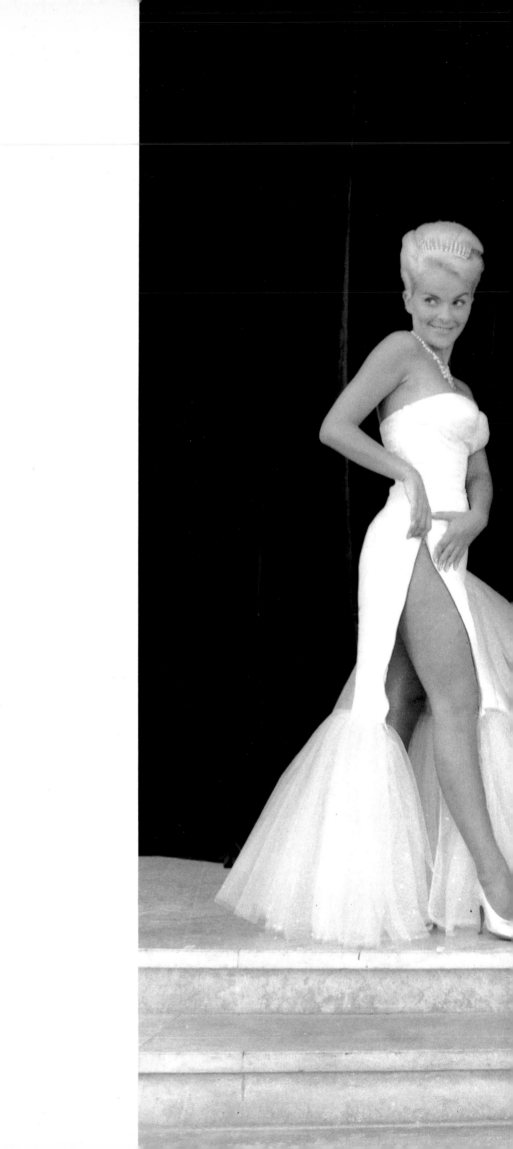

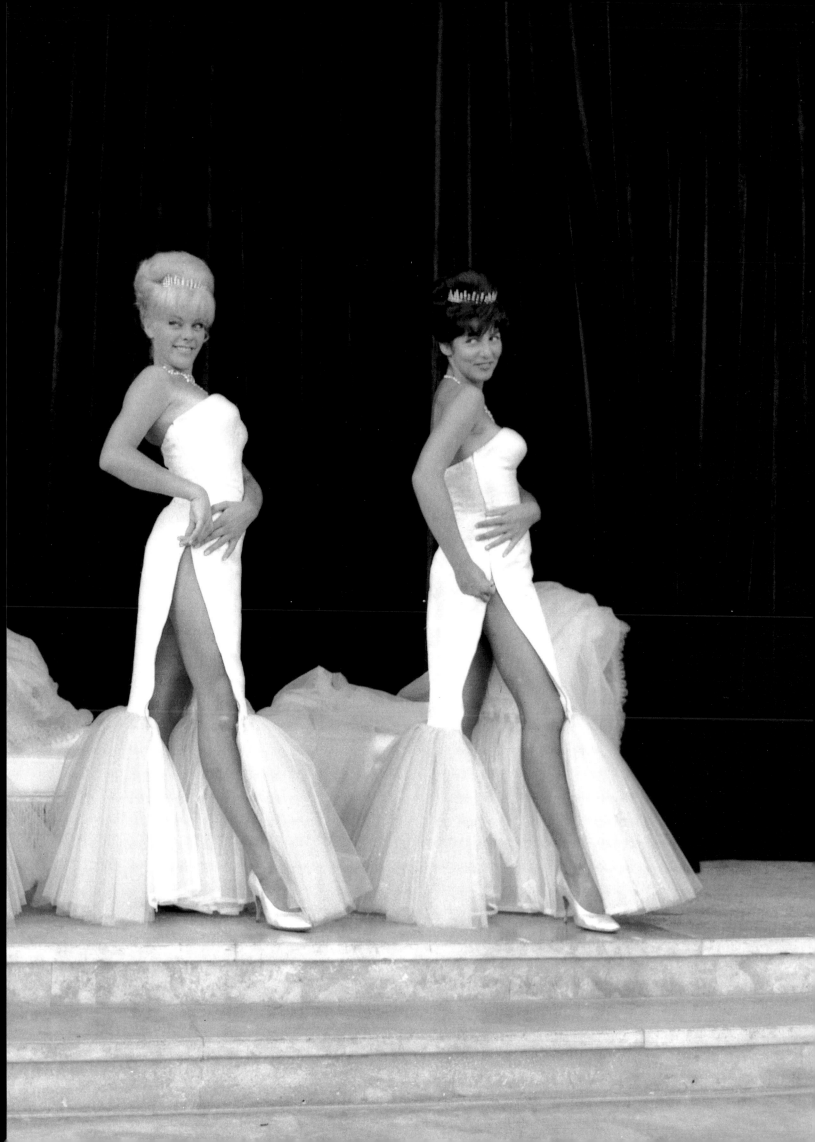

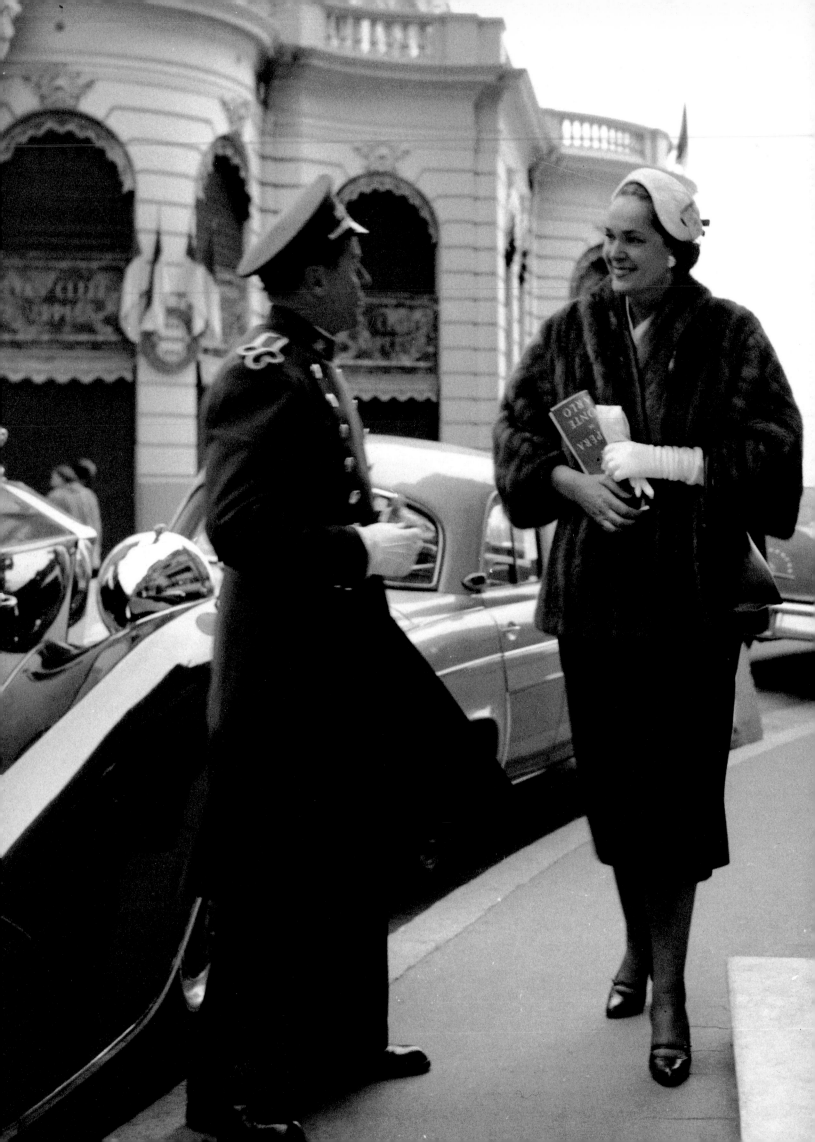

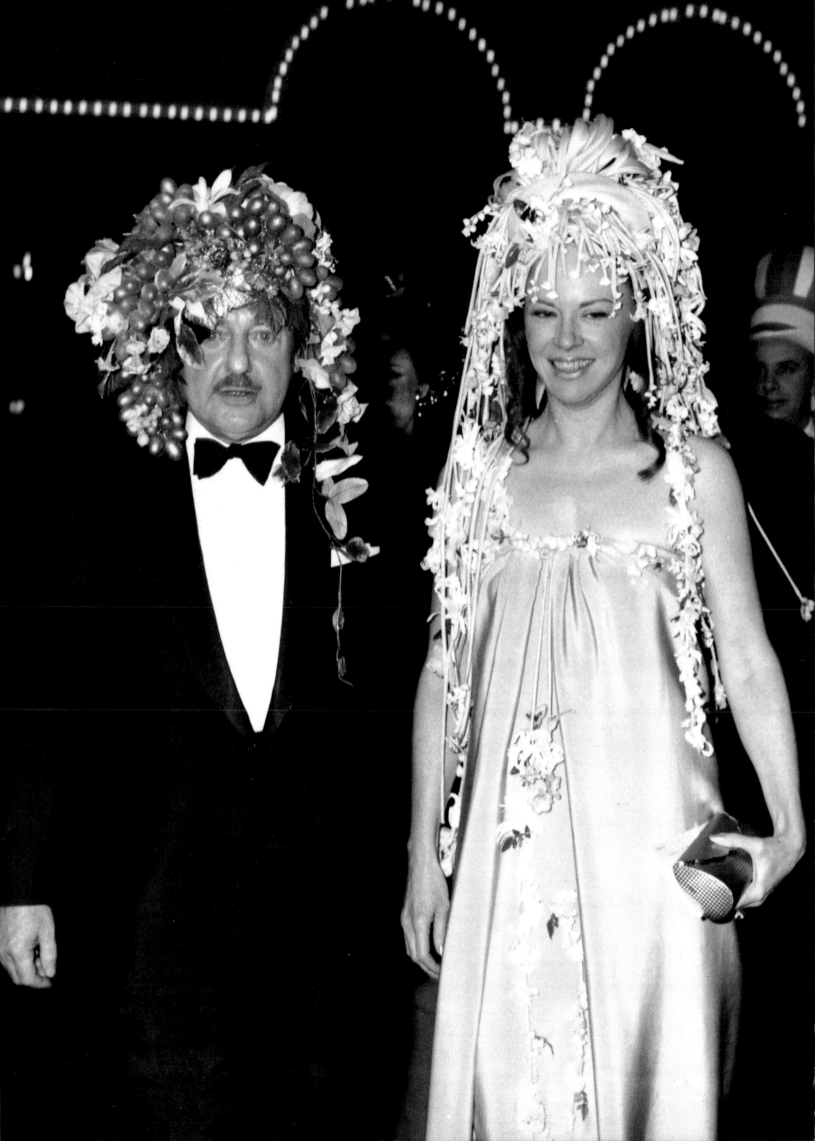

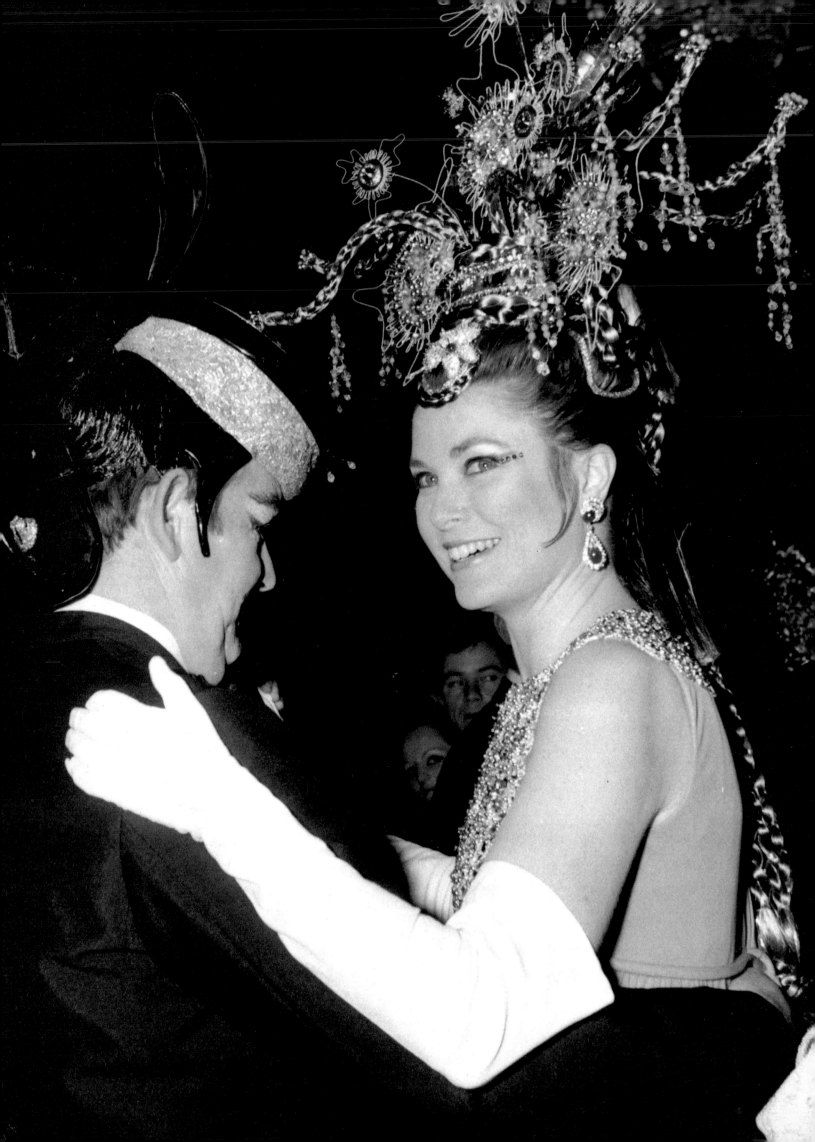

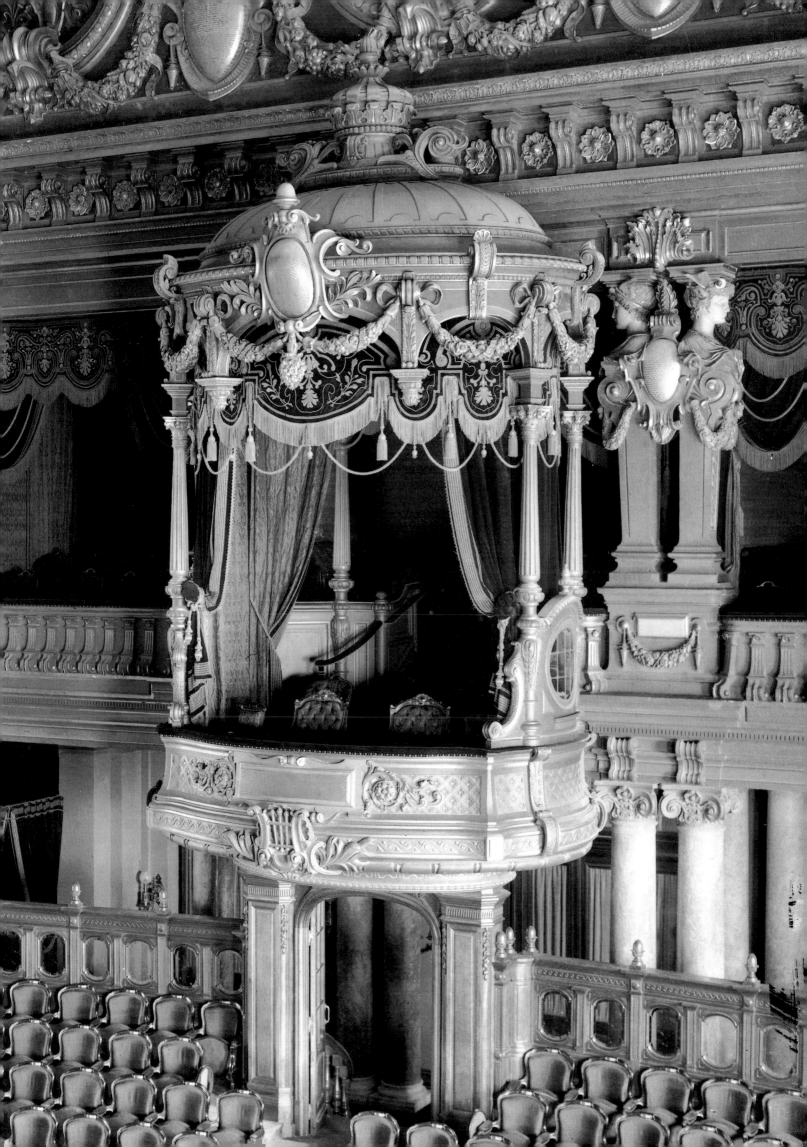

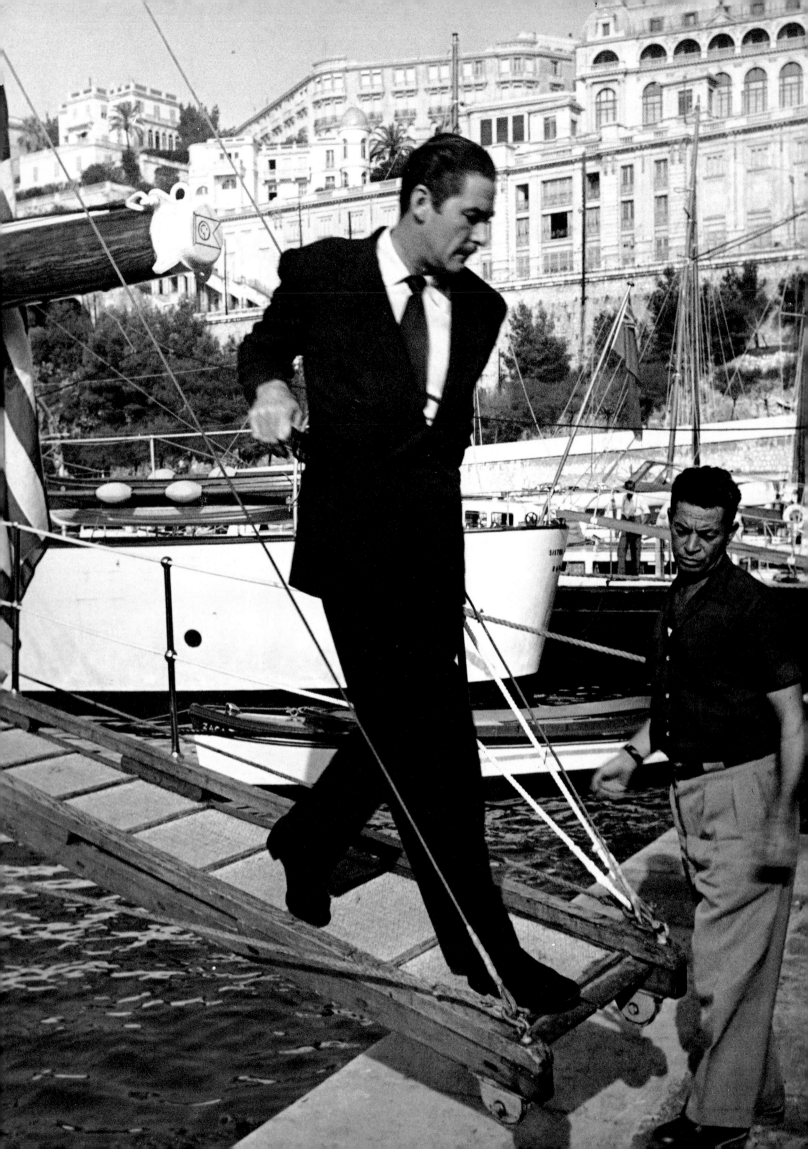

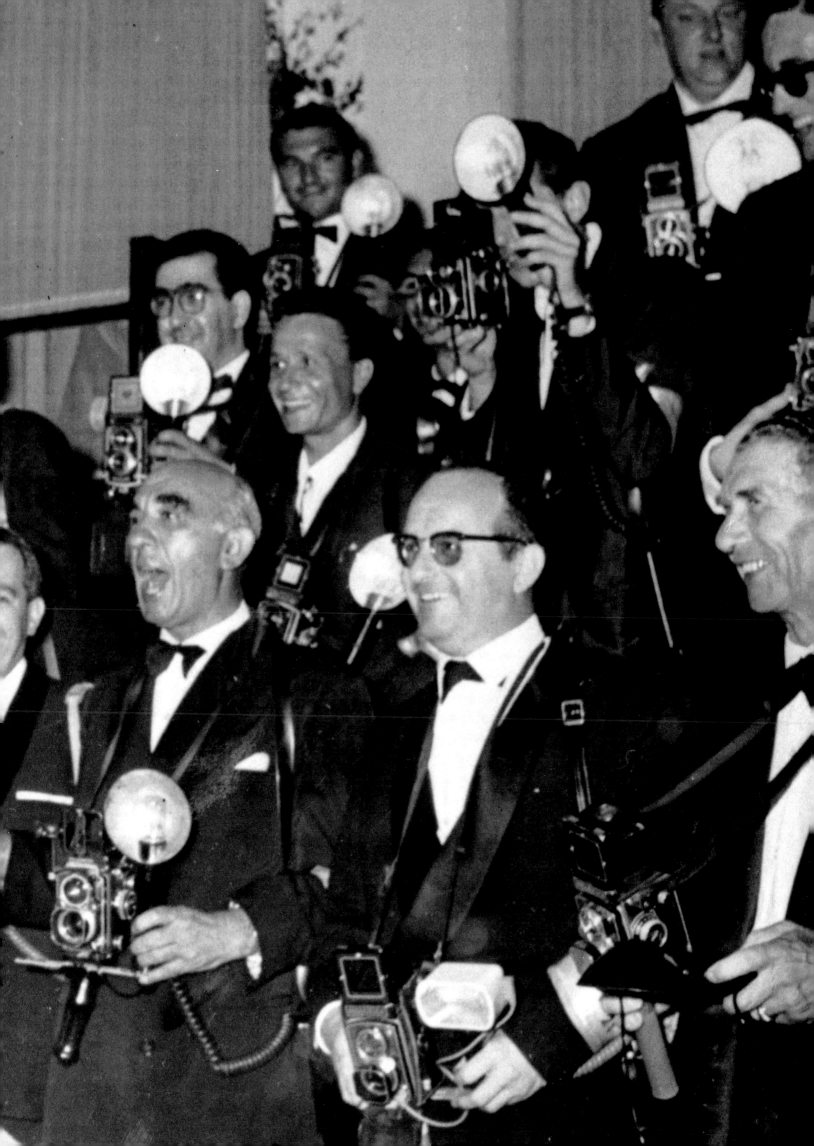

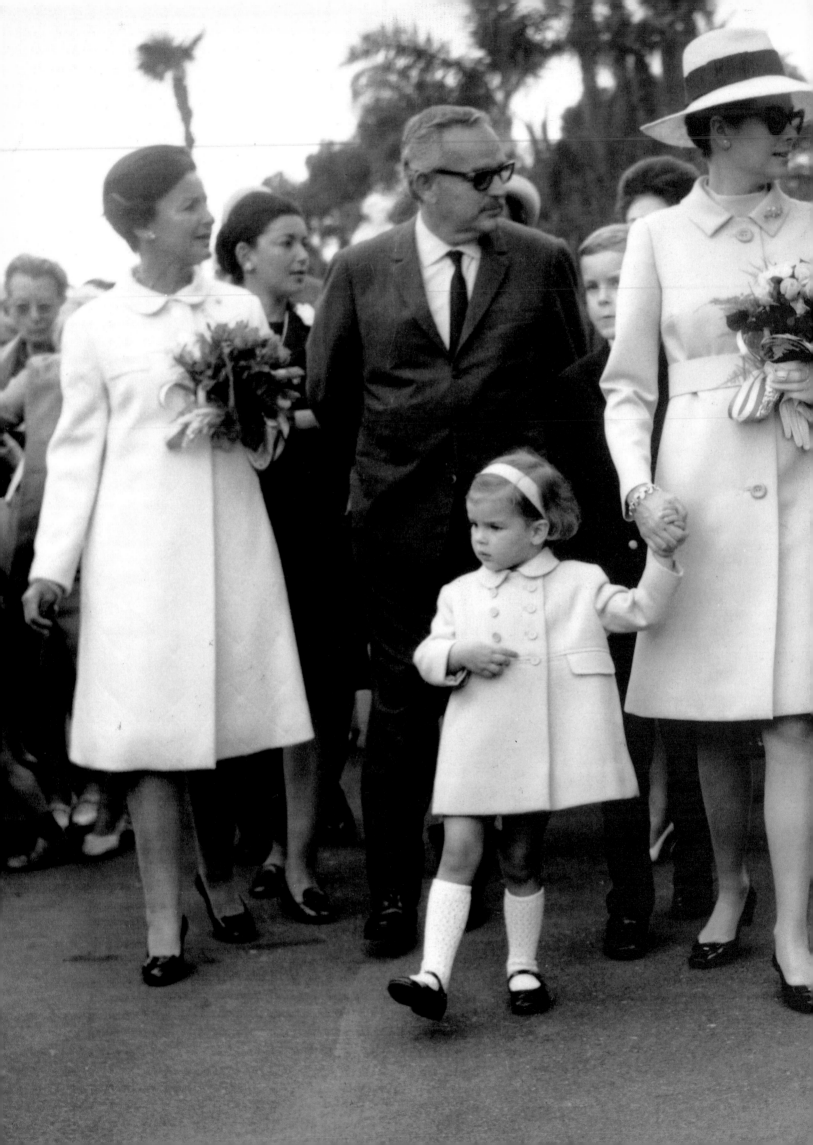

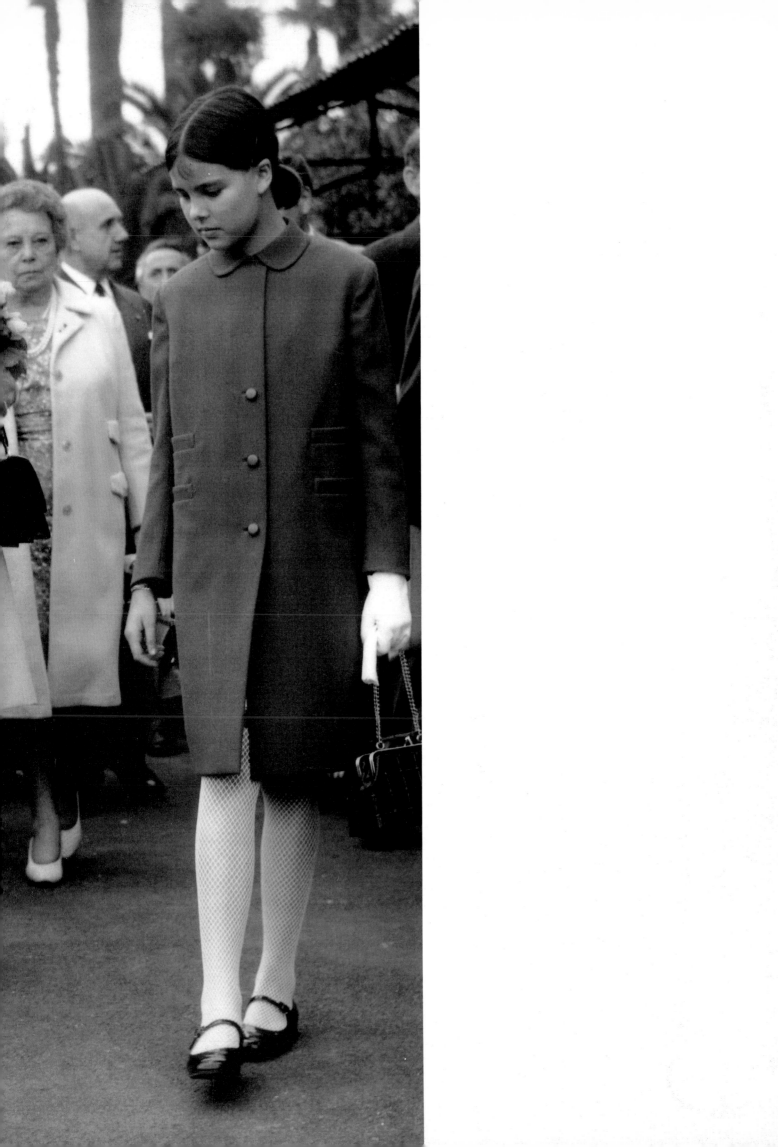

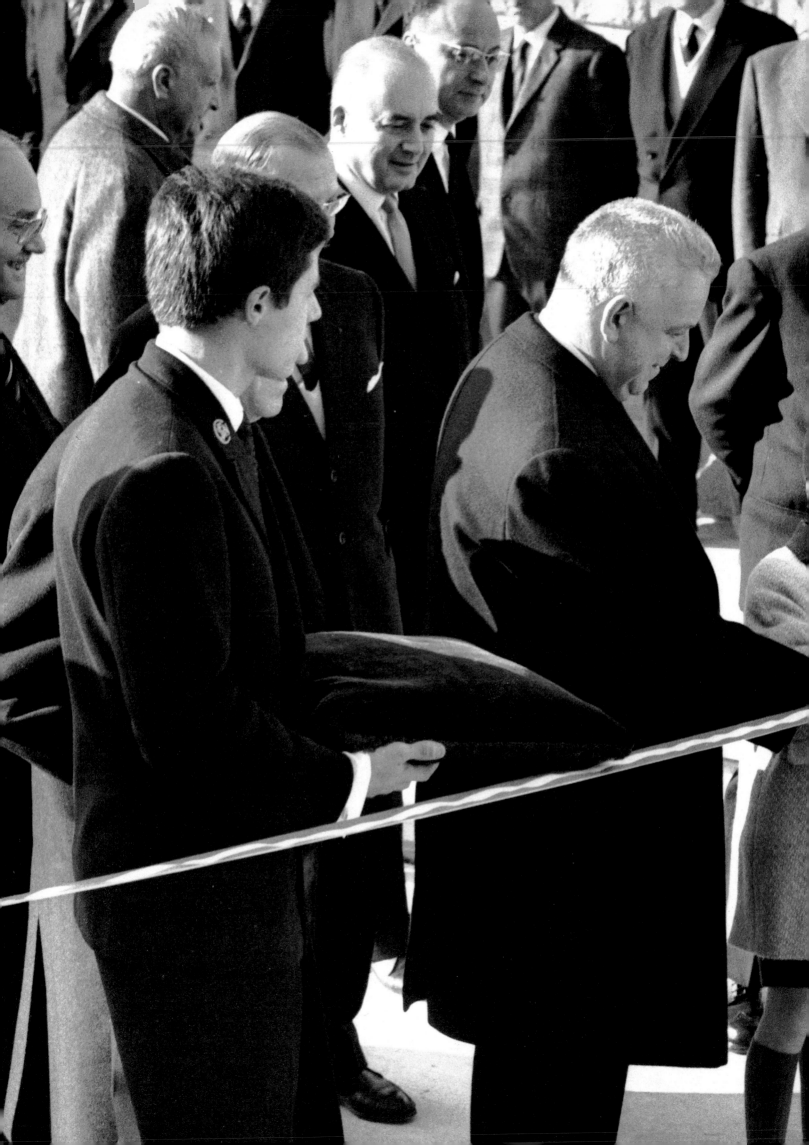

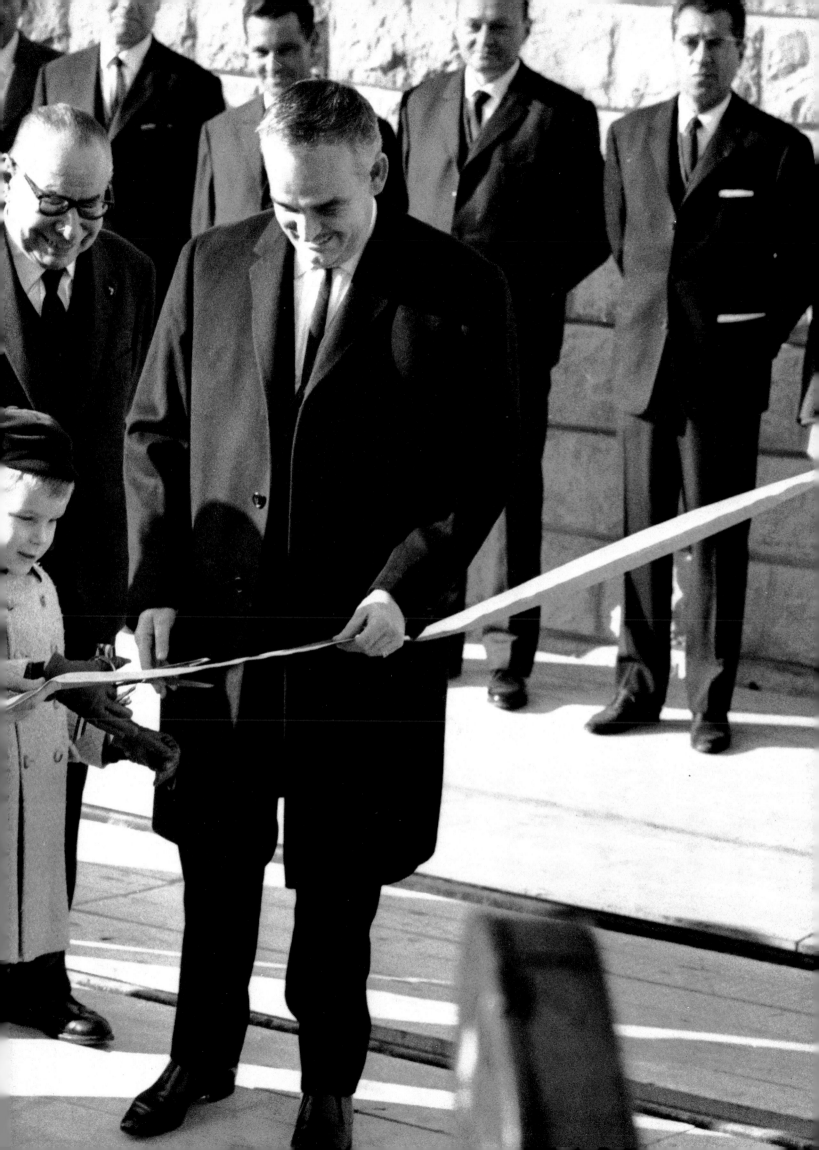

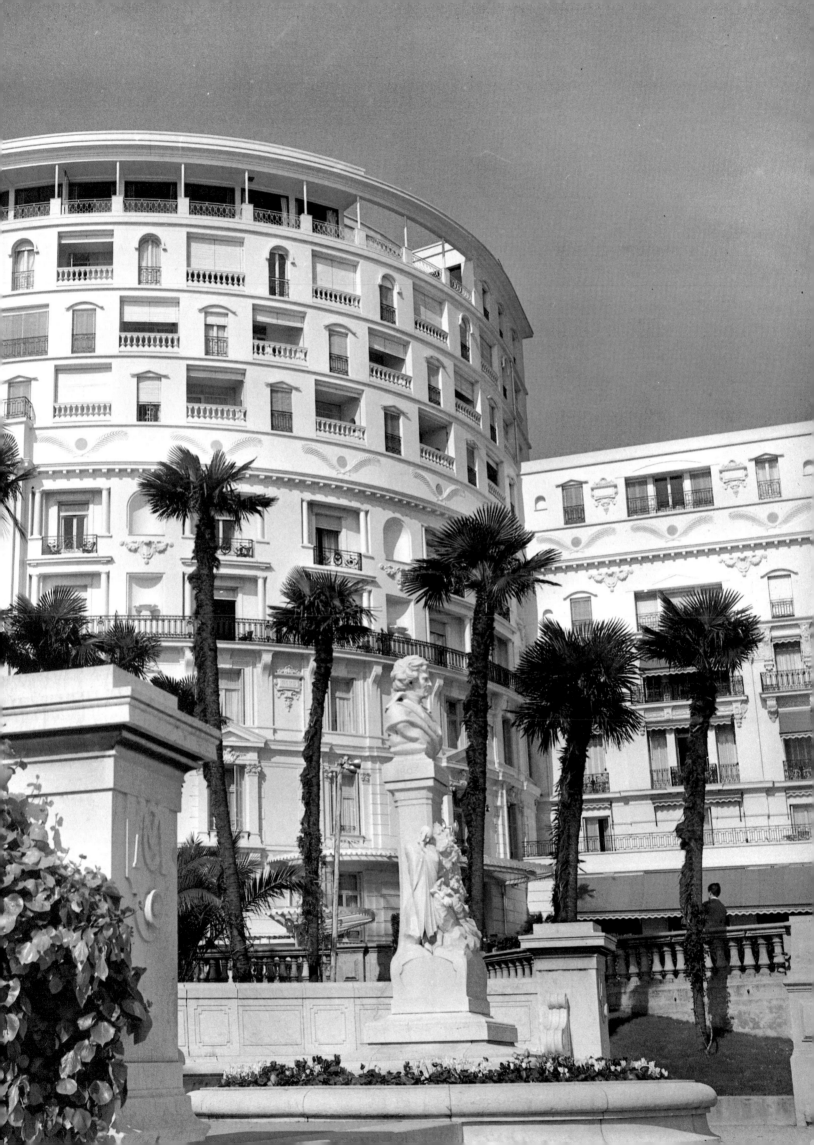

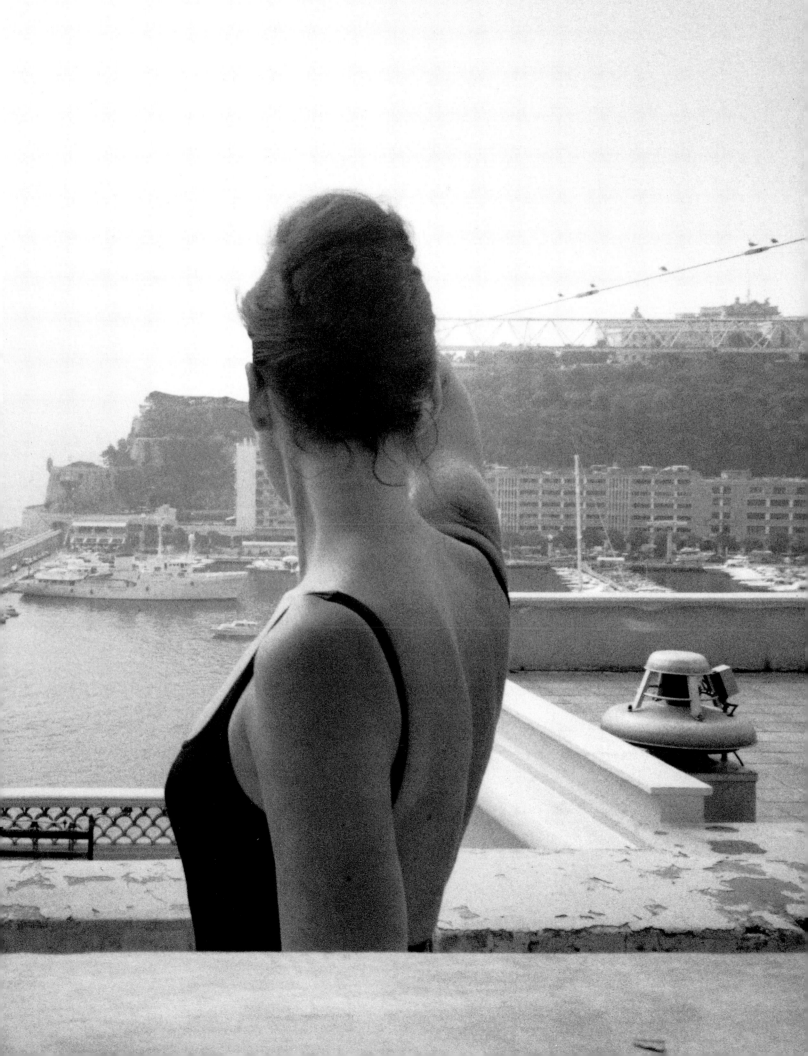

MONTE CARLO
THE LEGENDS

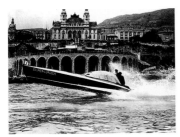

1912. *The 9th racing meet of the Monaco motorboats. Boat no. 172 Saurer-Lürssen.*

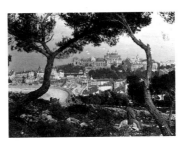

1910. *The Casino, photographed from the Middle Corniche.*

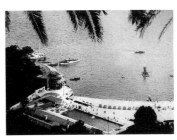

1951. *Monte Carlo Beach.*

1931. *Mr. and Miss Wessel on Monte Carlo Beach.*

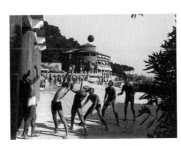

1931. *Mr. John McMullin and Mrs. Loyer Osberne on Monte Carlo Beach.* **1934.** *Diving exhibition at the swimming pool on Monte Carlo Beach.*

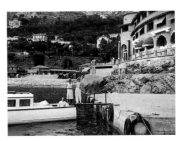

1930. *The landing stage at Monte Carlo Beach.*

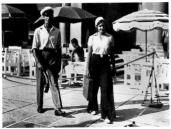

1935. *Overview of the Hôtel Old Beach, from the Monte Carlo Country Club. M. Aleco Noghés.*

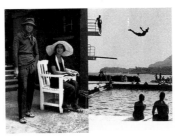

1936. *Playing ball on Monte Carlo Beach.*

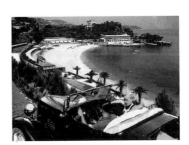

1934. *Monte Carlo Beach and La Vigie (Lookout).*

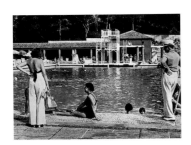

The swimming pool on Monte Carlo Beach.

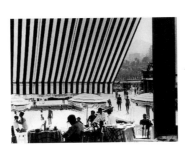

1934. *The terrace at the restaurant on Monte Carlo Beach.*

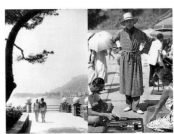

1934. *Overlooking Monaco and "Tête de Chien" from Monte Carlo Beach. M. Aleco Noghés and a friend.* **1931.** *Comte Étienne de Beaumont, standing; M. Buster and Marquise de Poliganc on Monte Carlo Beach.*

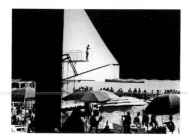

1934. *Diving exhibition at the swimming pool on Monte Carlo Beach.*

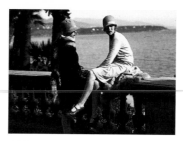

1928. *Models on the Monaco terrace.*

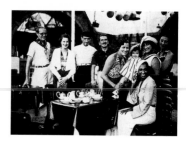

1932. *Jospehine Baker at the "Can-can de la Marine" in Lavrotto.*

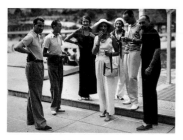

1931. *Monte Carlo Beach.*

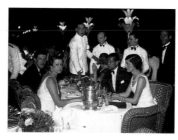

1933. *Coco Chanel and Serge Lifar at the Sporting d'Été.*

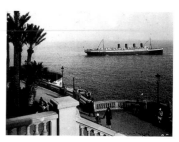

1928. *The ocean liner France in the Baie d'Hercule.*

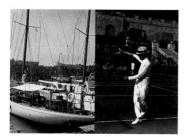

1958. *Yachts in the Monte Carlo port.*
1938. *His Majesty King Gustav V of Sweden at the Sporting Club.*

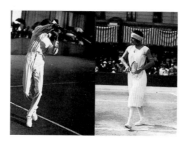

1911. *The Maharajah of Indore playing tennis at La Condamine.*
1922. *Suzanne Lenglen playing championship tennis at La Festa.*

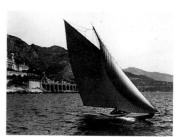

1910. *Regatta in the Baie d'Hercule.*

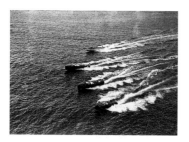

1931. *The Monte Carlo motorboat race: nos. 9, 30, 40, and 0.*

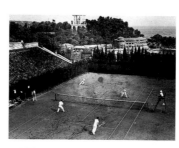

1932. *Men's doubles, with Gentien-Lesueur playing against Rosi-Journu, at the Monte Carlo Country Club.*

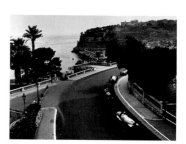

1937. *The 9th Grand Prix of Monaco, here passing before the terrace of the Hôtel de Paris.*

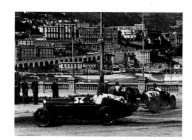

1929. *The 1st Grand Prix of Monaco: no. 32, Dore in a Licorne; no. 30, Lepori in a Bugatti; no. 26, Sterligh in a Maserati.*

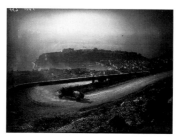

1921. *The coastal race at Mont-Angel. The Turcat-Méry of M. de Soncy.*

1910. *The French team at a fencing tournament.*
1910. *Baron de Woot on a pigeon shoot.*

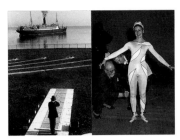

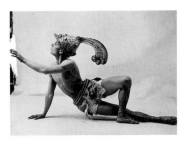

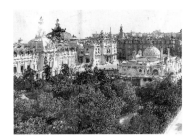

1928. *A pigeon shoot.*
1939. *Preparing for the ballet* Rouge et noir, *Henri Matisse and Alicia Markova.*

1925. *Serge Lifar in the ballet Zéphyre et Flore.*

1905. *The Casino and the Café de Paris.*

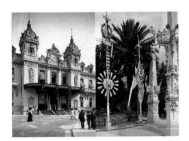

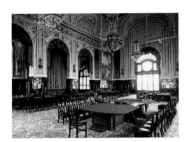

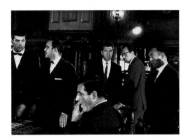

1910. *Entrance to the Casino.*
1910. *The Saint Albert Festival on the Place du Casino.*

1933. *Salle Medecin, the Casino's gaming hall inaugurated on New Year's Eve 1910.*

Salle des Privés in the Monte Carlo Casino.

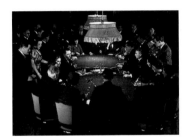

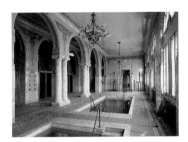

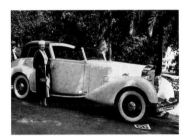

1936. *The Casino.*

1908. *Thermal baths on the Casino terrace, inaugurated on the 3rd of March 1908.*

1935. *The elegant automobile competition.*

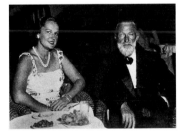

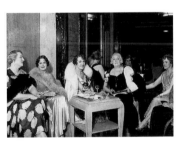

1936. *Mlle Yvette Labrousse, future Begum Agan Khan and the painter Kees van Dongen at the Sporting d'Été.*

1932. *Mmes Georges, Armstrong Colman, McLellan, and Lessing at the Sporting d'Hiver.*

1938. *M. and Mme Snoart, Mme Jacqueline Delubac, M. Sacha Guitry, and the porter at the Hôtel de Paris.*

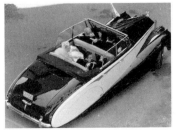

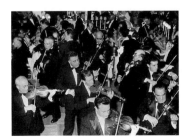

Mrs. Kelly, mother of Princess Grace, arriving at the Hôtel de Paris.

1956. *The wedding of Miss Grace Kelly and His Serene Highness Prince Rainier III of Monaco.*

1962. *The "Hundred Violins" at the Sporting d'Hiver Rose Ball.*

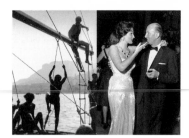

1934. *The raft*
on Monte Carlo Beach.
1959. *Baroness Stefania von*
Kories zu Goetzen at the Sporting
d'Hiver's Easter Gala.

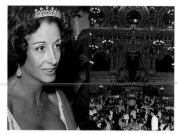

1965. *Comtesse de Riancourt*
at the Sporting d'Été gala.
1970. *The Rose Ball at*
the Opéra, starring Mady Mesplé.

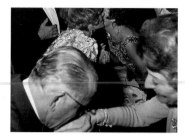

Arriving at the Red Cross gala.

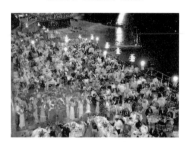

1936. *The Sporting d'Été terrace.*

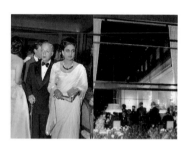

1959. *The Maharanee*
of Baroda at the Sporting d'Été.

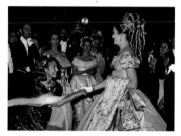

1966. *The Centenary Ball.*
Mme Hélène Rochas in deep curtsy
before Her Serene Highness
Princess Grace.

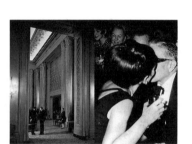

1933. *Gaming rooms at*
the Sporting Club d'Hiver.
1966. *Aristotle Onassis and Maria*
Callas at the Sporting d'Hiver's
gala on New Year's Eve.

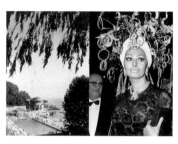

1934. *The swimming pool*
on Monte Carlo Beach and
the Hôtel Old Beach.
1969. *Sophia Loren at the "Bal des*
Têtes," the second Bal du Casino.

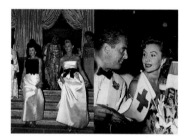

1954. *Red Cross gala*
at the Sporting d'Été.

1962. *Their Serene Highnesses*
Princess Grace and Prince Albert,
Heir Apparent, leaving
Monte Carlo Beach.

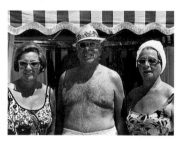

1967. *M. Wolfe, loyal*
fan of Monte Carlo Beach.

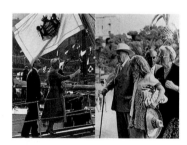

1956. *Their Serene Highnesses*
Prince Rainier and Princess Grace.
1958. *Sir Winston Churchill*
on Monte Carlo Beach.

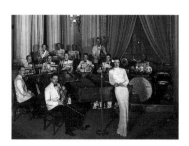

1939. *The Sporting*
d'Hiver orchestra.

Gala at the Sporting d'Été.

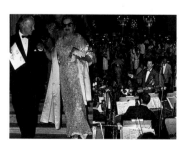

1967. *Mme Frank Jay Gould,*
at the Sporting d'Hiver opening gala.

1963. The "Gala of Kings" for the benefit of refugees: Prince Rainier and Princess Grace, with Aristotle Onassis and Maria Callas.

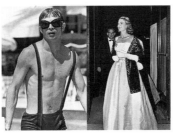

1966. Rudolf Nureyev on Monte Carlo Beach.
1959. Their Serene Highnesses Prince Rainier and Princess Grace at the Sporting d'Été.

1962. Frank Sinatra and Yul Brynner at a Sporting d'Été gala.

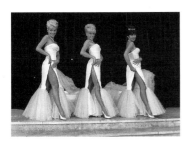

1962. The Ballet "Paris" performed by the "Monte Carlo Dancing Stars" at the Sporting d'Été.

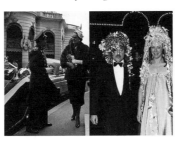

1958. The Begum Aga Khan in front of the Hôtel de Paris.
1969. Prince Louis de Polignac and Mme Jeanne Kelly van Remoortel at the "Bal des Têtes."

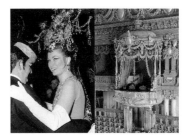

1969. Their Serene Highnesses Prince Rainier and Princess Grace at the "Bal des Têtes," the second Bal du Casino.
1905. The royal box.

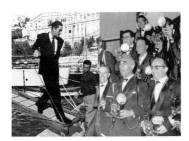

1950s. The arrival of Errol Flynn at Monte Carlo.
1962. Photographers at the Sporting d'Été for the Red Cross gala.

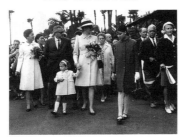

1958. The arrival of the princely family at the dog show.

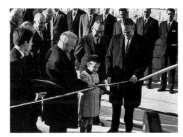

1964. The inaguration of the Monaco-Monte Carlo railway station. Their Serene Highnesses Prince Albert, Heir Apparent, and Prince Rainier III, with M. Marc Jacquet, French Minister of Transport.

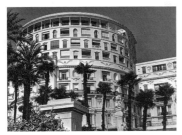

1960. The Hôtel de Paris and its Rotonde.

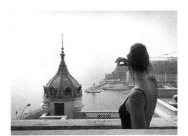

1992. The port seen from the Hôtel Hermitage.